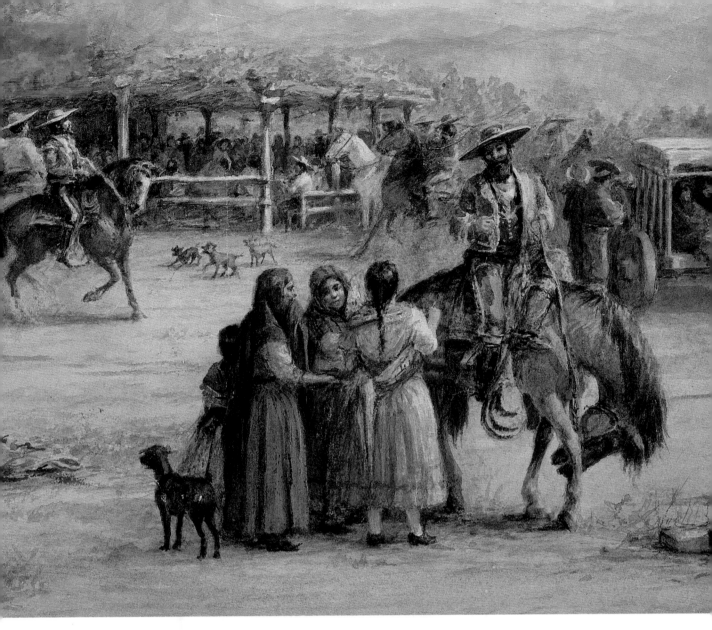

El Pueblo
THE HISTORIC HEART OF LOS ANGELES

Jean Bruce Poole

Tev

The

and

Los Angeles

The Getty Conservation Institute works internationally to advance conservation in the visual arts. The Institute serves the conservation community through scientific research, education and training, model field projects, and the dissemination of information. The Institute is a program of the J. Paul Getty Trust, an international cultural and philanthropic institution devoted to the visual arts and the humanities.

This is the fifth volume in the Conservation and Cultural Heritage series, which aims to provide information in an accessible format about selected culturally significant sites throughout the world. Previously published are *Cave Temples of Mogao: Art and History on the Silk Road* (2000), *Palace Sculptures of Abomey: History Told on Walls* (1999), *The Los Angeles Watts Towers* (1997), and *House of Eternity: The Tomb of Nefertari* (1996).

© 2002 The J. Paul Getty Trust
Getty Publications
1200 Getty Center Drive, Suite 500
Los Angeles, California 90049-1682
www.getty.edu

Sheila Berg, *Copy Editor*
Vickie Sawyer Karten, *Series Designer*
Jim Drobka, *Designer*
Anita Keys, *Production Coordinator*
Printed by CS Graphics, Singapore
Separations by Professional Graphics, Rockford, Illinois

Library of Congress Cataloging-in-Publication Data

Poole, Jean Bruce.
 El Pueblo : the historic heart of Los Angeles / Jean Bruce Poole, Tevvy Ball.
 p. cm. — (Conservation and cultural heritage)
 Includes bibliographical references and index.
 ISBN 0-89236-662-1 (pbk.)
 1. El Pueblo de Los Angeles Historical Monument (Los Angeles,Calif.) 2. Historic sites— Conservation and restoration— California— Los Angeles. 3. Los Angeles (Calif.)— History. 4. Pluralism (Social sciences)— California— Los Angeles. 5. Los Angeles (Calif.)— Ethnic relations. I. Ball, Tevvy. II. Title. III. Series.
 F869.L86 E4 2002
 979.4'9402—dc21

 2001008262

Contents

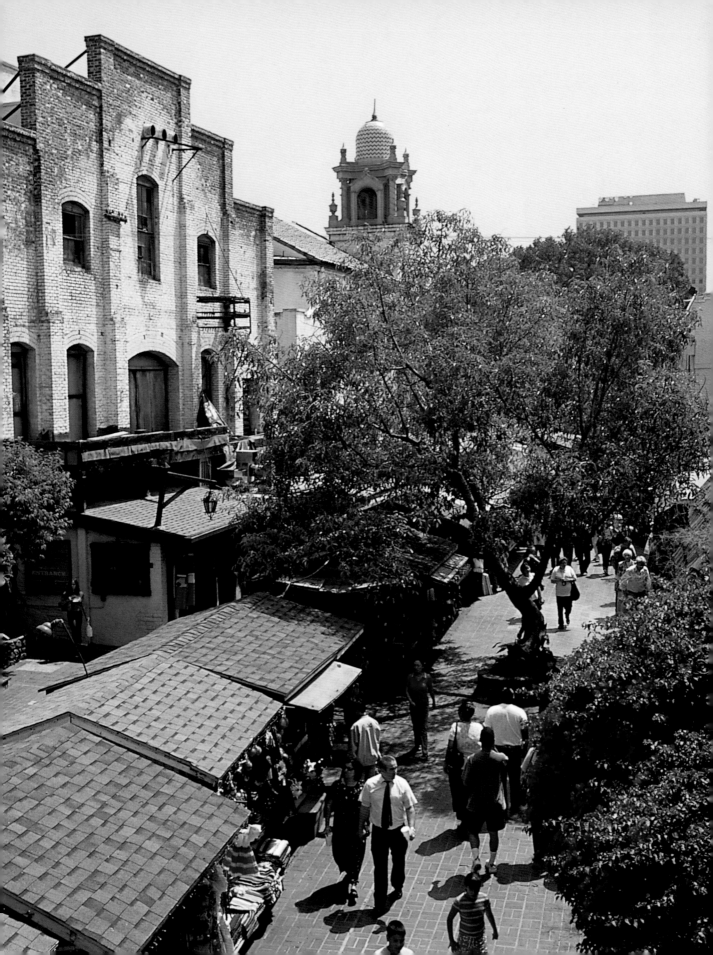

THE BIRTHPLACE OF LOS ANGELES

From the Plaza, the central square of El Pueblo de Los Angeles, the surrounding cityscape affords a fine sense of the area's history. To the north, past the great Moreton Bay fig trees, is the Mexican marketplace on Olvera Street; to the east lies Union Station, the last major railroad terminal built in the United States. The Pico House, the town's first grand hotel, fronts the square on the south, as does the red-brick Hellman/Quon building, one of the few surviving landmarks of Old Chinatown. To the west rises City Hall, which, when it opened in 1928, symbolized the burgeoning modern metropolis. Other skyscrapers have gone up in the decades since. Under these towers, just above the humming Santa Ana Freeway, built alongside the historic district half a century ago, El Pueblo seems perched on the edge of another world.

The marketplace at Olvera Street, seen from a balcony of the Sepúlveda House, built in 1887. The Plaza Substation and the Plaza Methodist Church are on the left; to the right, the tower of Los Angeles City Hall can be seen.
Photo by Susan Middleton, 2001

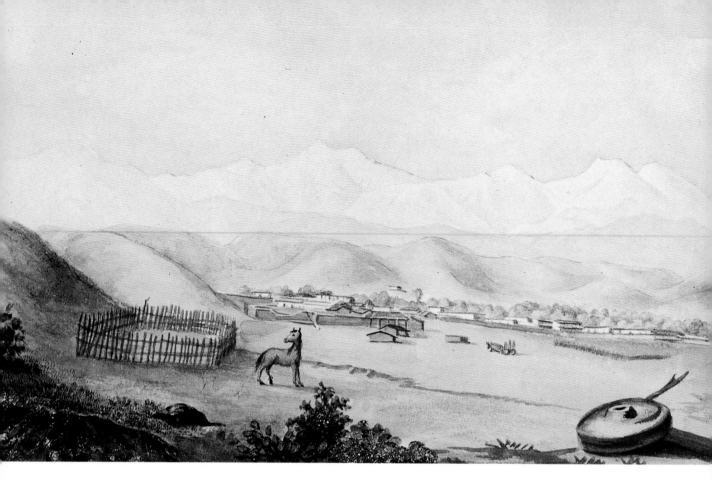

A view of the pueblo in 1848 is seen in this pencil and watercolor drawing by William Rich Hutton entitled Los Angeles from the South.

When the pueblo was founded in 1781, this vista was a grassy valley inhabited by small villages of Native Americans. In the next century and a half, Los Angeles grew rapidly: from a few dozen adobes and about three hundred people in 1800 to a rowdy frontier town of sixteen hundred inhabitants in 1850 to a vast city of over a million people eighty years later. It takes some effort to imagine this terrain as it appeared in the mid-nineteenth century, when the land sloping toward the river was covered with vineyards of Californio, French, and Italian winemakers, and the great ranchos of the Sepúlvedas, Avilas, and other families stretched to the sea. In the 1830s and 1840s the rancheros, many of whom owned town houses around the Plaza, came here to do business and attend fiestas. The pueblo was then the capital of Mexican Alta California. While newer buildings have long since replaced most of those original adobes, the city's oldest existing house is still to be found here, along with many other architectural and historic treasures. In a metropolis known for its ephemerality, the pueblo testifies to the continuities that also mark the character of Los Angeles.

Today preserved as a historic landmark, El Pueblo is many other things as well—a place of living culture, of recreation and celebration, a place, too, that has seen its share of tragedy. A department of the City of Los Angeles, it also belongs to the merchants of Olvera Street, to the more than two million visitors who flock here each year, to the thousands who worship on Sundays and religious holidays at the Old Plaza Church, and to the thousands of others who come to celebrate traditional fiestas such as Cinco de Mayo. Still other visitors come in search of their heritage or, perhaps, to enjoy a stroll through the area that represents so much of the city's eventful and multiethnic history.

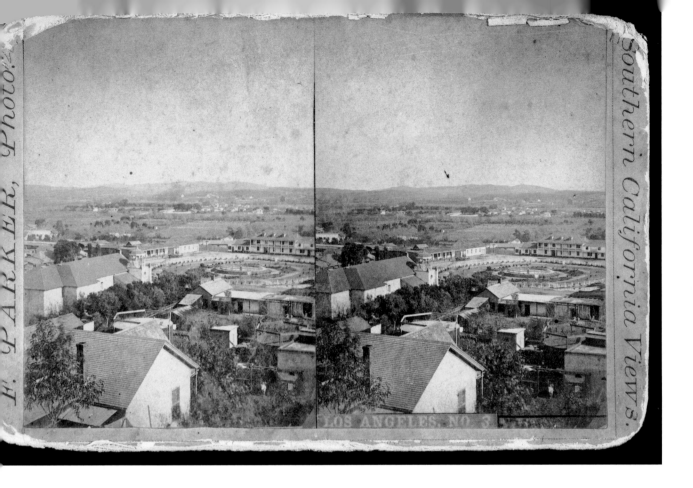

LOS ANGELES. NO. 3.

This history has been richly told, and we aim to complement, not duplicate, the ample narratives, several of which can be found in the Suggested Reading, that recount the story of early Los Angeles. This book seeks rather to profile the pueblo in such a manner as to illuminate the central issues that have shaped its heritage—the significance it bears today and the legacy it will pass on to the future. The pueblo's first 150 years are painted in broad strokes: its founding in 1781 by settlers of Indian, African, and European descent; its halcyon days as the capital of the Californio rancheros; and its metamorphoses following the arrival of Anglo-Americans, Europeans, Chinese, and others in the nineteenth and early twentieth century. We then bring the story up to date, considering how new—and sometimes contradictory—ideas have influenced the ways in which the pueblo's heritage has been viewed and valued. Christine Sterling and various city leaders saw the site through popular romantic myths of old

California when she created the Olvera Street marketplace in 1930, revitalizing this historic district after it had fallen into ruin. For others, including much of the Mexican American community, the Plaza and environs have fostered a very different kind of urban cultural expression. And for some, including the revolutionary Mexican painter David Alfaro Siqueiros, the pueblo has been a place of protest. The story of his mural *América Tropical,* painted on an exterior wall of a building on Olvera Street, is a fascinating tale of art and ideology in 1930s Los Angeles.

In the decades since, the pueblo has remained one of the city's most enduring cultural symbols. Today its heritage comprises many meanings—historical, cultural, social, architectural, artistic. Those who manage and conserve the site are the custodians of all these values, which they seek to preserve by preserving the physical fabric—

Los Angeles. ca. 1875. The pueblo in the 1870s still bordered fields and vineyards. Fronting the Plaza is the two-story Lugo House, which had belonged to one of the great ranchero families of early California. Francis F. Parker, albumen stereograph.

Courtesy the J. Paul Getty Museum, Los Angeles. Gift of Weston J. and Mary M. Naef. 84.XC.979.6912

the historic buildings and streetscapes—that
embody them. In Los Angeles, as in many
other cities, historic districts have not always
been given the respect they deserve, and the
resounding commercial success of Olvera
Street unfortunately did not ensure that the
rest of the pueblo would be saved. Faced
with threats posed by continuing develop-
ment, the City of Los Angeles signed an
agreement in 1953 with Los Angeles County
and the State of California, creating El
Pueblo de Los Angeles State Historic Park.
This allowed the state to purchase most of
the pueblo's historic buildings. In 1992 the
property was transferred to the city; in 1994
it was made into a separate city department,
with the authority to make policy, and
its name was changed to El Pueblo de Los
Angeles Historical Monument.

Under this stewardship, the preservation
of El Pueblo's heritage has continued with
renewed commitment. Several long-term
projects are coming to fruition. The Pico
House is being attractively renovated. The
new Chinese American Museum will occupy
space in the Garnier building. The landmark
mural *América Tropical* has been saved from
ruin, and an interpretive center telling its
story is being installed in the Sepúlveda
House, built in 1887 by one of the great fami-
lies of Mexican California and itself recently
restored. Other buildings are still awaiting
new life. Today, as public debate continues
over the meanings and future uses of the
historic Plaza area, the pueblo's story—and
its multicultural legacy—are of particular
relevance to the diverse city that is contem-
porary Los Angeles.

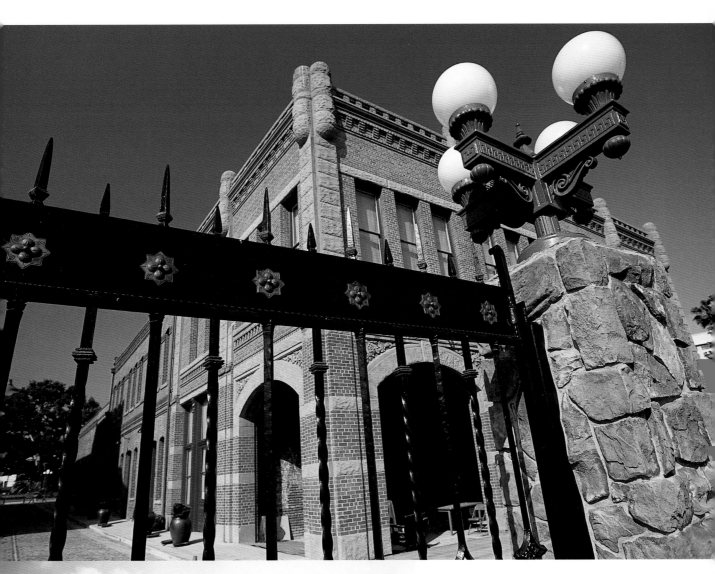

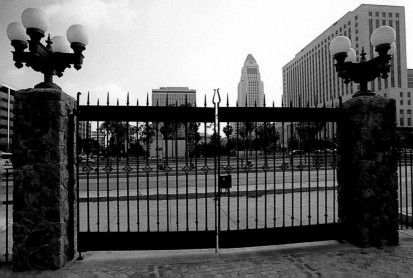

ABOVE
*The Garnier building,
seen through the iron gate
on Sanchez Street, has
recently been restored. It
will house the new Chinese
American Museum.*

LEFT
*The gate on Sanchez Street
frames part of the down-
town skyline.*

Photos by Susan Middleton, 2001

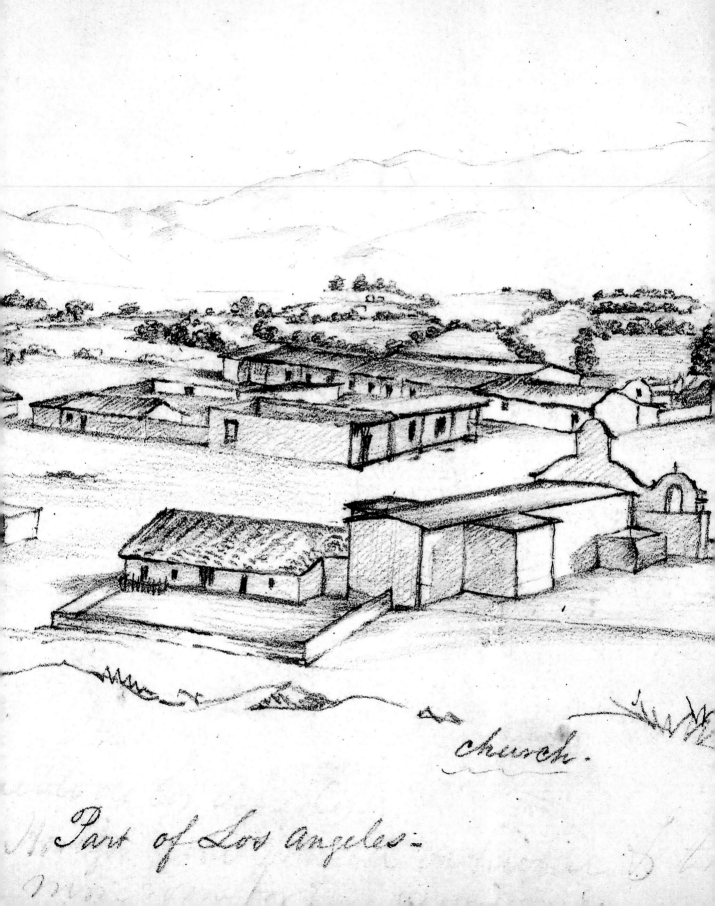

Church.

Part of Los Angeles.

THE CALIFORNIA PUEBLO

In June 1777, Felipe de Neve, the Spanish governor of the Californias, asked the viceroy of the territories then known as New Spain to send him settlers for a new pueblo, to be founded some 350 miles south of the Alta California capital of Monterey. Seeking to head off Russian and British imperial ambitions, Spain had recently begun to colonize the region. One of Neve's primary tasks as governor was to survey Alta California and select promising sites for small farming towns to support the Franciscan missions and the military presidios already being established there.

The Plaza, as it appeared in 1847. In the center is the Plaza Church.
Drawing by William Rich Hutton (detail).

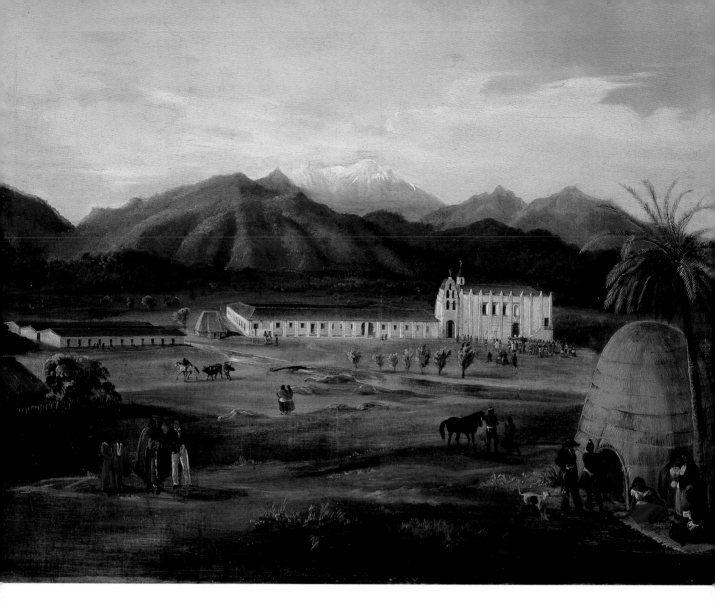

An idealized rendering of Mission San Gabriel, painted in 1832 by Ferdinand Deppe, an amateur artist who worked for a German cattle company based in Mexico. At right is a traditional Gabrielino Indian house, with a round floor plan and domed thatched roof. At left are men in European dress. The low buildings to the left of the mission housed the mission's neophytes, or Christianized Indians.

Courtesy Santa Barbara Mission Archive Library

The site that Neve was thinking of had first been seen by Europeans some eight years earlier, after a Spanish expedition under the leadership of Gaspar de Portolá headed north from San Diego. A few weeks into their journey, noted Father Juan Crespí, the expedition's diarist, Portolá and his men "entered a very spacious valley, well-grown with cottonwood and alders, among which ran a beautiful river." This would be the perfect place for a settlement, the padre thought, with "good land for planting all kinds of grain," as well as "a large vineyard of wild grapes" and "an infinity of rose bushes in full bloom." Indians living in the nearby villages greeted the visitors warmly. Crespí's only concern was a series of strong *temblores*, or earthquakes, "the continuation of which astonishes us."[1] He named the river El Río de Nuestra Señora de Los Angeles de La Porciúncula, after the feast day of the

ca. 10,000 B.C.
Los Angeles basin inhabited by Native Americans.

1542
The Spanish explorer Juan Cabrillo sails into San Pedro Bay, claims land for king of Spain.

Porciúncula, a commemoration of Saint Francis of Assisi that the explorers had celebrated the previous day.

To found the new pueblo, Neve wanted "men of the field," or experienced farmers, "without vices or defects." Recruits were enlisted from the territories of Sinaloa and Sonora, in New Spain. They were given rations of food and a monthly salary of ten pesos and lent livestock, clothing, and farming equipment. With their garrison of four soldiers, the settler families headed north early in 1781, sailing from San Blas and Guaymas across to Loreto and continuing one thousand miles on foot up the Baja California peninsula.

While waiting for them to arrive at Mission San Gabriel, Governor Neve laid out the town. He named the settlement El Pueblo de la Reina de Los Angeles (sobre el Río de la Porciúncula)—Town of the Queen of the Angels (on the River Porciúncula)— and planned it according to the Laws of the Indies, which governed Spanish colonies in the New World. There would be a rectangular plaza, or town square, with its corners at the cardinal points of the compass and house lots laid out on three sides. On the fourth side would be public buildings and a church. Neve also selected a location for a dam, to allow for irrigation of the fields that would be planted. After San Jose, which had been established in 1777, this would be the second Spanish pueblo in Alta California.

The eleven pioneer families and their guard—a total of forty-eight people— arrived in different parties at Mission San Gabriel during summer 1781. Some of them had barely recovered from smallpox con-

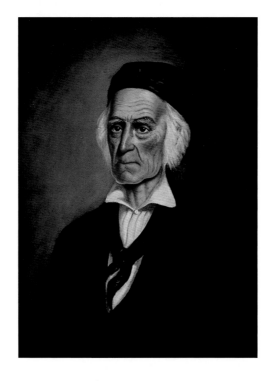

Don Antonio María Lugo arrived in 1781 as a six-year-old boy with his father, a soldier accompanying the settlers who founded the pueblo. Lugo would become one of the great rancheros of California. He is seen here in about 1855 in a portrait by Henri Pénélon, a Frenchman who settled in Los Angeles in the late 1840s and was the town's first resident artist. Pénélon's portraits are among the pueblo's most important visual documents.

History Collections, Los Angeles County Museum of Natural History

tracted during their journey. For a time they were quarantined some distance from the mission. Finally the settlers were allowed to continue the final eleven miles west, over a dusty Indian trail, arriving in late August and early September at the grassy site in the fertile river valley Crespí had described. House lots (*solares*) were distributed, with each settler receiving two fields (*suertes*) that could be irrigated and two that could not, as well as other fields to be cultivated in common.

While these settlers, known as *pobladores,* all had Spanish surnames, they were of varied origins, reflecting the ethnic and cultural mixtures of northern Mexico. More than half possessed some African ancestry; others were of Indian and Spanish background. Basilio Rosas, a sixty-seven-year-old Indian, made the arduous journey with his *mulata* wife and four children. Fifty-five-year-old Luis Quintero, who came with his wife and five children, was listed as *negro.* Nineteen-year-old Alejandro Rosas, the youngest head of

1602
The Spanish explorer Sebastian Vizcaíno sails along the California coast.

1769
Spanish expedition under Gaspar de Portolá, heading north from San Diego, enters fertile valley by river; expedition's priest, Juan Crespí, names river El Río de Nuestra Señora de Los Angeles de La Porciúncula.

1771
Mission San Gabriel is founded. Native Americans, to be known as Gabrielinos, will serve as labor force.

1775
Felipe de Neve is appointed governor of the Californias and given task of developing settlements in the territory.

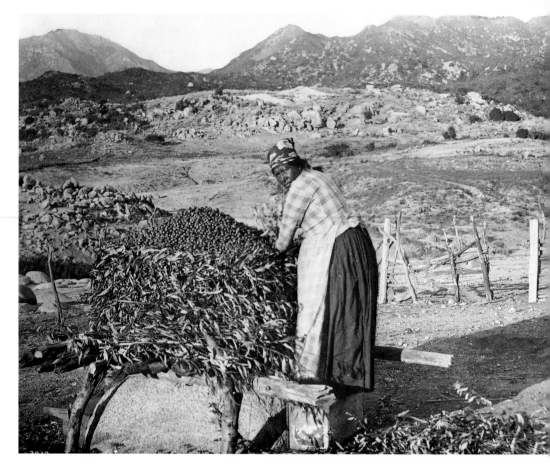

Cahuilla Indian woman gathering acorns, ca. 1900. California's indigenous people faced a harsh life under the missions and the ranchos. Very few survived into the twentieth century.

Seaver Center for Western History Research, Los Angeles County Museum of Natural History

family, had married his wife, Juana, after enlisting for the expedition. The four soldiers included José Vicente Feliz, whose wife had died in childbirth a few years before and who in coming years would guard and govern the pueblo; and Francisco Salvador Lugo, whose descendants would reign over one of the great ranching families of Mexican California.

Three families soon departed, leaving the eight who are considered the true founders of Los Angeles. The first homes, of earth-covered willow-and-tule huts, were soon replaced by adobe dwellings with flat roofs, which were later waterproofed with a coat of *brea* from the tar pits a few miles west on the Indian trail toward the ocean. The pioneers

constructed a dam and irrigation canals, including the *zanja madre,* or mother ditch, to bring water to the pueblo, and set about tilling and planting the fields. The town was governed in the Spanish style, under an honorary *alcalde* (mayor) and two *regidores* (councilmen). Five years after the founding, the settlers were given title to their land. By the end of the first decade, the pueblo's population had increased to 139, with twenty-nine adobe houses, as well as a chapel, granaries, a town hall, and a barracks.

In spite of early conflict at Mission San Gabriel, occasioned in part by the brutish behavior of soldiers toward Indian women, the pobladores enjoyed largely peaceful relations with the area's Native Americans.

1777
Neve selects site visited by Portolá on the banks of the Porciúncula River as possible settlement.

1781
Neve plans and names El Pueblo de la Reina de Los Angeles sobre el Río de la Porciúncula. Over the summer, 44 settlers recruited in Sinaloa and Sonora in Mexico arrive at Mission San Gabriel; ca. September 4 they found pueblo near the Native American village of Yangna.

1784
Chapel is built; first three ranchos granted in area around pueblo; cattle industry begins.

1786
Pueblo's first *alcalde,* or mayor, is José Vanegas, a Mexican Indian; settlers receive land titles.

Alexander F. Harmer,
Indian-Mexican Woman.
Oil on canvas, undated.
California Indians worked
on the missions and on the
ranchos as house servants,
field hands, and vaqueros.

Santa Barbara Museum of Art,
Bequest of Agnes Patten Parma.
Photo by Scott McClain, 2000

The indigenous people were descendants of the Shoshonean tribes that had arrived in the basin in about 500 B.C. and gradually displaced the indigenous Hokan language groups. At least five thousand lived in the area around the pueblo in small villages, or *rancherías,* of cone-shaped huts framed with willow branches and thatched with grasses and river rushes. There were also religious buildings and sweathouses. The Indians were hunters and gatherers, and their society included trade and intermarriage among villages. The settlers assimilated some aspects of California Indian culture, such as the medicinal use of herbs. In 1784 a son of Basilio Rosas married a young Indian woman, the first of many such unions.

From the beginning, as at other missions, the Franciscan missionaries at San Gabriel, which had been founded in 1771, sought to convert the Indians to Christianity. Mission life was difficult for the Indians, and it disrupted cultural traditions that had evolved over more than a millennium. As the mission system developed, with its cattle ranches, vineyards, and orchards, Indians would become its principal source of labor. They served in such capacities as vaqueros, field hands, and house servants and were generally forbidden to practice their traditional customs. Mission authorities meted out corporal punishment for various offenses, such as refusing to work or turning away from Christian belief.[2]

1787
José Vicente Feliz is named comisionado of the pueblo.

1790
Town's population is 139; there are 29 adobe houses, as well as granaries, the chapel, and town hall.

1792
After heavy rains cause flooding, Plaza is moved to higher ground.

1793
Francisco Reyes is town's first black alcalde.

1797
Mission San Fernando Rey de España is founded in valley northwest of the pueblo; it will supply the pueblo with food, wine, and other goods.

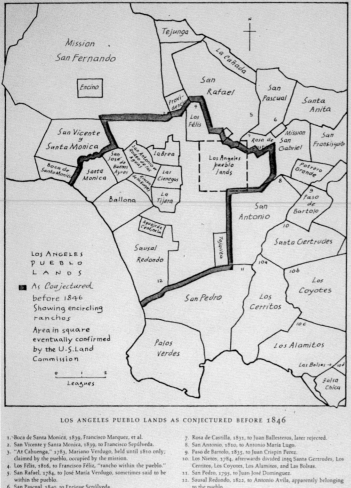

LOS ANGELES PUEBLO LANDS AS CONJECTURED BEFORE 1846

1. Boca de Santa Monica, 1839, Francisco Marquez, et al.
2. San Vicente y Santa Monica, 1839, to Francisco Sepúlveda.
3. "At Cahuenga," 1783, Mariano Verdugo, held until 1810 only; claimed by the pueblo, occupied by the mission.
4. Los Félis, 1816, to Francisco Féliz, "rancho within the pueblo."
5. San Rafael, 1784, to José María Verdugo, sometimes said to be within the pueblo.
6. San Pascual, 1840, to Enrique Sepúlveda.
7. Rosa de Castilla, 1831, to Juan Ballesteros, later rejected.
8. San Antonio, 1810, to Antonio María Lugo.
9. Paso de Bartolo, 1835, to Juan Crispin Perez.
10. Los Nietos, 1784, afterwards divided into Santa Gertrudes, Los Cerritos, Los Coyotes, Los Alamitos, and Las Bolsas.
11. San Pedro, 1795, to Juan José Dominguez.
12. Sausal Redondo, 1822, to Antonio Avila, apparently belonging to the pueblo.

Great rancho estates surrounded El Pueblo de Los Angeles.
Courtesy El Pueblo Historical Monument

Encarnación Sepúlveda de Avila married Francisco Avila in 1822 at the age of fifteen. She would live in the pueblo, as well as on Rancho La Cienega, for more than thirty years, until her death in 1855.
Courtesy El Pueblo Historical Monument

For the first forty years of the pueblo's existence, California was ruled by colonial Spain, although apart from priests there were rather few *europeos,* or European Spaniards, in the territory.[3] Under Spanish rule, about twenty land grants would be awarded, beginning in 1784, primarily to soldiers retiring from active service. Early recipients included a soldier from the Portolá expedition, Juan José Dominguez, who put a house and corrals on land overlooking the bay at San Pedro, and José Vicente Feliz, who built Rancho Los Feliz just northwest of the pueblo.

The church and the Spanish crown often disagreed about governance of the territory. Neve was an able administrator, and he repeatedly came into conflict with Father Junípero Serra, founder of the California mission system, who refused to acknowledge the governor's authority over the missions. To some degree, Neve attempted to promote self-determination for Native Americans, and he issued strict orders forbidding their mistreatment. Land belonged to the crown, and in the early 1800s only trade with Spanish ships was allowed, although foreign vessels occasionally smuggled in manufactured goods.

In spite of these restrictions, by 1818 the pueblo's population had grown to almost six hundred. A new adobe church, La Iglesia de Nuestra Señora de Los Angeles, was completed in 1822, funded by donations from the missions nearby. The pueblo was still a frontier settlement, where life was often quite rudimentary. "The Angel village ... contained 70 or 80 Houses, the walls of mud or unburnt brick and the roofs of thatch or tile," wrote the American trapper Jedediah Smith when he visited in 1826. "They were general[ly] small and few of them cleaner than they should be." Smith noted that the Californians were skilled horsemen and that a few families were "rich in Cattle, horses, and Mules."[4]

1800
Population is 315.

1801
Birth of Pío Pico at Mission San Gabriel.

1804
Territory divided into Alta California and Baja California.

1805
First American, a sailor captain, visits the pueblo.

1810
Population is 354.

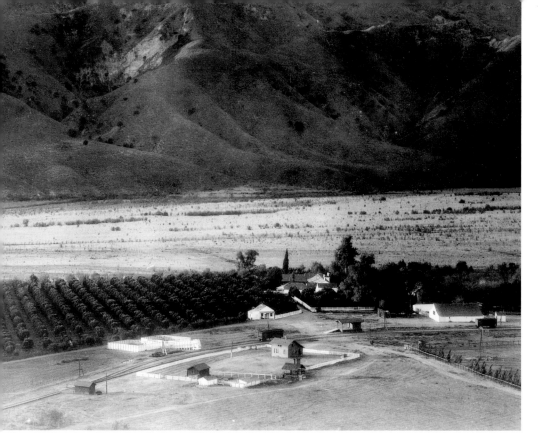

Among the latter was the family of Francisco Avila, at whose adobe the trapper spent a night that December. Avila had arrived in Los Angeles in 1794 from Sonora and following the death of his first wife in 1822 had married Encarnación Sepúlveda, the daughter of another prominent citizen of the pueblo. The Avila town house, a few hundred yards from the Plaza, was known for its hospitality.

Following Mexican independence from Spain in 1821, power struggles between religious and civil authorities in California intensified. In the 1830s, as the liberalizing effects of the European Enlightenment gradually percolated into the old colonial outposts, the missions were secularized. They thus lost their estates and their Indian laborers. Secularization was supposed to give Indians title to half of the mission lands, but few actually received any, and fewer still were able to keep what they did receive. The properties in reality passed into the hands of settlers with political connections in the Mexican government. Under Mexican rule more than eight hundred land grants were awarded, many to attract settlers. A number of settlers received large tracts, which they developed into the cattle ranches, or ranchos, that would dominate California life for nearly half a century.

By the 1830s the pueblo had blossomed into the economic, political, and social center of Alta California. Dusty roads led from the pueblo in all directions, past cornfields, vineyards, and cattle herds to the more than forty great ranchos that would cover the rolling terrain between the San Gabriel

1812
Serious earthquake damages many pueblo buildings.

After 1815
After flooding, Plaza is relocated northwest of present site.

1818
The ranchero Francisco Avila begins building his adobe town house near the Plaza.

1821
Mexico gains independence from Spain; the following year, this news reaches the pueblo and Spanish rule in California gives way to Mexican rule. Joseph Chapman is first American to settle in the pueblo.

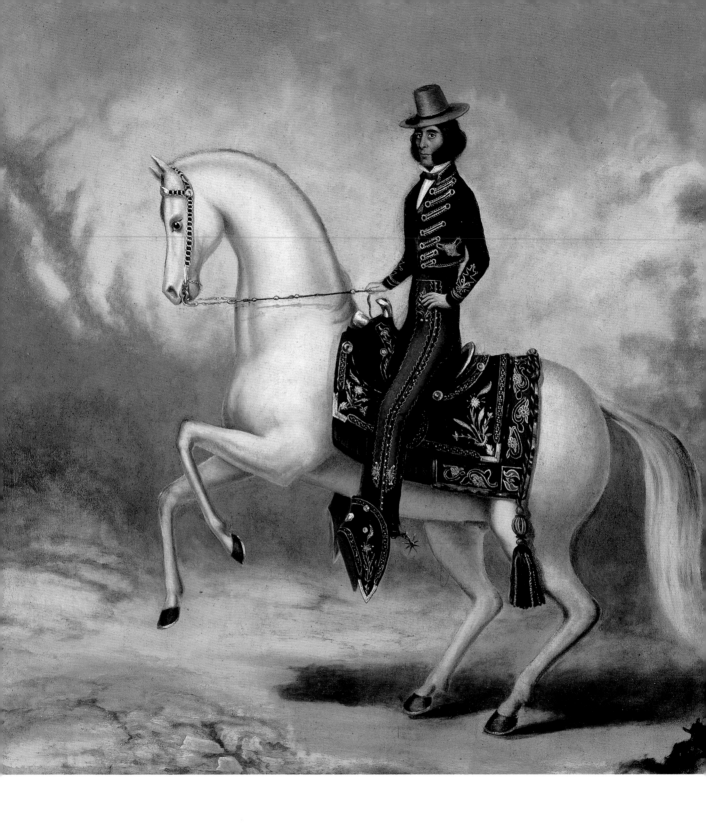

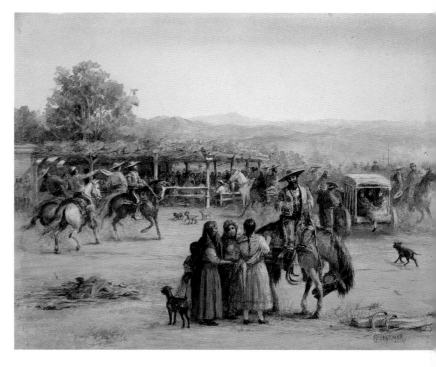

Mountains and the sea. The economy of the Californios, as California-born Mexicans increasingly began to call themselves, was largely based on the trade of cattle hides and tallow, used for making candles and soap. At the top of Californio society were the *gente de razón*—Christian, Spanish-speaking "people of reason."

The pueblo's residents included the elite of Californio society, many of whom, along with their families, would play important roles in the history of Los Angeles. Most of the region's prominent rancheros maintained second residences near the Plaza, where they stayed when they came into town to sell cattle, play a game called *monte* in gambling houses (monte banks), and attend mass, fiestas, and other social activities. Down a short lane was the adobe of Francisco Avila, who owned Rancho La Cienega. Francisco Sepúlveda, proprietor of the thirty-thousand-acre Rancho San Vicente y Santa Monica, had a town home south of the Plaza. Fronting the Plaza on the west was the adobe of Pío de Jesús Pico, who owned several ranches, including one with his younger brother, Andrés, whose adobe was near La Iglesia de Nuestra Señora. The elder Pico, possessed of a love of politics, horse racing, and gambling, would serve twice as governor of California, while the younger would enjoy a distinguished career in the military and in politics. Don Antonio María Lugo, who had arrived as a child with his father in the original contingent of pobladores and soldiers, was the patriarch of one of California's most powerful families. His home lay half a mile from town on the road to San Pedro, for he preferred the peace and quiet of country life to the hustle and bustle of the Plaza. His son Vicente, a celebrated horseman, fancied life in town; his adobe fronted the Plaza on the east. Next door was the town home of Ignacio del Valle, part owner of the Rancho San Francisco. Nearby were the homes of Ygnacio Coronel, owner of Rancho La Cañada, and his son, Antonio; and the adobe belonging to Antonio's cousin, the lawyer and ranchero Agustín Olvera.

As the pueblo grew, an increasing number of foreigners, including French, Italians, and *norteamericanos,* trickled into town. Some became leading citizens. Abel Stearns, who had previously lived in Mexico and was a naturalized Mexican citizen, settled in Los Angeles in 1829, married Arcadia Bandini, the fourteen-year-old daughter of a prominent San Diego family, and built her a home, known as El Palacio, which was among the pueblo's grandest. Don Abel, as he was called, became a prominent ranchero and one of the wealthiest men in California.

Fiestas were an important part of Californio society. These celebrations often accompanied the annual cattle roundup, as portrayed here in Alexander F. Harmer's Fiesta Scene. *Watercolor on paper, n.d.*
History Collections, Los Angeles County Museum of Natural History

OPPOSITE
Don Vicente Lugo, a son of Antonio María Lugo, was a celebrated horseman. In the late 1830s he built an adobe on the east side of the Plaza. He is seen here in an undated portrait by Henri Pénelon, attired in the fine garb of a wealthy Californio; his saddle is studded with silver.
History Collections, Los Angeles County Museum of Natural History

*The winemaker
Jean-Louis Sansevain.*

Courtesy Security Pacific National
Bank Photograph Collection/Los
Angeles Public Library

The French at El Pueblo

French settlers began to arrive at the pueblo in its early days. The Plaza Church's first resident priest was a Frenchman named Augustine Alexis Bachelot, who had been sent to evangelize in the Sandwich Islands but was forced to leave by Protestant missionaries and sent to California. He settled in the pueblo in 1831 and served five years before returning to the islands. Another Frenchman was the sea captain Charles Baric, who arrived in 1834; he lived just south of the Plaza Church and at one time owned the La Brea Tar Pits.

A number of French were winemakers. Louis Bauchet, a former Napoleonic Guard, arrived in 1827, bought land where Bauchet Street is located today, and grew grapes. The most prominent was Jean-Louis Vignes, for whom Vignes Street would be named. He arrived in Los Angeles from Bordeaux in 1831 at the age of fifty-one and bought a ranch between the pueblo and the Los Angeles River that he named El Aliso. Although the local soil was perfect for viticulture, Vignes did not think that good wine could be made from the mission grape, so he sent home to Bordeaux for cuttings to graft onto the mission stock. Soon he was making the best wine in Alta California. In the 1850s Vignes sold the thriving vineyards on the Aliso ranch to his nephews Pierre and Jean-Louis Sansevain, and they continued in the family tradition. The arrival in 1859 of the first French consul (who was actually Belgian) was heralded by a parade of French residents and a banquet held at El Aliso. By 1860 nearly 10 percent of the town's population were of French origin.

The Garnier brothers arrived from southeastern France, purchased Rancho Las Encinas in the San Fernando Valley, and set about raising sheep. Philippe Garnier would become an important merchant and banker, and he would build the Plaza House in 1883 and the Garnier Block in 1890.

In the 1860s Joseph Mascarel and a French Canadian named Damien Marchessault served as mayors of Los Angeles. The former was married to an Indian woman, who occasioned a scandal when a party of visiting French dignitaries called on her one afternoon and found her grinding corn, naked from the waist up.[5] Despondent over gambling debts and the failure of a water pipe system he had designed for the town, Marchessault committed suicide in the council chambers in 1868. A thoroughfare near the pueblo bore the name Marchessault Street until 1902, when it became part of Sunset Boulevard.

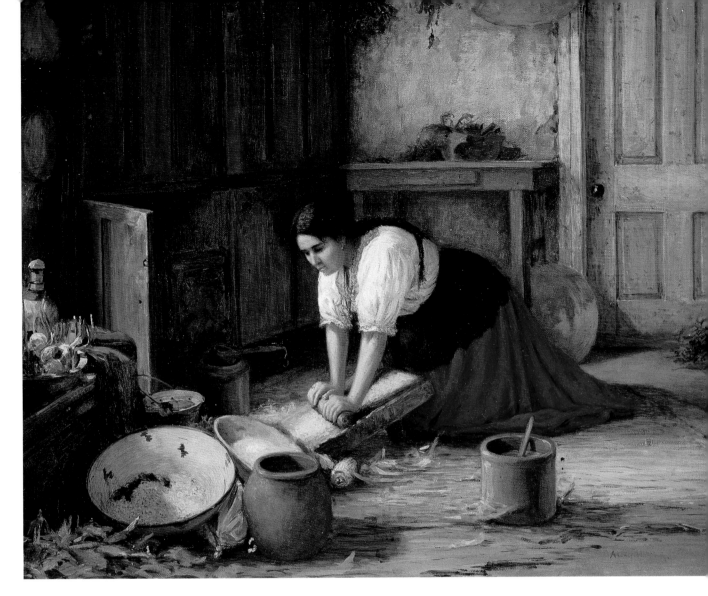

The social life of the Californios included a generous number of festivities. Weddings were celebrated by great balls, such as the one following Pío Pico's marriage in February 1835 to María Ignacio Alvarado at the Plaza Church. The wedding celebration, held at the Plaza adobe of José Antonio Carrillo, Pico's brother-in-law and political ally, was attended by people from throughout the region and lasted for eight days. Throughout the year cockfights were held in the front yard of Don Francisco Ocampo, near the Plaza. On weekends crowds would gather to see bull-and-bear fights. Fiestas were celebrated regularly, such as one held annually forty days after Easter, when processions of flower-bedecked girls and boys would go among the altars set up in the Plaza. Each Christmas brought enactments of miracle plays—often performed by soldiers.

While life in the pueblo was festive for the wealthy rancheros, it was arduous for those who occupied the lower end of

Life in old California was not without its household chores, which were generally carried out by women. In Alexander F. Harmer's Doña Mariana Coronel Grinding Corn, *the wife of Antonio Coronel is shown working in the traditional way. Oil on canvas, ca. 1885.*

History Collections, Los Angeles County Museum of Natural History

1833
Mexican congress begins secularizing California missions.

1833–45
Former mission lands sold to soldiers and settlers; rancho system develops.

Late 1830s
As mission estates break up, Indian labor force goes to work on ranchos or moves into pueblo.

1835
Mexican government elevates Los Angeles to status of city (*ciudad*) and names it capital of Alta California, although government will stay in Monterey for ten more years.

By the end of the Mexican period, the pueblo's population had grown to about fifteen hundred. In this 1847 view of the south side of the Plaza, the adobe belonging to the wealthy merchant and rancher Abel Stearns— the U-shaped house in the center— can be seen. The two-story adobe belonged to another American, Alexander Bell. Drawing by William Rich Hutton.

Reproduced by permission of The Huntington Library, San Marino, California

the social scale, such as more recent Mexican-born immigrants and California Indians. Abruptly displaced when the missions were secularized, many of the region's Native Americans went to work on the ranchos, which also came to depend on their labor. They carried out many of the same tasks that they had performed on the mission estates. Although they enjoyed greater freedom on the ranchos than they had under the regimes of the Franciscan padres, many Indians preferred life in the pueblo, where they nonetheless often led a tenuous and difficult existence.

Southern California soon rivaled the north in economic and political power. Sectional struggles occasionally broke into armed conflict. Governors followed one another in rapid succession, sometimes, as in the case of Pío Pico's first term in 1832, staying in office for only a few weeks. During this time, the pueblo saw its share of intrigue, as Pico, Carrillo, and others, often meeting in Carrillo's adobe, plotted against their northern rivals. One morning in the late 1830s, "the aristocrats of the Plaza fronts looked out their doors to see Captain Luis Espinoza with his northern detachment camped in the public square. The northerners…proceeded to go from house to house to arrest leaders of the southern movement, including José Antonio Carrillo, Pío Pico, Andrés Pico, and the alcalde himself."[6] These men were taken north as prisoners before eventually being released.

Los Angeles had been named the capital in 1835, although it would be ten years before the government actually was moved. The importance of the region continued to grow, and early in 1845, along with his brother Andrés, José Antonio Carrillo, Abel Stearns, and others, Pío Pico led the southern faction of a revolt ousting Governor Manuel Micheltorena, whose authoritarian rule had displeased the southerners. Pico again became governor of Alta California, advocating local power and civilian, as opposed to military, authority. He moved the capital in fact to Los Angeles,

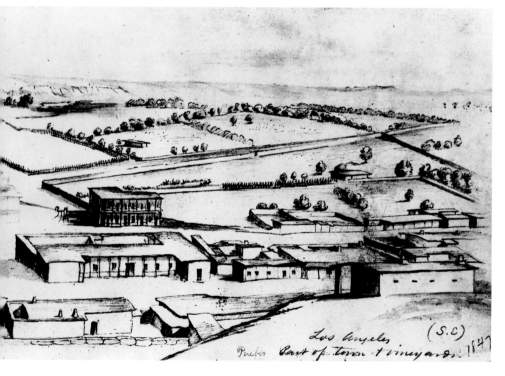

1836
Town's first vigilante group executes two lovers for murdering woman's husband. First official census records population of 2,228 in pueblo and surrounding area, including 603 men, 421 women, 553 Indians, and 50 foreigners, among which are 29 Americans and 5 Frenchmen.

ca. 1838
Vicente Lugo builds house on the Plaza.

1840s
United States continues westward expansion.

1841
First commercial orange groves planted near the pueblo.

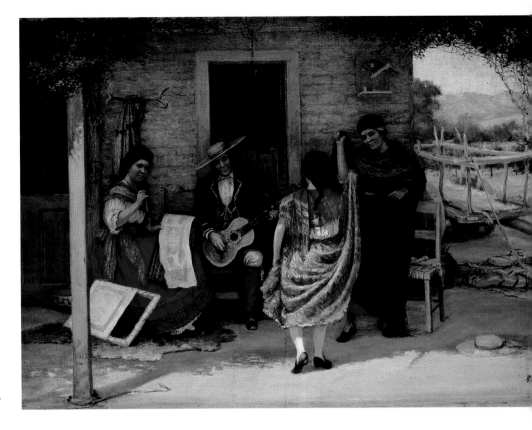

which by then had grown to about fifteen hundred people. In honor of the occasion, the Los Angeles *ayuntamiento,* or council, ordered that the pueblo's buildings be repaired and whitewashed, so that the town could "show its cleanliness, magnificence, and brilliance in such a manner that the traveler who visits us may say, 'I have seen the City of the Angels.'"[7]

Pío Pico would be the last governor of Mexican California. The United States had been interested in the territory since the presidency of Andrew Jackson. Driven by Manifest Destiny and enticed by the prospect of vast acreages of prime land, increasing numbers of Americans began to arrive and settle. Initially the Californios welcomed the newcomers. Unlike such norteamericanos as Abel Stearns, however, the more recent arrivals cared little about assimilating into Californio society. When war between the United States and Mexico broke out in 1846, the United States sought to expand its territory. In August Governor Pico issued a proclamation stating that the United States "had ambitions to dismember the Mexican nation," then departed for Mexico to seek assistance. Within a few days American forces arrived at the pueblo, where a new and very different era was about to begin.

NOTES

1 In Herbert E. Bolton, ed., *Fray Juan Crespí, Missionary Explorer* (Berkeley: University of California Press, 1927), 146–54.
2 William McCawley, *The First Angelinos: The Gabrielino Indians of Los Angeles* (Banning and Novato, Calif.: Malki Museum Press and Ballena Press, 1996), 195–97. Jedediah Smith, who stayed briefly at the pueblo and for several weeks at Mission San Gabriel in 1826, commented in his journal on the frequency with which Indians at the mission were flogged. *The Southwest Expedition of Jedediah S. Smith,* ed. George R. Brooks (Glendale, Calif.: Arthur H. Clark, 1977), 108–9.
3 Antonio Ríos-Bustamante, *Mexican Los Ángeles: A Narrative and Pictorial History* (Encino, Calif.: Floricanto Press, 1992), 233.
4 In Brooks, ed., *Southwest Expedition,* 123.
5 Horace Bell, *On the Old West Coast: Being Further Reminiscences of a Ranger* (New York: Grosset and Dunlap, 1930), 244–6.
6 W. W. Robinson, *Los Angeles from the Days of the Pueblo,* 2d ed., rev. Doyce B. Nunis Jr. (1959; San Francisco: California Historical Society, 1981), 52.
7 Robinson, *Los Angeles,* 37.

Alexander F. Harmer, Dancing on the Veranda, Coronel Home. Oil on canvas, undated.

History Collections, Los Angeles County Museum of Natural History

1841–44
30 new ranchos established in Los Angeles area.

1842
Governor Micheltorena spends month in Los Angeles; orders Yankees to leave. Gold discovered at Placerita Canyon, near Saugus.

1845
Alta California government moves from Monterey to Los Angeles.

1845–46
Pío Pico serves second term as governor of Alta California.

1846
War breaks out between United States and Mexico.

LEONE HOOVER.

SAN JUAN.

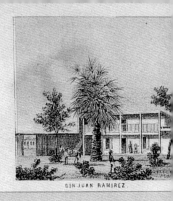

DON JUAN RAMIREZ.

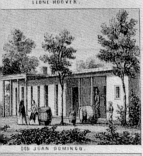

DON JUAN DOMINGO.

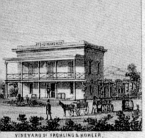

VINEYARD OF FROHLING & KOHLER.

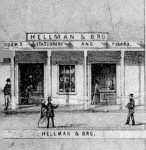

HELLMAN & BRO.

ABEL STEARNS.

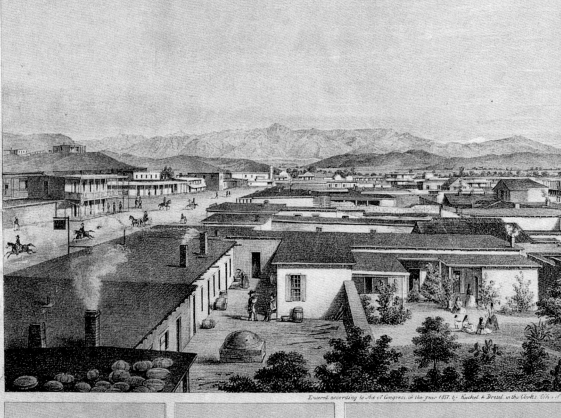

Entered according to Act of Congress, in the year 1857, by Kuchel & Dresel, in the Clerk's Office of the

DON LORENZO LECK.

FLASHNER & BREMERMANN.

J. TEMPLE.

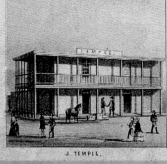

FRANCIS MELLUS.

SOLOMON L

AN AMERICAN TOWN

Shortly after the outbreak of the Mexican-American War, American troops under Commodore Robert F. Stockton and Major John C. Frémont marched into the pueblo behind a military band playing "Hail Columbia" and "Yankee Doodle." Stockton's sailors and marines had advanced from the harbor at San Pedro, Frémont's soldiers had come north from San Diego, and the two groups had met in the vineyards and fields outside of town. On the hot afternoon of August 13, 1846, they found the pueblo's dusty streets deserted. That evening Stockton ordered the band to give a concert in the Plaza. Residents gradually emerged from their houses to listen and, it is said, when the music was finished, to applaud.[1]

An overview of the pueblo in 1857 is shown in the center of this engraving, framed by various scenes of Los Angeles life. Los Angeles, Los Angeles County, Cal., 1857 (detail). From the Kuchel & Dressel "Views of California."

In the days following the Americans' arrival there was no armed resistance, but such tranquil beginnings gave little indication of the tumultuous decades to come. Two weeks later, Frémont and Stockton withdrew, leaving a Marine lieutenant named Archibald Gillespie in command. Gillespie promptly banned all public gatherings, angering the town's inhabitants, for whom such events were an important part of daily life. He also ordered arbitrary house searches and had prominent citizens jailed at the least provocation. This was perhaps the first—but it would not be the last—conflict over social and cultural expression in the Plaza area.

Although Pío Pico had left for Mexico, other outraged Californios, led by José María Flores, José Antonio Carrillo, and Andrés Pico, soon rose in revolt, and the pueblo that had been so peacefully won over now became the center of Mexican opposition to the U.S. invasion. Californio patriots banded into a fighting force and encamped on the heights east of the Los Angeles River. From here they called on the inhabitants to drive out the Yankees, and in early October Gillespie and his men were forced to withdraw to the port at San Pedro. Californio forces briefly occupied San Diego and Santa Barbara. In December, near present-day Escondido, Californios under Andrés Pico inflicted heavy losses on American dragoons under the command of Stephen W. Kearney at the battle of San Pascual.

American forces soon regrouped, however, and under Stockton and Kearney, assisted by the scout Kit Carson, marched north. They reoccupied Los Angeles in January 1847, commandeering the adobe of Francisco Avila, which became Stockton's headquarters while peace was being negotiated. On January 13, 1847, Andrés Pico and Frémont signed the Treaty of Cahuenga, ending hostilities in California. When the war ended with the Treaty of Guadalupe Hidalgo in 1848, the year that gold was discovered east of Sacramento, Alta California came under U.S. authority. In 1850 it gained U.S. statehood.

Although the Californios were guaranteed that they would receive treatment equal to that afforded U.S. citizens, the gold rush and American rule brought gradual changes to the old pueblo, as the Californio society came into contact—and conflict—with the cultures and economic interests of the new arrivals. Miners drifted into town after striking out in the northern gold fields. Mexican prospectors heading north from Sonora, as well as some fleeing racial violence in the gold fields, settled north of the Plaza in what became known as Sonoratown.[2] In 1849 the town council decided to sell off some land, the first of the many sales that would transform southern California in the second half of the nineteenth century. It ordered Lieutenant E. O. C. Ord to survey the town and make what was, except for Neve's original plan, the first map of Los Angeles. Streets now received English names as well. Calle Principal became Main Street; Calle Primavera became Spring Street; and to the northwest, it was now Eternity Street (later

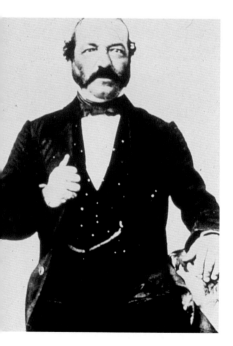

Andrés Pico, brother of Pío Pico, who commanded Californio forces during the war with the United States. After the war, he would remain one of the pueblo's leading citizens.
Seaver Center for Western History Research, Los Angeles County Museum of Natural History

1846
Mexican-American War begins; U.S. Army occupies Los Angeles; Californios rally and retake the town, defeat U.S. forces at battle of San Pascual.

1847
U.S. Army troops under Robert Stockton retake Los Angeles; Treaty of Cahuenga signed by Andrés Pico and John C. Frémont ends conflict in California.

North Broadway) that led to the Campo Santo (Holy Ground), the cemetery.

By the time of the American takeover, the pueblo had blossomed into a bustling town of about sixteen hundred people. It expanded to more than four thousand inhabitants during the 1850s and remained predominantly Spanish speaking for some time. While they no longer ruled the region, wealthy Californios continued to participate in its political life, aided by sympathetic Anglos such as Abel Stearns. Shortly after the Yankee arrival, a group of prominent citizens had met in the adobe home of Agustín Olvera and drawn up a slate of Californio candidates, who ran successfully in the first election held in what was now Los Angeles County. Prominent Angelinos such as Andrés Pico and Ignacio del Valle served, albeit as a minority, in the state senate. Antonio Coronel was elected mayor. Nearly forty Los Angeles Californios would serve in local or state office in the 1850s.[3] For several years traditional fiestas continued to be held in the Plaza.

For a time the gold rush stimulated the region's economy, and, unlike in the northern part of the state, life on the southern California ranchos went on much as before.

A romanticized depiction of Antonio Coronel and his wife, Mariana, attired in classic Californio dress. Coronel played an important role in the life of the pueblo following the American arrival in 1846. He provided detailed accounts of life in early California to assistants of the historian Hubert Howe Bancroft and to the novelist Helen Hunt Jackson, who visited Coronel at his adobe near the Los Angeles River in the early 1880s. Alexander F. Harmer, Don Antonio F. Coronel and Doña Mariana Coronel in the Arbor. Oil on canvas, ca. 1885.
History Collections, Los Angeles County Museum of Natural History

1848	1849	1849–55	1850
Treaty of Guadalupe Hidalgo ends Mexican-American War.	Lt. E. O. C. Ord surveys Los Angeles.	Gold rush brings prosperity to Los Angeles; cattle business booms; lawlessness and crime are rampant.	California gains statehood; state legislature establishes County and City of Los Angeles; town's population is 1,610.

James Walker, Cattle Drive #2. *Oil on canvas, 1868. With the gold rush, the Californio rancheros amassed considerable wealth by providing beef for the thousands seeking their fortunes in the gold fields of northern California. Vaqueros such as those seen here, who were often Indians, drove the cattle to the markets in San Francisco.*

Courtesy the California Historical Society. Gift of Mr. and Mrs. Reginald Walker, FN-30659

An immensely profitable trade in beef replaced the earlier hide-and-tallow trade, and the rancheros continued to amass considerable wealth, taking their cattle north to markets at San Francisco and the gold fields. "The vast herds," wrote Horace Bell, a contemporary observer, "seemed absolutely without limit, the many picturesque horsemen driving the neighing and snorting [cattle] in all directions. The retainers of the Lugos, the Dominguez, Avilas and Sepulvedas…made quite an army, and from early dawn to the shade of evening were continually on the move, with jangling spurs, cavorting steeds, and whizzing *riatas*."[4]

Prominent Californios spent some of their profits on luxury items and activities, such as fancy carriages, fine lace clothing, and gambling. "Everybody in Los Angeles seems rich," Bell noted. "The streets were thronged throughout the day with splendidly mounted and richly dressed caballeros, most

of them wore suits of clothes that cost…from $500 to $1,000, with saddle and horse trappings that cost far more….Of one of the Lugos, I remember, it was said his horse equipments cost $2,000."[5] Indeed, the patriarch of the Lugo clan, Don Antonio María, was, virtually until his death in 1860 at more than eighty-five years old, "a familiar figure as a sturdy *caballero* in the streets of Los Angeles, his ornamental sword strapped in…soldier fashion" to his silver-studded saddle.[6]

As the pueblo's wealth grew, gamblers and prostitutes from San Francisco followed the money southward, and Los Angeles developed a reputation as one of the most lawless towns in the American West. Saloons and houses of ill repute proliferated east of the Plaza along the notorious Calle de los Negros, or Negro Alley, which was frequented by thugs with names like Crooked Nose Smith and Cherokee Bob. Here, in addition to "the great gambling house on the plaza," Bell wrote, "were four or five gambling places, and the crowd [on the street]… was so dense that we could scarcely squeeze through. Americans, Spaniards, Indians, and foreigners, rushing and crowding along from one gambling house to another, all chinking the everlasting eight square $50 pieces up and down in their palms."[7] Between August 1850 and October 1851 there were forty-four homicides in the town, whose population

1850s
Three newspapers start publication: the Star, El Clamor Publico, and the Southern Vineyard. More European and North American settlers arrive; Italian winemakers ply their trade near Plaza.

1852
As many as 3,700 Native Americans are estimated to be living in the Los Angeles/San Bernardino area.

1853
Vigilante group known as Los Angeles Rangers is formed to combat lawlessness. Vigilante justice often carried racial and ethnic overtones. Los Angeles mayor Antonio F. Coronel confirms house-lots.

African Americans at El Pueblo

The African American presence in Los Angeles dates back to the earliest days of the old pueblo. Of the forty-four original pobladores who settled in 1781, twenty-six had some African ancestry.

Many of their descendants became rancheros. Francisco Reyes, for example, owned much of the San Fernando Valley before receiving another rancho when Mission San Fernando was established in 1797. María Rita Valdez, a descendant of the poblador Luis Quintero, was granted Rancho Rodeo de Aguas in 1841; she later sold it to developers who created a subdivision named Beverly Hills. Peter Biggs arrived in Los Angeles in 1852 and set himself up as the town's only barber, leasing his shop in a store on Main Street near the Bella Union Hotel. Biggs charged high prices, only to lose his business when a newly arrived French barber took all his customers. Other prominent citizens with African ancestry included Pío Pico and his brother Andrés, who served as commander of the Californio forces during the Mexican-American War.

In the mid-nineteenth century African Americans made up only a small part of those who immigrated to Los Angeles, but a number became important figures. Two leading citizens were Biddy Mason, a slave who had been brought to California by her owner, and Robert Owen, a prominent businessman. Mason's owner, Robert Smith, had planned to settle with the Mormons in Utah. In 1851 he took his slaves to San Bernardino to establish a Mormon community there, but four years later he decided to move to Texas, which was still a slave state. Hearing of his plans, Owen's son, Charles Robert Owen, alerted the sheriff, who placed the slaves under his protection. The judge who heard the case prevented Smith from leaving with the slaves, holding that "by prohibiting slavery, the California Constitution emancipated all slaves brought into the State." The Owen and Mason families were later joined by the marriage of Charles to Mason's eldest daughter. A free woman, Mason found employment as a nurse and eventually saved enough money to acquire two properties between Spring and Broadway, near the pueblo. She later sold some of her real estate and became a leading philanthropist. She was instrumental in founding the First African Methodist Episcopal Church of Los Angeles. She died in 1891.

As blacks joined in the movement west, the African American community in Los Angeles grew considerably in the late nineteenth century, from 102 persons in 1880 to 2,131 by 1900 and to more than 19,000 by 1929. By 1930 Los Angeles claimed the largest African American community on the West Coast.

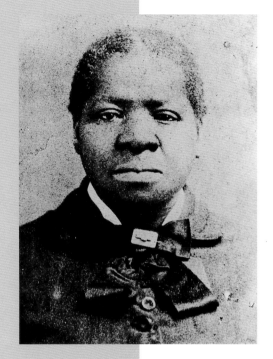

Biddy Mason, who arrived in California as a slave, became one of the leading citizens of Los Angeles.

Courtesy Security Pacific National Bank Photograph Collection/Los Angeles Public Library

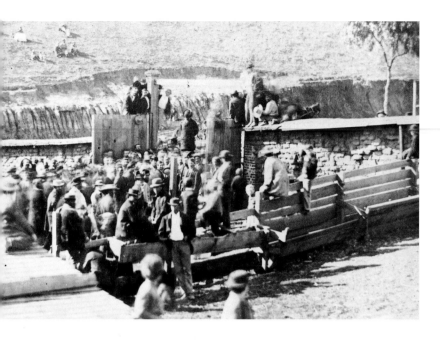

During the 1850s, Los Angeles was ruled by vigilante law, and hangings were commonplace. Seen here is one of the last vigilante executions, in 1870.

Reproduced by permission of The Huntington Library, San Marino, California

Despairing over the high crime rate, prominent Californios at times sided with the vigilantes, as did a number of Mexicans and less wealthy Californios. Other Californios and Mexicans, however, strongly condemned the racial injustices of vigilante rule. Francisco P. Ramirez, for example, the young editor of *El Clamor Público,* the American pueblo's first independent Spanish-language newspaper, while accepting some vigilante activity as a necessary response to lawlessness, often protested that "Mexicans alone have been the victims of the people's insane fury."[9] Although Anglo-Americans and others also went to the gallows, poor Californios, Indians, and Mexicans were frequently the victims of a fatal double standard.[10] Hangings were generally public, and they were often well attended.

Throughout California, these were also the years of the Mexican *bandidos,* who roamed the countryside, robbing stage-coaches and attacking travelers and settlers. Some historians see the bandidos as callous killers, some see them as guerrillas seeking revenge for the norteamericano invasion. The bandidos may have been both. Whatever their considerable depredations, outlaws such as Joaquin Murietta and Juan Flores became folk legends; for many residents of the pueblo and environs, their exploits came to symbolize "the daily struggles of the Spanish-speaking."[11]

The pueblo's most celebrated case was perhaps that of Flores, a rebel and bandit whose band of some fifty men took over Mission San Juan Capistrano and terrorized the southern countryside in 1857. When

now numbered about 2,300. "With all our natural beauties and advantages," editorialized the *Los Angeles Star,* "there is no country where human life is of so little account. Men hack one another to pieces…as if God's image were of no more worth than the life of one of the two or three thousand ownerless dogs that prowl about our streets."[8]

To stem the rising tide of lawlessness, leading citizens met in the El Dorado Saloon on Main Street on a hot day in July 1853 and formed a vigilante group known as the Los Angeles Rangers. Various such groups were mustered, including one, based in El Monte, comprising rough-and-ready former Texas Rangers who had fought in the Mexican-American War. The pueblo thus entered a period of vigilante "justice," a justice imbued with racial, ethnic, and class overtones.

1855
Pelanconi House, oldest fired brick house still standing, begins construction. Biddy Mason wins freedom from slavery, will become prominent business leader. First public schools built.

1856
Title to four square leagues of land confirmed to Los Angeles by U.S. Land Commission. Wells Fargo & Co. establishes office in Los Angeles.

1857
The Mexican bandido Juan Flores is hanged along with several accomplices.

the gang killed a German settler and then members of the sheriff's posse sent after it, a clamor went up among the pueblo's citizenry. Rumors spread of a general Mexican uprising. More than one hundred vigilantes in several groups—one made up of Californios led by Andrés Pico and Juan Sepúlveda, another of the rangers from El Monte (who ransacked Sonoratown looking for Flores sympathizers), and still another of French and German settlers—galloped off in pursuit as soon as the lawmen's funerals were over. Although hindered by some campesinos who aided the outlaws, vigilantes soon captured and summarily hanged about a dozen bandits. The El Monte rangers, swept up in their enthusiasms of the moment, also lynched three innocent Mexican men, one of whom, barely more than a boy, died in his wife's arms. Flores and most of his band were brought before the vigilance committee back in Los Angeles. It was resolved to turn his accomplices over to the regular courts but to hang Flores immediately. This was done, on February 21, 1857, before a crowd of nearly three thousand people.[12]

While the pueblo remained Spanish speaking well into the 1870s, it gradually became more diverse. As more Anglo-American and European immigrants took up residence, Los Angeles began to evolve into what one historian has aptly called a "town of mixed essences."[13] Harris Newmark, a young German Jew from East Prussia, had arrived in 1853 and entered merchant life with his brother; more than sixty years later he would publish his reminiscences, one of the great chronicles of the period. A Croation or Dalmation settler built the pueblo's first brick building, known as the Pelanconi House after it was purchased by Antonio Pelanconi, one of the Italian merchants who plied their trade in the short lane off the Plaza known as Calle de las

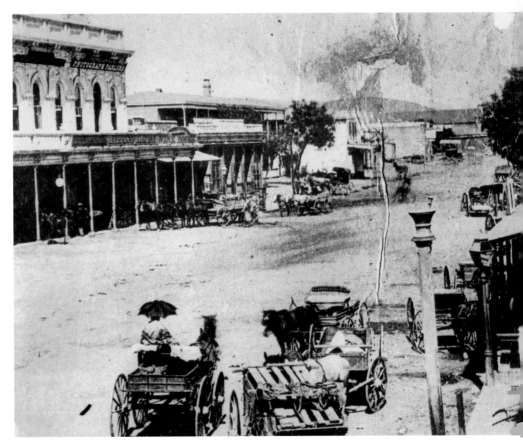

Main Street in the 1870s. The studio of the painter Henri Pénélon was in the upper floors of the Temple Block, the building seen at left.

Courtesy Security Pacific National Bank Photograph Collection/Los Angeles Public Library

1858
Masonic Hall is built.

1860
John G. Downey of Los Angeles elected governor of California; telegraph line links San Francisco and Los Angeles; brick reservoir built in Plaza; town's population is 4,385.

1861
Civil War begins, heightening tensions in the pueblo; fifty inches of rain in one month causes devastation; Plaza Church facade crumbles.

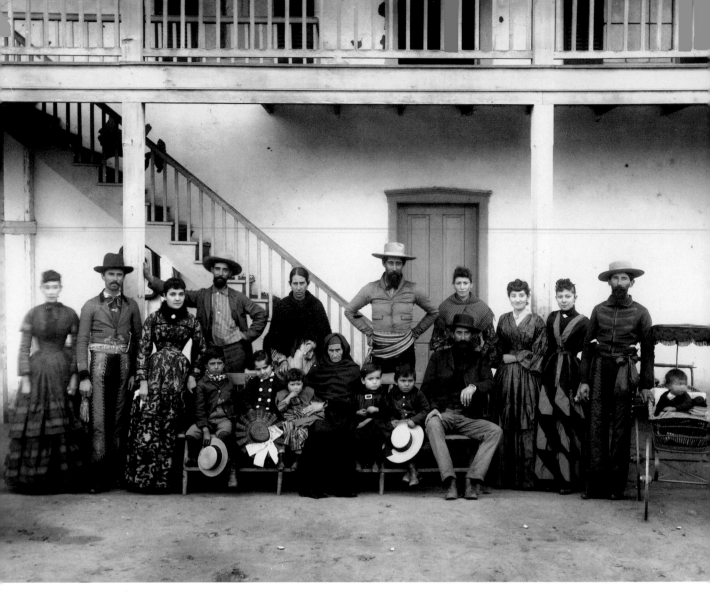

Vignas, or Vine Street, selling wine from
vineyards on the fertile lands stretching east
toward the river. Here French winemakers
also owned property. In some ways the
pueblo remained relatively rural; in the
words of Newmark, "much usually charac-
teristic of country life was present in what
was called the city of Los Angeles." There
were perhaps seventy-five vineyards within
the city precincts, he noted, not counting

the "once famous 'mother vineyard' of
San Gabriel Mission, which the padres
used to claim had about fifty thousand vines,
but which had fallen into somewhat pictur-
esque decay."[14]

Vigilante activity eventually subsided,
although the ethos of extralegal violence in
the pueblo had not borne the last of its bitter
fruit. In the early 1860s a smallpox epidemic
decimated the remaining Indian population.
Civil wars in both the United States and

Early 1860s
Andrés Pico mounts
unsuccessful political
campaign for the sepa-
ration of southern
California and the crea-
tion of a new territory.

1862–64
Drought destroys cattle
industry; smallpox
epidemic devastates
town's remaining Native
American population,
and more than half die.

1860s
Two members of the pueblo's French community,
Damien Marchessault and Jean Louis Sainsevain,
establish a system of wooden pipes to replace
the open ditches and update the town's primitive
water system.

1865
Civil War ends; with
cattle gone, most
rancho properties
are foreclosing.

Mexico brought new tensions. Confederate sympathizers, of which there were many, gathered at the Bella Union Hotel on Main Street, while Californios such as Pío Pico, who had returned after the Mexican-American War and was a great admirer of Abraham Lincoln, favored the Union.

The year 1860 saw the town's last bull-fight and its first baseball team—a harbinger, perhaps, of the massive cultural changes in the decade to come. While the elite Californios had been able to retain their wealth, if not their power, for the first decade of American rule, the 1860s brought an end to the rancho way of life. New laws required verification of all landownership and brought heavy tax burdens on large landowners. Californio rancheros faced years of expensive litigation over property claims in a legal system that favored Anglo-Americans seeking land and power. Lenders charged exorbitant interest rates on often paltry loans and eagerly seized property put up as collateral. The gold rush ended, and floods and severe drought killed thousands of cattle, further weakening the rancho economy. By decade's end the Californio ranching elites had lost most of their land and wealth. The alliances between the old Californio and the new Anglo-American elites dissolved, and Californios as well as Mexicans became increasingly excluded from the economic life of the town.

Most of the Californio rancheros gave up their Plaza residences, and many left Los Angeles. Pedro Seguro's gambling house was purchased by an American named John G. Downey, who became a wealthy landowner and governor of California. Don Ignacio

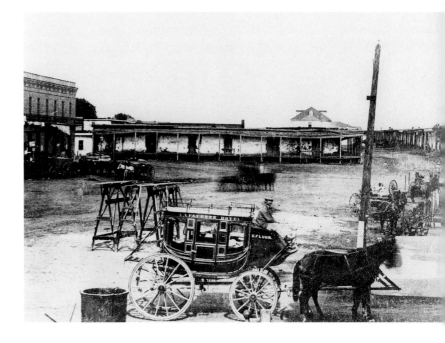

del Valle moved to Rancho Camulos, the sole surviving remnant of the once-great Rancho San Francisco. Don Vicente Lugo donated his adobe to the parish priest. Encarnación Sepúlveda Avila's daughter Francisca continued to live in the Avila adobe with her husband, a German settler named Theodore Rimpau, until 1868, when the couple and their many children moved to Anaheim. Californios who stayed in the pueblo often found their new circumstances difficult to bear. As an old man, Francisco Ocampo, whose front yard had once been the scene of popular cockfights, now "used to sit on the curbstone near the Plaza, a character quite forlorn, utterly dejected in appearance, and despondently recalling the bygone days of his prosperity."[15]

The Lafayette Hotel stagecoach, near the street of old adobes known as Negro Alley (top right), which was lined with saloons and bordellos, during the 1870s. The alley runs past the adobe that had belonged to Antonio Coronel.

Courtesy Security Pacific National Bank Photograph Collection/Los Angeles Public Library

1867
First gas street lights installed.

1868
Francisca Avila and her husband, Theodore Rimpau, move away from pueblo. Other old Californio families also leave during this time. Adjacent to the pueblo, the Sonoratown barrio grows over next few decades.

1869
Transcontinental railroad completed; Chinese railroad laborers begin settling in Los Angeles. Phineas Banning builds the city's first railroad, a short line from nearby Wilmington to Los Angeles.

The Last Governor of Mexican California

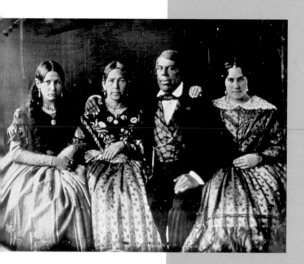

*Don Pío Pico in 1852,
with his wife and two
of their nieces.*

Seaver Center for Western History
Research, Los Angeles County
Museum of Natural History

The life of Pío de Jesús Pico, one
of the most significant names in
California history, spanned almost the
entire nineteenth century. Born under
the flag of Spain, he became one of
the great land barons of Mexican
California before finally coming to
ruin in American Los Angeles. While
he accommodated the vast changes
that occurred over his lifetime, he
remained at heart a Californio.

Pico was born at Mission San
Gabriel on May 5, 1801, the fourth of
twelve children. Like many in northern
Mexico, he was of mixed African,
Indian, and European ancestry. After
a stint in the army, where his younger
brother Andrés would distinguish him-
self, in 1828 Pico became a member
of the Diputación, or Territorial
Assembly, an advisory council
appointed by the governor. He soon
received his first land grant, 8,922
acres near San Diego.

After an insurrection in 1831,
in 1832 Pico became acting governor
for twenty-two days. Some three years
later, on February 24, 1835, he
married María Ignacia Alvarado at the
Plaza Church. Pico and his wife had no
children, although he is said to have
had several children with other women.

Owing largely to Pico's political
connections, in 1841 he and Andrés
received an enormous land grant,
133,441 acres, called Rancho Santa
Margarita y las Flores, the site of
present-day Camp Pendleton. His
prominence in Californio society
continued to grow, and he became
governor for a second time in 1845.
He opposed the American invasion

of California and left for Mexico the
day before U.S. forces occupied
Los Angeles.

While in Mexico, he vainly sought
government troops to retake
California. Pico returned to California
in 1848, and in about 1850 he bought
Rancho Paso de Bartolo Viejo, in
present-day Whittier, which he called
El Ranchito. Sadly, his wife did not live
to enjoy its beautiful gardens. She
died in 1854, and Pico buried her,
surrounded by jewels, in an elegant
tomb. The grave was later plundered
and her jewels stolen.

Back in American California, Pico
again took up his place as a prominent
citizen of the pueblo. He pursued his
many interests, including horse racing,
on which he bet heavily. One of
California's most celebrated races
occurred in October 1852, when
Pico's horse, Sarco, raced José
Andrés Sepúlveda's Black Swan. The
stakes were enormous: $50,000 in
gold and five hundred mares, along
with other livestock. Thousands of
people came from as far away as San
Francisco, lining the route on San
Pedro Street to watch the race. Black
Swan won by seventy-five yards.

This proved but the beginning of
Pico's misfortunes. Los Angeles was
now filling with Americans, and Pico,
who never learned to read or write
English, proved an inept businessman.
He became involved in ruinous entan-
glements with moneylenders, and he
lost the Santa Margarita ranch to his
brother-in-law. Nonetheless, hoping to
revive the declining Plaza neighbor-
hood, in 1869 and 1870 he built the

Pico House, which for a decade was the most elegant hotel in Los Angeles. In 1880, however, it was taken over by creditors. For years after, Pico used to frequent its ornate saloon, entertaining friends in the style of the grand land baron he once had been.

Then in 1881 he borrowed $62,000 from a financier named Bernard Cohn, putting up his Whittier ranch as collateral. But when Pico tried to pay Cohn back, Cohn claimed that the transaction had actually been a sale and persuaded Pico's interpreter to lie about the deal. After years of legal proceedings that ended up before the California Supreme Court, Cohn was awarded the property, and in 1892 Pico was evicted from his home. For his few remaining years, he would depend on the hospitality of friends, including Antonio Coronel. The interpreter later recanted on his deathbed, stating that he was paid $2,000 to perjure himself.

By then it was too late. The last governor of Mexican California died penniless, on September 11, 1894, at the age of ninety-three. He was buried in Old Calvary Cemetery on North Broadway in a "quaint iron tomb" that had been brought around the Horn in the 1850s. (Pico and his wife were later reinterred in a private mausoleum at the Workman and Temple Homestead in the City of Industry, now the Homestead Museum.) One of Pico's contemporaries wrote in a eulogy that all who knew "the venerable ex-governor spontaneously bore witness to the kindness of his heart, to his uniform courtesy and to

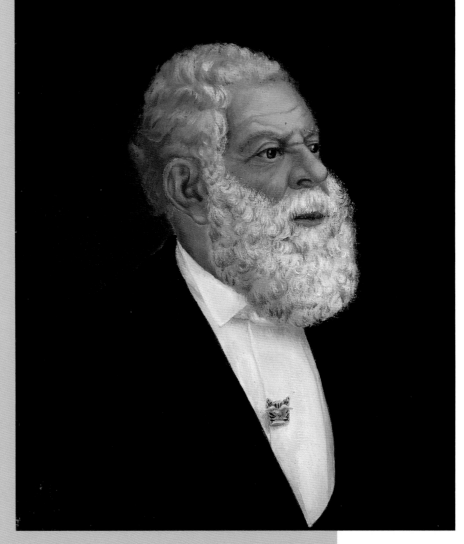

his entire lack of malice or ill will." Others claimed, however, that Pico was a difficult man to do business with and was quite capable of pulling off an occasional shady deal.

In his final years, according to *Harper's Magazine*, Pico was "one of the colorful sights of Los Angeles, above 80, with his stocky figure, square head and bright eyes contrasting with his bronzed skin and close cropped hair and beard." He has a certain resemblance to Victor Hugo, the magazine noted, and, in spite of his misfortunes, "carries himself with a bearing still erect and stately."

Portrait of Pío Pico, ca. 1885, by an unknown artist. Oil on canvas.
History Collections, Los Angeles County Museum of Natural History

By the 1880s Negro Alley was part of the pueblo's growing Chinatown. Carts of vegetable peddlers can be seen, along with a posted notice advertising an anti-Chinese rally, on the wall at lower right (detail, opposite), indicating that the 1871 massacre did not suffice to purge the town of its virulent prejudice. Alexander F. Harmer, Chinatown, Los Angeles, 1886. Oil on canvas.
Courtesy Irvine Museum

Several of the Californio adobes, such as the one belonging to Don Antonio Coronel, were rented out to other new arrivals. Chinese immigration had begun with the gold rush and increased with the building of the transcontinental railroad. By the 1860s Chinese men started moving into the pueblo, fanning race-based animosities. In 1863 the California legislature enacted a law prohibiting Chinese and Indians from offering court testimony in cases involving whites. When the railroad was completed in 1869, increasing numbers of Chinese drifted into the towns of California. By 1870 about

two hundred had settled in the pueblo's Calle de los Negros, where they would work as laborers, shopkeepers, and growers of agricultural produce, selling vegetables and fruit from carts around the Plaza. The street was inhabited by the town's poorest residents, including Mexicans, Indians, Chileños, French, and Anglos, and the newcomers' presence stirred resentment among those who feared competition for jobs. On the night of October 24, 1871, simmering hostilities exploded in the Chinese Massacre, one of the worst incidents of racial violence in Los Angeles history.

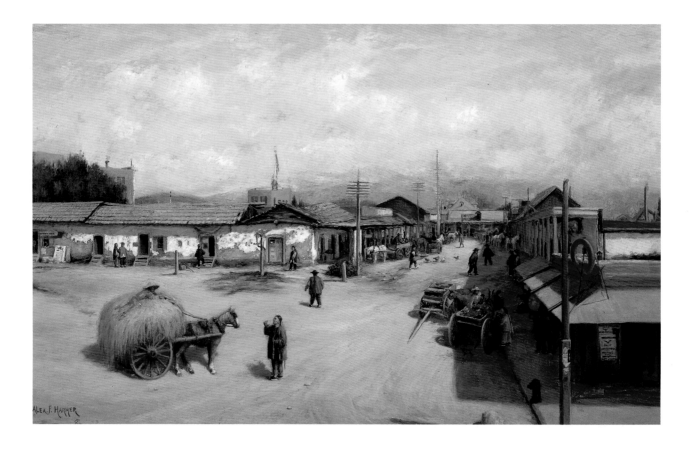

1870
Pico House and Merced Theatre built; town population 5,728, including about 200 Chinese living near the Plaza. The Winery is built.

1870s
Plaza landscaped.

1871
Eighteen Chinese killed in one night by mob of five hundred people.

1873
First synagogue built.

1874
Local transportation is improved by a horse-drawn trolley car line; its route leads past the Pico House and the Plaza Church.

The Chinese Massacre of 1871

The Chinese Massacre began with an argument between members of two rival tongs over a woman.[16] On October 23, 1871, several of them shot at each other in Negro Alley. The next day they were arrested and hauled into court on charges of attempted murder. A storekeeper named Sam Yuen stated that he had $6,000 in his store to help cover the bail. The judge sent a police officer to verify his claim, and one of the men, Ah Choy, was released. That evening Choy was shot, and three days later he died.

Meanwhile, a police officer had come across several Chinese fighting in Negro Alley. Two pointed their guns at the officer and fled into the Coronel adobe. Another officer as well as a bystander named Robert Thompson arrived and started shooting. Fire was not returned, so Thompson climbed onto the building's balcony, where he was shot and killed by those inside.

The city marshal, Frances Baker, cordoned off the block with volunteer guards recruited from the crowd that had gathered. He ordered them to shoot any Chinese who tried to escape, and then he left the scene. The mayor, Cristobal Aguilar, also arrived, but he too stayed only briefly. Word spread that Chinese were "killing whites whole-sale," and the restless crowd turned into a mob. When a man named Wong Tuck tried to escape from the house, he was caught, dragged to a corral at the corner of Temple and New High Streets, and hanged.

A few hours later, men climbed up on the Coronel adobe and started shooting down into the building through holes in the roof. The Chinese ran out into the street, where they were attacked by the so-called guards. When they fled back inside, the mob pounded down the door and threw in a large fireball.

By this time police officers tried to save the Chinese and were able to res-cue four men and four women. Many others, however, were soon hanged. The roof of a wagon shop and two prairie schooners in Commercial Street served as gallows. Looting of the Chinese quarters ensued. Standing on a barrel, the sheriff now implored the rioters to stop, but he fell off. An attor-ney named Henry Hazard climbed on a wagon and tried to calm the crowd, but he was fired at and hauled off for his own safety. Robert M. Widney, an entrepreneur who would later be one of the founders of the University of Southern California, managed to res-cue several people. By eleven o'clock that evening, however, eighteen inno-cent Chinese, including the commu-nity's respected doctor, Chin Lee Tong, and a ten-year-old boy, had been killed.

Although the Coroner's Jury found that the mob included people of all nationalities, blame for the murders was widely attributed to Irish and Mexicans. Eight men were brought to trial, convicted, and sentenced to terms of between two and six years in San Quentin. A year later the California Supreme Court reversed the verdicts on technical grounds. In com-ing years, in keeping with the federal Chinese Exclusion Acts first passed in 1882, virulent anti-Chinese legislation would be enacted by the Los Angeles City Council.

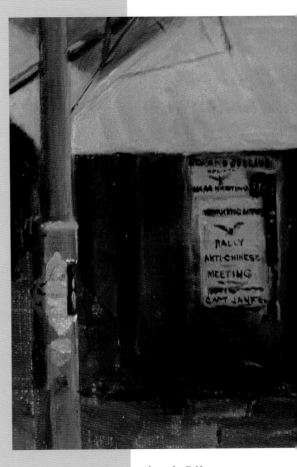

Alexander F. Harmer, Chinatown, Los Angeles, 1886. *Detail.*
Courtesy Irvine Museum

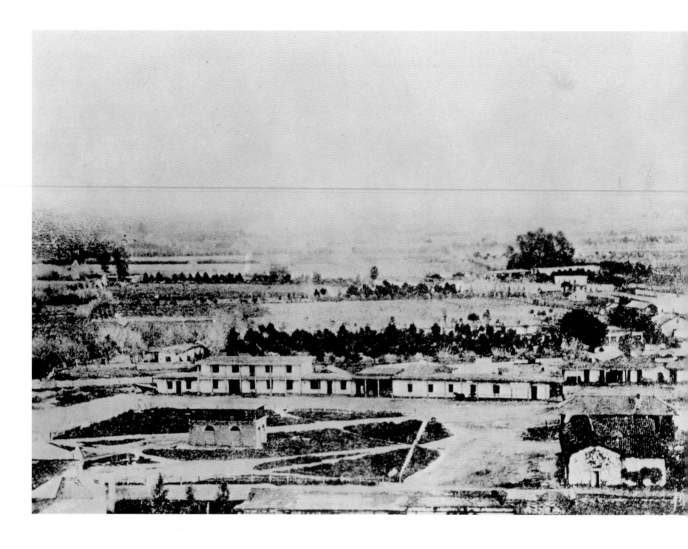

The pueblo was changing in other ways as well. For more than a decade, the business and professional heart of Anglo-American Los Angeles had been moving southward, to Temple and Main Streets, and the Plaza was becoming increasingly run down. In 1869 Pío Pico attempted to revive the neighborhood, building the Pico House on the site of the old Carrillo adobe, where Pico had celebrated his marriage with an eight-day fiesta thirty-five years before. The Merced Theatre,

the town's first building constructed for theatrical performances, built by the son of Swiss immigrants, opened next door in 1870. For a time the hotel and the theater were the most elegant in Los Angeles. The Plaza was given a circular shape and adorned with a fountain in 1871, and in 1875 it was planted with flower beds and orange trees; the Moreton Bay fig trees were added a few years later, transplanted as young saplings from a nursery a few blocks away. The neighborhood's reputation as among the seediest in

1876
Southern Pacific Railroad completes line from San Francisco to Los Angeles, connecting town with East Coast; St. Vibiana's Cathedral completed a few blocks south of the Plaza. Most Anglo parishioners move there, while the Plaza Church remains active place of worship for the Spanish-speaking population.

1877
Vine Street is renamed Olvera Street.

1880
Town's population is 11,183.

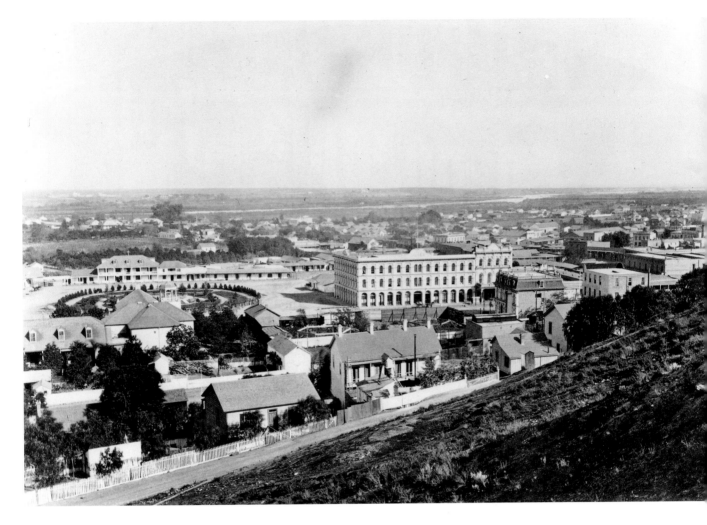

town persisted, however, owing largely to the Calle de los Negros, which was still rife with crime and prostitution. The area was, one newspaper complained, a "sinkhole of depravity." The Merced would soon see its customers lured away by a nearby burlesque house. Pico and his hotel would fall on hard times, and like so many of the old Californio rancheros, he would end his life in poverty (see pp. 30–31).

LEFT
The first photograph of Los Angeles, ca. 1862, shows the two-story Lugo house fronting the Plaza. At right is the adobe built by José Carrillo and, behind it, the adobe of Pío Pico. In the middle of the Plaza is the water reservoir built in 1860.
Courtesy Security Pacific National Bank Photograph Collection/Los Angeles Public Library

ABOVE
The Plaza, ca. 1876, from Fort Moore Hill. The Plaza has been landscaped, and the Lugo House is now a boys' school. At right are the Pico House (1870), the town's most elegant hotel, and the Merced Theatre (1871), its first performing arts house. The Plaza Church and rectory are at the left; the Los Angeles River is seen in the distance beyond.
Courtesy Security Pacific National Bank Photograph Collection/Los Angeles Public Library

1880s
Los Angeles grows as thousands of people arrive and settle; romantic views of Old California begin to form "mission myth," which helps lure people to region. Chinatown develops east of the Plaza.

1880–1900
Blacks join in the movement west, and the city's African American community increases from 102 in 1880 to 2,131 in 1900.

1882
Electric street lighting installed; federal government passes first Chinese Exclusion Act; tomb of Father Serra discovered at mission in Carmel, inspiring new awareness of need for mission restoration.

CALIFORNIA The Cornucopia of the World

ROOM FOR MILLIONS OF IMMIGRANTS

43.795.000. ACRES OF GOVERNMENT LANDS UNTAKEN

Railroad & Private Land for a Million Farmers

A CLIMATE FOR HEALTH & WEALTH WITHOUT CYCLONES OR BLIZZARDS.

Rand, McNally & Co., Printers and Engravers, Chicago.

1883
Plaza House built.

1884
Firehouse built on Plaza; the novel *Ramona*, by Helen Hunt Jackson, is published, fostering romantic views of California history.

1885
Charles F. Lummis walks from Ohio to Los Angeles, starts working for *Los Angeles Times*.

As the nineteenth century waned, sweeping changes came to southern California. The ranchos gave way to subdivisions and new commercial orange groves. Los Angeles had been connected by rail to the East Coast in 1876, and soon the crowded trains of the Southern Pacific were arriving in the rail yards that had been built just east of the Plaza. Land booms lured thousands of immigrants to Los Angeles, whose population grew from eleven thousand in 1880 to fifty thousand by the decade's end. The vast majority were Anglo-Americans, although the black, Mexican, and Chinese populations continued to grow as well. The 1880s, the *Los Angeles Times* would rhapsodize in a style characteristic of the era, brought "a wonderful transformation from a semi-Mexican town of adobes to a flourishing American metropolis of brick, stone, and iron."[17] Advertisements extolled the virtues of the climate, and civic boosters romanticized the rancho period, which now came to be known as the "Days of the Dons." The town's new—and very American—sense of self-promotion was exemplified by an event in 1885: Charles Fletcher Lummis, who would become the first city editor of the *Times*, walked from Cincinnati to California, filing stories as he went. Arriving in San Gabriel, he met the paper's publisher, Colonel Harrison Gray Otis, who had come to Los Angeles a few years earlier. The two of them walked the final eleven miles together, retracing—with some fanfare—the steps of the original pobladores.

ABOVE
In 1885 Charles F. Lummis walked from Ohio to Los Angeles, filing stories for the Los Angeles Times *as he went. He is shown here in the garb of his "tramp across America." As the* Times *city editor, Lummis would help to create the romantic ideal of the California past. He also founded the Southwest Museum and the Landmarks Club, which was dedicated to restoring the missions of early California.*
Courtesy Southwest Museum

OPPOSITE
Land booms in the 1880s lured thousands to southern California, aided by advertisements such as this, produced by the California Immigration Commission in 1883.
Reproduced by permission of The Huntington Library, San Marino, California (RB 248676)

1886
Santa Fe Railroad opens second railroad to Los Angeles; land boom begins.

1887
Sepúlveda House built on Main Street.

1888
Los Angeles Street is cut through the Plaza, demolishing the notorious Calle de los Negros; project could be regarded as an effort to displace the Chinese, who had settled there in large numbers.

1889–90
Boom ends; local economic depression.

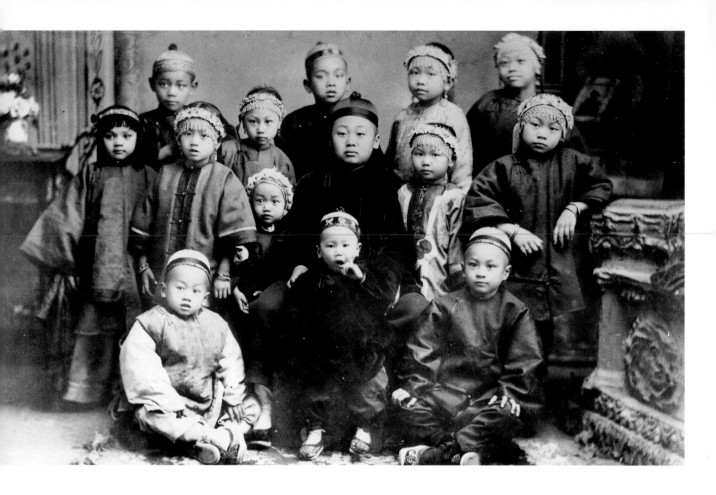

By the turn of the century, the Chinatown spreading south and east from the Plaza was home to more than three thousand people. Dozens of restaurants served dishes from the homeland. Herbal stores, meat markets, laundries, and other businesses proliferated. There were three temples, eight missionary churches, and a Chinese school. Chinese operas were performed in a special theater. Merchants sold goods for both Chinese and non-Chinese customers along Main, Los Angeles, Marchessault, and Alameda Streets. A number of organizations, under the umbrella of the Chinese Consolidated Benevolent Association, would provide support for the community, which still faced considerable prejudice.

Just north of the pueblo, Californios who stayed in Los Angeles blended in with more recent immigrants from Mexico in the emerging Sonoratown barrio. Shaped by poverty and the gradual exclusion of Mexicans from the city's political and economic life, the barrio was also fashioned by growing ethnic and family solidarities, and it fostered a new urban Mexican American culture, more resilient than the traditional culture of the Californios, in the modern Anglo-American city.[18] Sonoratown was a place where Mexican holidays were celebrated, where "in the cantinas and on the street corners" were sung "the deeds of quasi-revolutionary bandidos," and for

1890
Garnier building constructed; Los Angeles population is 50,395.

1892
Edward Doheny taps first oil well in downtown area, sparking major oil boom.

1894
First Fiesta de Los Angeles is celebrated; Simpson-Jones building completed; Pío Pico dies.

1895
First known automobile in Los Angeles.

ca. 1898
Building at 425 North Los Angeles Street completed; leased to Chinese tenants.

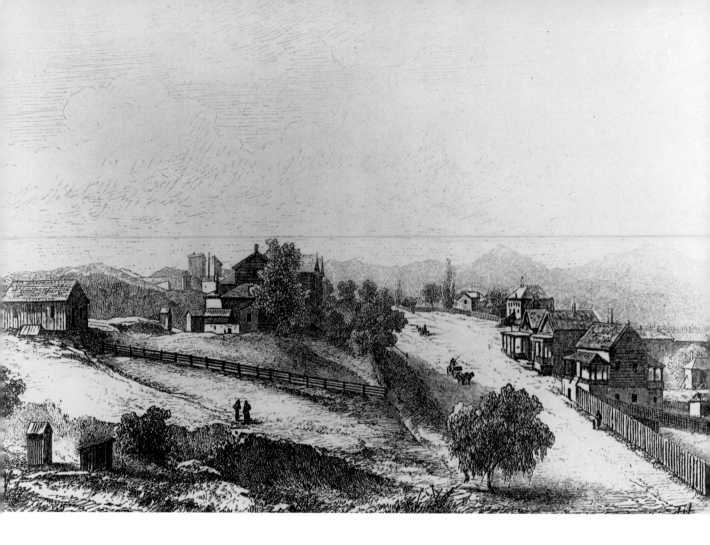

whose residents the nearby Plaza and
environs would retain a wealth of meanings
as a place of cultural expression and
political protest.[19]

Much of the pueblo itself, meanwhile,
had fallen into serious disrepair. The razing
of Calle de los Negros in 1887 had not
improved the neighborhood. A few Californio
families maintained a presence in the Plaza
area: Señora Eloisa Martínez de Sepúlveda,
for example, built a new residence and board-
inghouse on land acquired by her mother in
1847. But most of the old adobes were by now
being replaced by new buildings, such as the
Garnier Block, built by a Frenchman to house

businesses serving the vibrant Chinese
community, and a new brick firehouse,
which went up where Francisco Ocampo's
town home had been. The neighborhood's
character was also defined by the nearby
rail yards, along with machine shops, cheap
hotels, and a noisy substation providing
power for electric trolleys, part of the new
transportation system serving the city and
its fast-growing suburbs. The burgeoning
American metropolis, it seemed, had left
the old pueblo behind.

1900
Hellman-Quon building
completed on Plaza;
Los Angeles population
is 102,479.

1901
Angels Flight Railway
and Pacific Electric
Street Railway begin
operation.

1903
Pacific Electric Railway
workers strike.

1904
Plaza Substation built.

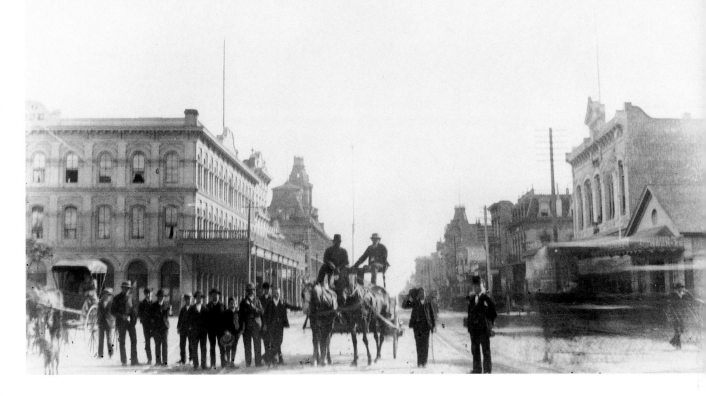

NOTES

1 Robinson, *Los Angeles,* 55–56.
2 A number of Californios tried their luck in the gold fields. One group, led by Antonio Coronel, spent some time there before being driven away by anti-Mexican and anti-Californio sentiments and laws.
3 Richard Griswold del Castillo, *The Los Angeles Barrio, 1850–1890: A Social History* (Berkeley: University of California Press, 1979), 155.
4 Quoted in Robinson, Los Angeles, 32.
5 Horace Bell, *Reminiscences of a Ranger* (1881; rpt. Santa Barbara: Wallace Hebberd, 1927), 26.
6 Harris Newmark, *Sixty Years in Southern California 1853–1913,* 4th ed. (1916; Los Angeles: Zeitlin and Verbrugger, 1970), 263.
7 Bell, *Reminiscences of a Ranger,* 28.
8 Cited in Leonard Pitt, *Decline of the Californios: A Social History of the Spanish-speaking Californians, 1846–1890* (Berkeley: University of California Press, 1966), 154.
9 Cited in Pitt, *Decline of the Californios,* 181.
10 Robert W. Blew, "Vigilantism in Los Angeles, 1835–1874," in *A Southern California Historical Anthology,* ed. Doyce B. Nunis Jr. (Los Angeles: Historical Society of Southern California, 1984), 85–108; Griswold del Castillo, *Los Angeles Barrio,* 105–15; Pitt, *Decline of the Californios,* 148–80.
11 Griswold del Castillo, *Los Angeles Barrio,* 110.

12 Pitt, *Decline of the Californios,* 148–71. Another famous bandit, Tiburcio Vasquez, was seen as both a hero and a villain. Vasquez claimed that his banditry was an attempt to resist the American "invasion" of California. "A spirit of hatred and revenge took possession of me," he said, shortly before he was hanged, in 1875. "I had numerous fights in defense of what I believed to be my rights and those of my countrymen." Several Californio rancheros had joined forces with Yankee vigilantes to capture the outlaw. Some critics, however, see Vasquez as a resistance fighter; see Raúl Homero Villa, *Barrio-Logos: Space and Place in Urban Chicano Literature and Culture* (Austin: University of Texas Press, 2000), 21–24.
13 Pitt, *Decline of the Californios,* 126.
14 Newmark, *Sixty Years in Southern California,* 199.
15 Ibid., 100.
16 This summary of the events surrounding the Chinese Massacre is based on the article by Paul de Falla, "Lantern in the Western Sky," *Historical Society of Southern California Quarterly* 42, no. 1 (March 1960); no. 2 (June 1960).
17 *Los Angeles Times,* December 4, 1891.
18 Ríos-Bustamante, *Mexican Los Ángeles,* 145–59; Griswold del Castillo, *Los Angeles Barrio,* passim.
19 Griswold del Castillo, *Los Angeles Barrio,* 173–74. See also Villa, *Barrio-Logos,* 20–66.

Men standing at the Plaza and Main Street, ca. 1900. New buildings have replaced the adobes that once lined the Plaza and the old Calle Principal, now Main Street. At left is the Pico House.

Courtesy Security Pacific National Bank Photograph Collection/Los Angeles Public Library

1905
Union Pacific, third major railroad, comes to Los Angeles; William Mulholland spearheads building of Los Angeles Aqueduct; massive Mexican immigration begins.

ca. 1906
First movie studio opens in Los Angeles.

CHRISTINE STERLING
AND A NEW OLVERA STREET

In about 1920 Christine Sterling moved to Los Angeles with her husband, a lawyer in the city's fast-growing movie business. Born Chastina Rix in Oakland, Sterling was possessed of immense energy and a passionate love of California history. "The attractive literature which Los Angeles sends out, enticing people to Southern California, drew me as it has thousands of others," she would write. "The booklets and folders I read…were painted in colors of Spanish-Mexican romance…with old Missions, rambling adobes—the 'strumming of guitars and the click of castanets.'" [1]

Aerial view of the Plaza in 1922, when much of the area had fallen into serious disrepair.
At left is Olvera Street; the Lugo House (top center), the Garnier Block (top right),
the Pico House and Merced Theatre (center right), the Brunswig building (lower right),
and the Plaza Church (bottom center) can also be seen.
Courtesy El Pueblo Historical Monument

Although Los Angeles was thriving, by the 1920s the old pueblo itself had become dilapidated. Olvera Street was an unpaved alley used mainly by vehicles making deliveries to the rear entrances of the machine shops and other businesses that fronted on Main Street. Because of Prohibition, which had begun in 1919, the Winery, where Italian winemakers had sold their wares in the 1870s, was reduced to making soft drinks and communion wine. Short-term boarders inhabited the now-decrepit Avila adobe. The Pelanconi House and the Sepúlveda House also took in lodgers and were apparently often used for prostitution. The civic and commercial heart of the city had moved south to the area around First Street, where the towering new City Hall would be completed in 1928.

Vine Street had been renamed Olvera Street in 1877, in honor of Agustín Olvera, the first superior court judge in Los Angeles County, whose family had long lived in the pueblo and who had died the year before. The Olvera adobe was demolished in 1917 to make way for buildings operated by the United Methodist Church. Since the 1880s the area gradually had become more industrial. Despite a fair amount of new construction, such as the Plaza Substation, built in 1903–4 to provide power for the electric streetcars of the Los Angeles Railway Company, and the Italian Hall, erected in 1907 as a meeting place for the area's growing Italian community, much of the district had fallen into serious disrepair.

As Sterling had written, she was lured to Los Angeles by promotional literature reflecting idealized views of California's past that would come to be known collectively as the mission myth. Such views had been born in the 1880s, and in the following decades they grew to dominate the idea of southern California in the popular imagination. Infused by a civic boosterism that sought to entice new settlers to the region, the myth substituted a belief in a "lost paradise" of a Spanish or Mexican California, when life was supposedly simple and unsullied, for a soberer appreciation of the region's complex history. This Edenic vision generally sought to propagate the interests of the

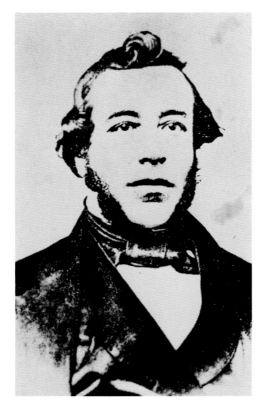

Agustín Olvera, who arrived in Los Angeles in 1845 and became a ranchero, lawyer, and, after the United States took over, the first county judge of Los Angeles. He lived in a house on the north side of the Plaza. The year after his death in 1876, the street fronting his adobe was renamed in his honor.
Courtesy California Historical Society/TI Collection

Early 1900s
As Los Angeles continues to grow, pueblo area becomes increasingly industrial.

1907
Italian Hall completed; Ricardo Flores Magon and the PLM ignite Mexican radicalism in the Plaza.

1908
City population 310,198.

1909
Public oratory banned in Los Angeles, except for the Plaza, which becomes a popular venue for political rallies; Hammel Building completed.

newly dominant Anglo-Americans. While it was fostered by civic leaders and commercial interests such as railroad companies, it also found literary and artistic expression, and the spirit of boosterism was at times combined with a genuine appreciation of indigenous southwestern culture.

Among those expressing such views was a group of eastern writers and journalists known as the Arroyo Set, gathered around the Arroyo Seco home of Charles Fletcher Lummis, the *Times* city editor who had walked across the country in 1885 and on whom the landscapes of the Southwest, with their combination of "sun, silence, and adobes," had had an effect comparable to "a religious conversion."[2] In 1895 Lummis was instrumental in founding the Landmarks Club, which played an important role in restoring many missions of Spanish California. He also founded the Southwest Museum, which would develop one of the country's finest collections of Native American materials, and edited *Land of Sunshine,* upgrading the magazine, whose title he later changed to *Out West,* from a promotional throwaway to a showcase for regional art and literature.[3] Lummis famously said that "the missions, next to our climate and its consequences, are the best capital Southern California has."

Ironically, the book perhaps most responsible for romanticizing the region's early days was written by Helen Hunt Jackson, a literary celebrity from the East Coast who had first arrived in the late 1870s, about the time that Hubert Howe Bancroft was collecting testimonials from aging Californios for his

Christine Sterling, who came to Los Angeles in the early 1920s, lured by romantic descriptions of its past. Discovering that the city's historic heart had fallen into ruin, she set about restoring it by creating a Mexican marketplace at Olvera Street.

Courtesy El Pueblo Historical Monument

seminal *History of California.* Jackson was appalled by the way in which Native Americans had been treated. With the assistance of the entrepreneur and Indian agent Abbot Kinney, she wrote a report to the government, based largely on information provided by Don Antonio Coronel, who had also provided a long account to Bancroft. Her report was ignored, so she decided to write a popular novel. *Ramona,* published in 1884, sought to publicize the Indians' plight much as Harriet Beecher Stowe's *Uncle Tom's Cabin* had done for slaves in the South some thirty years before.

1910–1917	**1910**	**1913**	**1914**	**1915**
The Mexican Revolution brings tens of thousands of new immigrants to Los Angeles.	*Los Angeles Times* building bombed.	Los Angeles Aqueduct brings water to city from eastern Sierra; Los Angeles County Museum opens.	World War I begins; speaker's rostrum placed in Plaza; Southwest Museum founded by Charles F. Lummis.	Annexation of San Fernando Valley expands city; Estelle Lawton Lindsey elected first woman on City Council.

Poster for the 1928 Ramona Pageant in the California town of Hemet, showing Ramona and Alessandro on the veranda of the fictional Moreno ranch. The pageant was based on Helen Hunt Jackson's novel, which was intended to expose the atrocious treatment of California's Native Americans but wound up popularizing romantic myths about the history of early California.

Courtesy the Ramona Pageant Association

However, the novel, which recounts the tragic love between Ramona, a woman of so-called mixed blood, and a Native American named Alessandro, had an effect quite different from what its author had hoped. Its love story, culminating in Alessandro's death at the hands of a bigoted white settler, was intended to entice the public into reading a book with a serious social message. Instead *Ramona*'s sentimental style ended up fostering a romantic perception of life on the missions and ranchos of old California. "Not a word for my Indians!" Jackson despaired after reading the first reviews. She died less than a year after the book's publication, fearing that her effort perhaps had failed.[4] *Ramona* became a runaway best-seller and was adapted several times for the screen, beginning in 1910 with a one-reeler produced by D. W. Griffith's Biograph Company and starring Mary Pickford. The novel inspired the Ramona Pageant in the southern California town of Hemet, which debuted in 1923 and would become the longest continuously running outdoor play in the country.

Given the currency of such mythology, which partakes of what Carey McWilliams has called the "fantasy heritage" of the American Southwest,[5] it is perhaps not surprising that Christine Sterling could describe old California as a place where "people lived to love, to be kind, tolerant, and contented. …Money, of which there was plenty, was just for necessities. The men owned and rode magnificent horses. The women were flowerlike in silk and laces. There were picnics into the hills, dancing at night, moonlight serenades, romance and real happiness."

1917
Olvera adobe demolished.

1918
World War I ends.

1920
City population 576,673.

1922
Hollywood Bowl completed.

1923
Coliseum opens at Exposition Park.

A young woman, probably of the del Valle family, plays the guitar on the veranda of Rancho Camulos. Helen Hunt Jackson visited the rancho, which became known as "the home of Ramona."

Seaver Center for Western History Research, Los Angeles County Museum of Natural History

Nor is it surprising that when Sterling encountered the historic heart of Los Angeles, she was aghast at how it had deteriorated. "Where," she asked, "was the romance of the past?…I visited the old Plaza, birthplace of the city, and found it forsaken and forgotten. The old Plaza Church …was suffocated in a cheap, sordid atmosphere. The old Pio Pico House, built by the last Mexican governor in California, its once fine patio filled in with a pool hall, the balconies torn away, [had] filth everywhere.… Down a dirty alley I discovered an old adobe, dignified even in its decay. Across the front door was nailed a black and white sign, CONDEMNED."

Cover of the sheet music for the song "Ramona," written for the 1928 movie version starring Dolores del Rio. Its chorus began, "Ramona, I hear the mission bells above, Ramona, they're ringing out our song of love." The song became a popular hit and would be recorded by various artists, including Louis Armstrong.

Courtesy the Ramona Pageant Association

1926
Los Angeles Central Library opens; *La Opinión* begins publication.

1928
Los Angeles City Hall completed; condemnation notice on Avila Adobe door inspires Christine Sterling to start campaign to save historic district.

1929
Stock market crash begins the Great Depression; in Los Angeles, where thousands are out of work, unemployed men congregate around the Plaza.

1930
Mexican marketplace opens at Olvera Street; Avila Adobe opens to the public; city population 1,238,048.

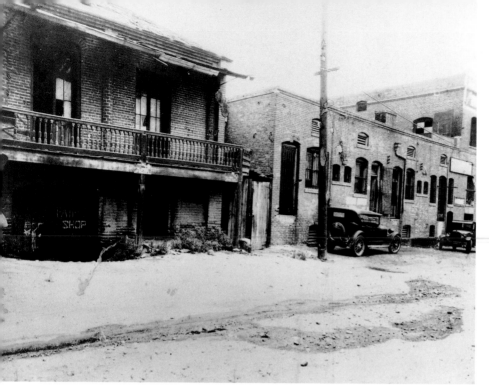

The alley was Olvera Street, and the dilapidated house Sterling had happened upon was the Avila adobe, the oldest extant building in Los Angeles. Here Stockton had headquartered when the United States occupied the pueblo some seventy-five years before. Following the Avila family's departure from the pueblo in 1868, the adobe had been variously rented out as a boardinghouse and an Italian restaurant and hotel. Sterling, whose husband had recently died, threw herself into a project to save the structure. She met with Harry Chandler, who had succeeded Otis as publisher of the *Los Angeles Times*. Chandler agreed to provide press coverage of her efforts. For several years she lobbied civic leaders, but her labors resulted, as she put it, "in miles of conversation but no definite results." On November 29, 1928, she again visited the decrepit adobe, only to find a final condemnation notice posted on its door. Standing, as she dramatically recalled, "in the dark silent rooms, I saw the crumbling walls, the boarded up windows....The fine old pepper trees were now just barren stumps....Why do people write and talk about history but do nothing to save it?"

Indeed, at this time the historic preservation movement in the United States was in its infancy. Elsewhere in the country, John D. Rockefeller Jr. was funding the preservation of Colonial Williamsburg. Patricians on the East Coast and in the South had saved a few historic districts, such as in Charleston, where an alliance of upper-class women

Olvera Street in the late 1920s, before its renovation, when it was an unpaved alley and service entrance for the machine shops fronting on Main Street. From left to right, the Pelanconi House, the Hammel building, and the Italian Hall can be seen.
Courtesy El Pueblo Historical Monument

This condemnation notice, posted on the front door of the decrepit Avila adobe, inspired Christine Sterling to develop a plan to save the house and create the Olvera Street marketplace.
Courtesy Security Pacific National Bank Photograph Collection/Los Angeles Public Library

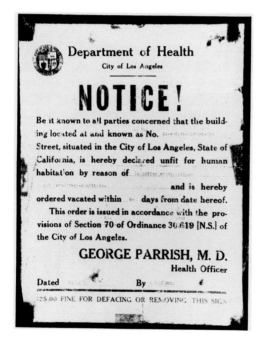

Department of Health
City of Los Angeles

NOTICE!

Be it known to all parties concerned that the building located at and known as No. _____ Street, situated in the City of Los Angeles, State of California, is hereby declared unfit for human habitation by reason of _____ and is hereby ordered vacated within _____ days from date hereof.

This order is issued in accordance with the provisions of Section 70 of Ordinance 36,619 (N.S.) of the City of Los Angeles.

GEORGE PARRISH, M. D.
Health Officer

Dated _____ By _____

$25.00 FINE FOR DEFACING OR REMOVING THIS SIGN

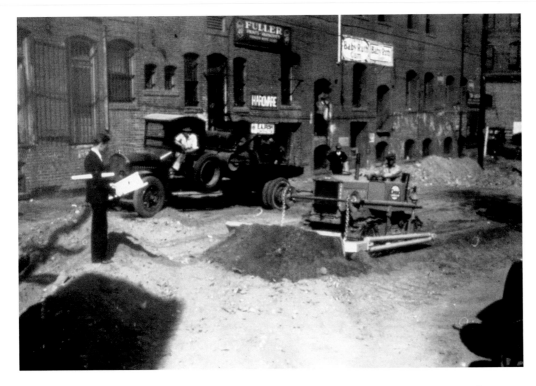

Engineer from the Los Angeles Department of Water and Power checks plans for the grading of Olvera Street during its renovation in late 1929 and early 1930.

Courtesy Security Pacific National Bank Photograph Collection/Los Angeles Public Library

pushed through local preservationist legislation. The federal government would not get seriously involved until the 1930s, when the National Park Service and other agencies began to survey and record the nation's historic buildings.

In California some restoration of the missions had begun in the late nineteenth century, owing largely to the efforts of individual priests, for whom the missions, as the first outposts of God in a theretofore "heathen" land, possessed considerable religious significance. In 1882 the recently discovered tomb of Father Serra was opened with great ceremony at the rundown Mission San Carlos Borromeo in Carmel, where other remains were also unearthed, including those of Father Juan Crespí, diarist of the original Portolá expedition. This event inspired new awareness of the need for mission restoration. Such groups as the Native Sons of the Golden West and, in southern California, Lummis's Landmarks Club

promoted certain aspects of the state's historical heritage.[6]

California's nascent tourism industry also played a role in popularizing the past, albeit while often blurring the line between history and myth. A case in point is Rancho Camulos, in what is today Ventura County, which belonged to one of the pueblo's most distinguished families. The del Valles, who had arrived from northern Mexico in 1839 and, their fortunes in decline, had moved there from Los Angeles in 1861, were now portrayed as of Castilian Spanish origin. Their rancho had been visited briefly by Helen Hunt Jackson and became widely known as "the home of Ramona."[7] At the family's suggestion, the Southern Pacific Railroad placed a small station at the ranch; soon the del Valles found themselves invaded by visitors expecting to encounter in real life the lovers of legend. Tourists would arrive unannounced, a family member complained to the press, and "insist on seeing everything, from the bedrooms to

1936	By 1938	1938	1939	1940
Plaza is again center of labor-political activity.	*América Tropical* mural entirely painted over.	Mayor Frank Shaw recalled for corruption; political reform begins.	Union Station opens, the last major train terminal to be completed in the United States; World War II begins in Europe.	Arroyo Seco Parkway (Pasadena Freeway) completed.

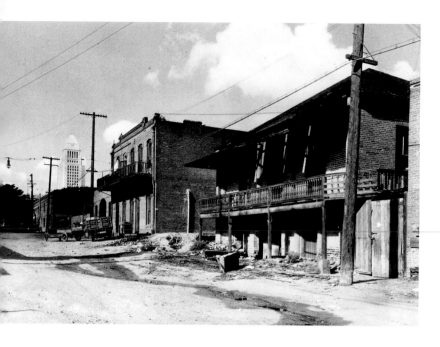

Olvera Street before restoration, looking past the Pelanconi House (right) and the Sepúlveda House (center) toward Los Angeles City Hall, which opened in 1928.

Courtesy Security Pacific National Bank Photograph Collection/Los Angeles Public Library

the sheep corral." Still a working ranch, the spread packaged its oranges and wine under the "Home of Ramona" label.[8]

When the California State Park system was founded in the 1920s, it included several historic sites, but the pueblo was not among them. The rescue of the historic district, therefore, depended almost entirely on the efforts of individuals. Sterling sought an alliance with the city's business and civic leaders, whom she had to convince—and at times convince again—to join in her project. By her account, she posted a sign in front of the 110-year-old building, proclaiming its history and stating, in characteristically flowery language, "If this old landmark is not worthy of preservation then there is no Sentiment, no Patriotism, no Country, no Flag." When the sign failed to attract the desired publicity, she called a few local newspapers anonymously to inform them of its presence. In the next few days stories ran in the *Times,* the *Examiner,* and other newspapers, and the campaign, aided no doubt by the considerable political clout of the *Times* publisher,

took on momentum. The city council reversed the order of condemnation, and the Rimpau family, descendants of the Avilas, gave Sterling permission to renovate the adobe. Labor was donated by the Ramona Parlor of the Native Sons of the Golden West, and lumber was provided by the Hammond Lumber Company and brick by the Simons Brick Company. Other firms provided cement and roofing for the structure.

Sterling quickly found that renovating the adobe would be only the first step. "Unless the street in front of the adobe could be paved and the surrounding buildings repaired," she wrote, "the future of the old house is very limited. Olvera Street was not only a filthy alley, but was a crime hole of the worst description. Bootleggers, white slave operators, dope operations; all had headquarters and hiding places on the street." She expanded her campaign to include the creation of a Mexican marketplace, a "Spanish-American social and commercial center, a spot of beauty as a gesture of appreciation to Mexico and Spain for our historical past."

Again Sterling went to Harry Chandler, who agreed to hold a fund-raising luncheon for civic leaders. Having plied the guests with tequila, Sterling asked them for financial support to "pave and beautify the street." Six men offered to cover the cost of materials: Chandler himself; Henry O'Melveny, a prominent lawyer; Lucien N. Brunswig, president of the Brunswig Drug Company, whose headquarters were located in the area; James R. Martin, a banker and member of the firm of Torrance, Marshall & Company; General Moses H. Sherman, owner of the Los Angeles Consolidated Electric Railway Company; and

1941
Japan bombs Pearl Harbor; U.S. enters World War II. During the war, Olvera Street gains national renown, as troops stop over in Los Angeles and at USO canteen in Sepúlveda House. City population 1,504,277.

1942
Colorado River Aqueduct delivers water to Los Angeles; President Roosevelt issues executive order placing Japanese Americans in detention camps; Mexican *bracero* workers replace them as laborers.

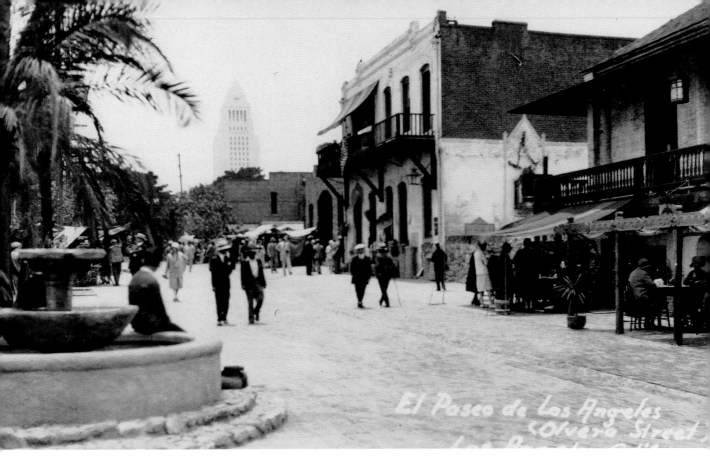

El Paseo de Los Angeles (Olvera Street)

the businessman Rudolfo Montes. This was the beginning of Plaza de Los Angeles Inc., the corporation that would oversee the development of Olvera Street, with Sterling as its manager. The tireless woman persuaded the Department of Water and Power (DWP) to help with the required engineering. To grade and brick the street, the Los Angeles chief of police donated the labor of a prison gang.

Olvera Street property owners filed a lawsuit against the project. They wanted the street to remain open so that their business tenants and their customers would have access to the buildings on the Olvera Street side. The matter was fought all the way to the California Supreme Court, where eventually it was decided in favor of the City and Mrs. Sterling.

It could be argued that civic leaders were more interested in the idealized past than in the difficult present faced by thousands of Mexican Americans. In the previous decades Mexican immigrants had flooded into the city. By the mid-1920s Mexican residents of the Sonoratown and Plaza area, along with more recent immigrants, were moving east across the river, where the new barrio was rapidly growing into one of the nation's largest. Mexicans in Los Angeles often encountered a harsh existence, including considerable prejudice and jobs requiring strenuous manual labor.[9]

In any case, reconstruction of Olvera Street started on November 7, 1929, shortly after the stock market crash that began the Great Depression. By the end of the month,

Olvera Street in the early 1930s, after renovation. A fountain adorns the street; the Pelanconi House is a restaurant, the Sepúlveda House has been painted, and there are shops inside.

1943
Zoot Suit Riots break out.

1945
World War II ends.

1948
Hollywood Freeway completed; gold rush centennial celebrations invigorate historic preservation movement in California.

1949
Chavez Ravine public housing controversy; Edward Roybal elected to City Council, first Mexican American to serve since 1881.

1950
City population 1,970,358; Pico House and Merced Theatre have severely deteriorated.

the prison workmen were laying bricks. Mrs. Sterling often mentioned the prison gang in her diary. "One of the prisoners is a good carpenter, another an electrician," she commented a few weeks after work had begun. "Every day I pray that they will arrest a bricklayer and a plumber." Early in January prisoners working in the Pelanconi House found some buried cases of wine or whiskey—this was the height of Prohibition—and were able to consume a considerable amount of drink. They were, Sterling noted, taken back to jail in "a very wilted condition." During construction, various other objects were found as well, including a box containing two silver bracelets, an old pistol, and a powder horn.

As work progressed, many of the historic buildings lining the street were renovated and adapted to new uses. Electric lanterns were installed along the street, as were vendors' booths, or *puestos,* each of which was to be given to a family from Mexico to sell goods from their home state. To adorn the street, the DWP trucked in a stone water trough, believed—erroneously—to have been "hewn by Mission Indians." The path of the old *zanja madre,* the pueblo's original irrigation ditch, which crossed Olvera Street diagonally, was marked with special tiles. Olive and pepper trees were planted, and a large wooden cross was erected at the Plaza entrance.

A print of the painting Days of the Dons, *by Alexander F. Harmer, date unknown. This print was used to decorate a 1901 calendar. By the early twentieth century, the period of Mexican California had become known as an idyllic time of romance and fiestas. Small American and Mexican flags are shown here side by side, suggesting the happy coexistence of these two cultures. In reality, the period following the United States occupation of Los Angeles saw considerable cultural conflict.*

Seaver Center for Western History Research, del Valle Collection, Los Angeles County Museum of Natural History

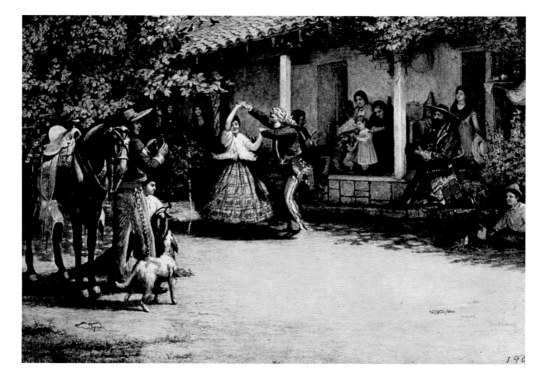

1951
Lugo House demolished.

1953
El Pueblo de Los Angeles State Historic Park dedicated; Avila Adobe and other buildings at El Pueblo purchased by State of California.

1956
City Council repeals 140-foot building height limit.

1960
In Los Angeles for the Democratic convention, John F. Kennedy visits Plaza; renovation of Masonic Hall and Plaza Firehouse completed.

El Paseo de Los Angeles, as the new marketplace was initially known, opened "in a blaze of glory," on Easter Sunday, April 19, 1930. "Olvera Street holds for me all the charm and beauty which I dreamed for it because out of the hearts of the Mexican people is spun the gold of Romance and Contentment," Sterling noted. "No sweeter, finer people live, than the men and women of Mexico and whatever evil anyone believes about them has been bred in the darkness of ignorance and prejudice."

From its opening day, visitors flocked to Olvera Street, which offered Mexican Americans suffering under the effects of the depression a place to display their wares and Anglo-American tourists a place to experience the "romance of old Mexico" just a few blocks from City Hall. It was popular with film stars such as Charlie Chaplin, John Barrymore, Douglas Fairbanks, and Greta Garbo. There was a leather worker, a blacksmith, a candlemaker, and a potter who made his wares in the dull red hues of Jalisco. In the renovated Sepúlveda House, where Spanish decorative motifs had been added, artisans and shopkeepers selling Mexican crafts and curios were installed on the basement and first floors. In the Pelanconi House was La Golondrina Café, which had been founded a few years earlier on Spring Street. It claimed to be the first eatery in the city to serve "Mexican," as opposed to Spanish, food.

Christine Sterling sought to "re-create" in Olvera Street the romance of the great fiestas of yore. Here dancers perform in front of the Avila adobe in the early 1930s, soon after Olvera Street opened.

Courtesy Security Pacific Bank Photograph Collection/Los Angeles Public Library

1961
City population 2,461,595.

1963
Christine Sterling dies.

1970
City population 2,811,801.

1971
Sylmar earthquake damages a number of historic buildings at El Pueblo and damages *América Tropical*.

1973
Tom Bradley elected first African American mayor of Los Angeles.

An Olvera Street blacksmith tends his shop in the early 1930s.

Not all the businesses were operated by Mexican Americans. The Dobe Dollar bookstore, operated by the poet and puppeteer Forman Brown, sold books at discount rates of under a dollar. The Yale Puppeteers, of which Brown was a member, had their theater in the Sepúlveda House, whose second floor was turned into a tearoom and center for artists and craftspeople. There were sculptors, painters, photographers, even an interior decorator. Each painted his shop door a different color, and their shops were known as the "Shop of the Green Door," the "Shop of the Orange Door," and so on. The renovated Avila adobe, meanwhile, became

a historic house museum and served as Sterling's office, from which she offered tours to casual visitors and groups of schoolchildren. Eventually she would take up residence there, and she would die in the house in 1963.

The years following the opening of Olvera Street brought other changes. Between 1933 and 1938, Old Chinatown, just east of the pueblo, was demolished to make way for the construction of the new Union Station train terminal. An earlier proposal would have built the station on the site of the Plaza itself, in which case the pueblo would have been almost entirely destroyed. The displaced Chinese moved over to the old Sonoratown district, where gradually the new Chinatown grew up, as residents of Sonoratown continued moving to the barrio in East Los Angeles. In 1938 Sterling, apparently moved by the plight of the Chinese, led the way in the creation of China City, a tourist marketplace similar to Olvera Street.

During World War II, Olvera Street gained national renown. Union Station, which had opened across the street in 1939, brought trainloads of troops to Los Angeles. Many of them had stopovers, and a USO canteen was established in the Sepúlveda House. By the end of the war, Olvera Street's fame was well established.

Its success did not always carry over to the rest of the pueblo. The adobe known as the

Lugo House had been built on the east side of the Plaza in about 1838. It had belonged to Vicente Lugo, a noted horseman and son of the prominent ranchero and Los Angeles alcalde Don Antonio Mariá Lugo. Don Vicente gave the house to the Catholic Church in 1865. It briefly housed St. Vincent's College, predecessor of Loyola Marymount University, and the Lafayette Hotel. By the late 1880s Chinese tenants had moved in, and they retained occupancy for the next seventy years. The Kong Chow Company installed a Buddhist temple there in 1891. The Hop Sing Tong and the Pekin Curio Store were also longtime tenants.

When the City of Los Angeles threatened to demolish the Lugo House in 1950, a group of Chinese merchants tried to save it, hoping to transform the historic structure, along with other buildings in the block stretching down to Alameda Street, into a cultural and commercial center. They raised thousands of dollars and posted a sign in the window asking for the public's help, much as Sterling had done with the Avila adobe almost twenty-five years earlier. Their efforts were unsuccessful, however, owing largely to Sterling herself, who said that "the Chinese must go" and insisted that the Lugo House be destroyed in order "to clean up the area." The city was adamant, and the structure was torn down on February 7, 1951.

In 1953, with the importance of historic preservation beginning to be recognized in cities across the country, the entire Plaza area was declared a state historic park, fulfilling Sterling's long-standing dream. She is owed considerable credit for saving the district.

A photographer with his cardboard "Mexican" waits for customers at Olvera Street in the 1930s.

Courtesy Security Pacific National Bank Photograph Collection/Los Angeles Public Library

By the late nineteenth century the Lugo House, on the east side of the Plaza, had become a landmark of Old Chinatown. It is shown here in about 1900. In spite of efforts by Chinese merchants to save this historic structure, the building was destroyed in 1951.

Courtesy El Pueblo Historical Monument

1986
Two arson fires severely damage Los Angeles Central Library, where restoration work soon begins.

1987
While in Los Angeles, Pope John Paul II visits the Plaza.

1988
Getty Conservation Institute, El Pueblo de Los Angeles Historical Monument, and Friends of the Arts of Mexico undertake conservation of *América Tropical*.

DRAGON ROAD CHINA CITY LOS ANGELES, CAL. 698

China City

Inspired by the success of Olvera Street, a group of Los Angeles citizens led by Christine Sterling and financed by Harry Chandler decided to create a Chinese version a few blocks away. China City, located in the former Sonoratown, opened in 1938, as the Old Chinatown district was being destroyed to make way for Union Station. "Since the days of Marco Polo the world has heard of the wonders and beauty of Cathay, its old civilization and its contributions to the Western World," Sterling proclaimed at the opening ceremony. "With this background, the Chinese came into California...and became part of our Pacific Coast tradition."

Surrounded by a "Great Wall," China City was a tourist marketplace reflecting a romanticized vision of Chinese culture and commerce. Sets from the recent film *The Good Earth*, based on Pearl Buck's novel, were donated by MGM, which had built an entire Chinese village in the San Fernando Valley. Tourists could explore the "romance of the exotic

ABOVE

China City postcard of the early 1940s.
Courtesy Security Pacific National Bank Photograph Collection/Los Angeles Public Library

The September 1940 cover of Arrowhead Magazine, *published by Union Pacific Railroad.*
Courtesy the Johnny Yee Collection, Los Angeles

Orient" and enjoy rickshaw rides that started from the Court of the Four Seasons and led along passageways with names like Dragon Road and Shanghai Street. (One of the rickshaw drivers was the future Olvera Street blacksmith Cruz Ledesma.) They could browse in curio shops and herb stores, some of which were operated by recently displaced residents of Chinatown, and dine in Chinese restaurants adorned with dried ducks hanging from kitchen beams.

Some merchants appreciated the opportunities that this commercial venture offered. Ruby Ling Louie remembers being told by Johnny Yee, who worked there as a young man, that "one could not forget the fragrant smell of temple incense and the sound of soft Chinese music as you enter the gate."[10] Other Chinese residents disliked the way the marketplace substituted a Hollywood image for a realistic representation of their daily lives. Regardless, in the words of Mae Elaine Quan, China City "was a unique place in a unique time."[11]

Yet China City would not know the enduring success of its Mexican predecessor. Destroyed by fire soon after its opening, it was rebuilt, only to be burned a second time in 1948. By 1950 China City was no more. The city's new Chinatown, however, grew up in the area where China City had been.

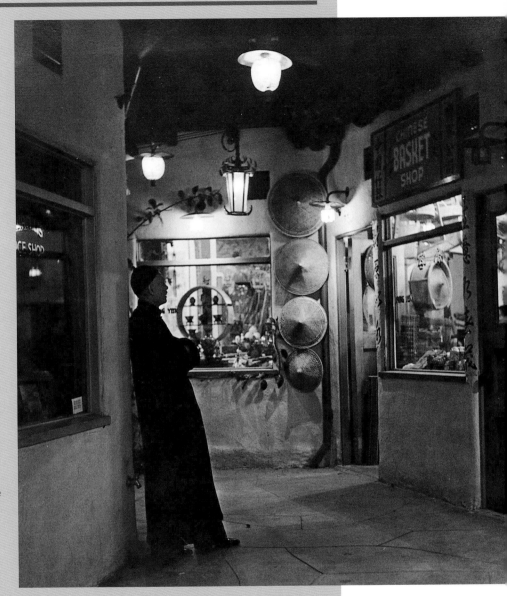

The merchant Fong Yun stands in front of one of his stores in China City, on an evening in the early 1940s.
Courtesy the Gim Fong Collection, Los Angeles

A crowd on Olvera Street during the 1930s.
Courtesy El Pueblo Historical Monument

Although Sterling's transformation of Olvera Street reflected the fanciful and somewhat paternalistic beliefs prevalent in her time and milieu, her love of the place and its people was genuine and profound. While the romantic tone of Olvera Street contrasted markedly with the harsh conditions facing Mexican Americans in Los Angeles during the early years of the depression, there is no doubt that many of its shopkeepers were virtually destitute at the time the marketplace opened. These merchants gained status partly through Sterling's access to the corridors of power, and they have since come to be a significant political force in downtown Los Angeles.[12]

In attempting to find commercially viable uses for a decaying historic district, Sterling addressed complex issues that preservationists—at El Pueblo de Los Angeles and elsewhere—are still grappling with today. The more somber aspects of the state's history, however, including the plight of its Native Americans and the pueblo's own episodes of racial violence, had little place in Sterling's worldview. On the Easter Sunday in 1930 when the resurrection of Olvera Street was celebrated, she could little imagine that barely two years later her romantic Mexican marketplace would find itself adorned by a monumental mural expressing a much darker vision.

While political disagreements about the operation and management of the park over the decades since have slowed the preservation of the buildings at El Pueblo, progress has gradually been made. In addition to the Avila adobe, the Firehouse was restored and opened as a museum in 1960. The Sepúlveda House and the Pico House have been restored, as has the Garnier Block, where the new Chinese American Museum is opening in 2003—fulfilling, fifty years later, the Chinese merchants' dream of a cultural center in the historic district.

1990
King Juan Carlos I of Spain visits Plaza and rededicates statue of Carlos III of Spain.

1991
Gloria Molina becomes first woman and first Latina elected to Board of Supervisors.

1992
Transfer of property of El Pueblo de Los Angeles Historical Monument from the State to the City of Los Angeles; city population 3,485,390.

1993
Central Library reopens.

1994
Northridge earthquake; limited damage at El Pueblo.

NOTES

1 Christine Sterling, *Olvera Street: Its History and Restoration* (privately printed, 1947), 8. Unless otherwise noted, all quotes from Sterling are from this booklet.

2 Edwin R. Bingham, *Charles Fletcher Lummis: Editor of the Southwest* (San Marino, Calif.: Huntington Library, 1955), 9.

3 Mark Thompson, *American Character: The Curious Life of Charles Fletcher Lummis and the Rediscovery of the Southwest* (New York: Arcade Publishing, 2001), 172–212.

4 Phil Brigandi, "The Rancho and the Romance," in *The Ventura County Historical Society Quarterly* 42, nos. 3–4 (1998): 13; see the Ramona Pageant website, at http://ramonapageant.com. In 1880 Jackson had published *A Century of Dishonor,* also intended to reveal the mistreatment of American Indians. In the 1890s Kinney would develop Venice of America, complete with canals and gondoliers, just south of Santa Monica.

5 Carey McWilliams, *North from Mexico: The Spanish-speaking People of the United States,* 2d ed., updated by Matt S. Meier (1948; New York: Praeger, 1975), 43–53.

6 Nadine Ishitani Hata, *The Historic Preservation Movement in California, 1940–1976* (n.p.: California Department of Parks and Recreation/Office of Historical Preservation, 1992), 1–9. The Pío Pico Historical and Museum Society restored Pico's rancho in Whittier and opened it as a museum in 1909.

7 Brigandi, "The Rancho and the Romance," 5–35. Brigandi notes that Lummis, who had fallen in love with a young woman of the del Valle family and was a regular guest at Rancho Camulos, published a booklet about the rancho in 1888 titled "The Home of Ramona." Rancho Camulos was designated a national historic landmark in 2000 and is being restored. It opened in May 2001 as a museum where visitors can experience the "birthplace of California tourism."

8 Brigandi, "The Rancho and the Romance," 19.

9 Ricardo Romo, *East Los Angeles: History of a Barrio* (Austin: University of Texas Press, 1983), 69–71.

10 Ruby Ling Louie, "Reliving China City," *Gum Saan Journal* 11, no. 2 (December 1988): 2.

11 Ibid.

12 See William Estrada, "Los Angeles' Old Plaza and Olvera Street: Imagined and Contested Space," *Western Folklore* 58, no. 2 (winter 1999): 107–29.

A couple strolls along Olvera Street.

Photo by Susan Middleton, 2001

1999
Renovation of Pico and Garnier Blocks begins.

2000
For Democratic National Convention held in Los Angeles, Pico and Garnier Blocks reopened.

2003
Conserved mural *América Tropical* opens for public viewing, along with interpretive center in nearby Sepúlveda House, which has also been restored. Chinese American Museum opens in restored Garnier Block.

Mexican Artist Completes Gigantic Creatio

A MEXICAN MURALIST IN LOS ANGELES

In the small hours of the morning of October 9, 1932, Arthur Millier, art critic for the *Los Angeles Times,* was strolling around Olvera Street, where he had been covering the making of a mural by the Mexican painter David Alfaro Siqueiros, scheduled to be unveiled later that day. The evening before, the artist had sent home the other painters who were working on the mural, then returned alone to add the final, central figure, which until then had remained a mystery. "At 1 am that night in a dead Olvera Street," Millier recalled, "I found Siqueiros sweating in an undershirt in the cold air, painting for dear life."[1] When the mural was unveiled that afternoon, it set off a controversy over art, ideology, and censorship that would reverberate for more than half a century.

Headline and photograph in the Los Angeles Times *on October 9, 1932, announcing the unveiling of* América Tropical, *by David Alfaro Siqueiros. The team of painters is seen, probably the day before, on scaffolding in front of the mural, whose central figure has not yet been painted.*

Courtesy *Los Angeles Times*

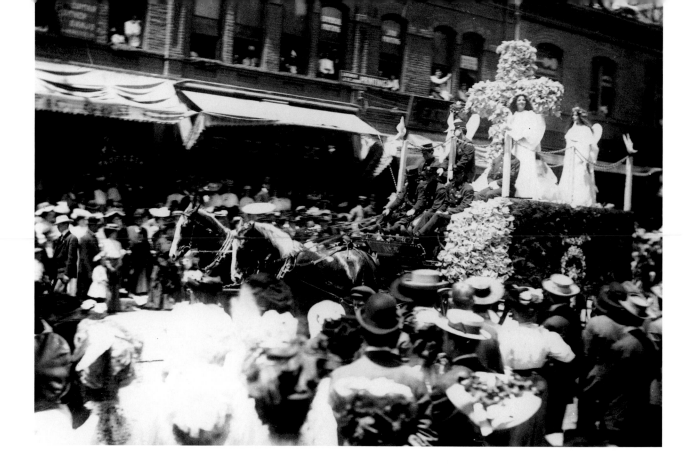

In the summer of 1932 Los Angeles was hosting the Tenth Summer Olympic Games. The city wore its new cosmopolitanism proudly. Its population now numbered more than 1.2 million, and the rise of Hollywood had transformed the cultural landscape, luring such foreign luminaries as Charles Laughton, Marlene Dietrich, and Josef von Sternberg. The nascent movie colony brought an international allure to the booming metropolis. A few blocks west of the pueblo, opulent new movie palaces lined Broadway. Visitors thronged the Mexican marketplace on Olvera Street, which had been declared an official Olympic tourist venue and where F. K. Ferenz had opened the Plaza Art Center in the Italian Hall the year before.

The Great Depression, however, was at its nadir, and to many it seemed as if the world order had been shaken to its foundations. Mass movements of communism and fascism, based on fervently held ideologies of class, race, and the nation-state, were contending for power in much of Europe. The Mexican Revolution (1910–17) had overthrown the dictator Porfirio Díaz and then spread into a bloody civil war; more than one million Mexicans immigrated to the United States in the first three decades of the twentieth century. That summer Franklin D. Roosevelt was running his first campaign for the White House, and unemployment was nearing a staggering 25 percent. Race relations were troubled, and membership in the Ku Klux Klan had grown to some five million. Because of mass unemployment there were also strong reactions to the increased presence of Mexicans in the Southwest, and between 1929 and 1939 more than five hundred thousand people of Mexican descent would be deported.

In Los Angeles hard times were nowhere more evident than downtown. Unemployed men congregated at the Plaza, where social and political expression continued to be

contested. The depression hit the city's Mexican American community particularly hard; migrant agricultural laborers had to work under rigorous conditions and were often subjected to harsh treatment by their employers. Thousands of Mexicans in Los Angeles County were deported, many from the rail yards just north and east of the pueblo, virtually within sight of the romantic Olvera Street marketplace created to honor their heritage. During one raid, in February 1931, police and immigration officers swept through the Plaza area, the historic fount of Mexican culture in Los Angeles. In September of the same year, a ten-day "fiesta" celebrated the city's 150th birthday. Some ten thousand people crowded into the Plaza to witness a parade in which "eleven white couples, with twenty-two white children in tow, represented the forty-four black and brown *pobladores*" who had founded the pueblo a century and a half before.[2]

Over the previous few decades, while the environs of the Plaza along Main Street and in Sonoratown had become a vibrant Mexican cultural space, with cafés, stores, and restaurants, they had also become a popular meeting place for various leftist political movements. Working-class communities of Italians and Irish, as well as Chinese, also inhabited the district. As immigration increased, some new arrivals from countries such as Italy and Mexico brought with them the radical traditions of their native lands. The exiled leaders of the Partido Liberal Mexicano (PLM), for example, including Ricardo Flores Magón, set up headquarters in the area, where they militated for reform of the Díaz government in Mexico. At the behest of antiunion merchants and *Los Angeles Times* publisher Harrison Gray Otis, in 1909 public oratory was banned in the city, except for the Plaza, which was declared a free speech zone. In 1914, as a result of

Facsimile of part of the front page of La Opinión, *the Los Angeles Spanish-language daily newspaper, August 18, 1931, describing the departure of thirteen hundred people who were being repatriated to Mexico. During the depression, more than five hundred thousand people of Mexican background, many of them U.S. citizens, were deported.*
Courtesy UCLA Research Library, Special Collections, and *La Opinión*

In the 1930s the Plaza was often used for left-wing and progressive political rallies. Here members of the Los Angeles Police Department arrest a well-dressed Communist demonstrator.

Courtesy El Pueblo Historical Monument

continuing requests for permission to hold political and public meetings, the city erected a speaker's rostrum there. Prominent American progressives such as Emma Goldman and Upton Sinclair spoke there, further establishing the Plaza's reputation as a place of political expression.[3] Many groups held rallies, including the PLM, which by then was actively engaged in the revolution that had erupted south of the border. Along with the socialists and members of International Workers of the World (IWW), the party recruited soldiers to raid cities in Baja. Flores Magón gave passionate speeches addressing the condition of Mexican Americans in the United States; one such address, in 1914 at the Italian Hall, was attended by more than seven hundred people. Word spread in the press that Flores Magón, supporters of Pancho Villa, and others were issuing strident calls for armed Mexican uprisings in the United States. In 1916 the Los Angeles chief of police, in response to such fears, enlisted special militia and tripled patrols in Sonoratown, and the Plaza's Cinco de Mayo festivities that year were the subject of heavy surveillance. Flores Magón would eventually be arrested and die in an American prison.[4]

After World War I the Plaza remained a center of radical politics. In the 1920s and early 1930s, rallies drawing as many as ten thousand people were staged there by such groups as the IWW, the Socialist Party, and the Communist Party, all of which had sympathizers in the Hollywood film community.

These activities continued to alarm Los Angeles civic leaders. The police department's Red Squad, under Captain William Hynes, was charged with protecting the city from agitators and subversives—a task that, by all accounts, the squad carried out with considerable relish. In June 1932 it prevented the Communist Party's presidential candidate from speaking at the Plaza.

Various groups were kept under surveillance, including the John Reed Club, named after the celebrated American revolutionary, which met at various venues in the city, including Ferenz's Plaza Art Center. In her diary entry of June 25, 1932, Christine Sterling mentions a letter she had received warning her of such a meeting and quoting *Los Angeles Times* publisher Harry Chandler as saying that "this is poison and will eventually wreck El Paseo."

When Siqueiros arrived in Los Angeles with his wife and son as a political exile that April, the last of the three great Mexican muralists to come to the United States, he enjoyed a growing reputation as an artist and a revolutionary. Born in 1896, he had served in the Constitutionalist army during the Mexican Revolution and formed the Congress of Soldier-Artists. In 1919 he was named military attaché to the Mexican Legation in Barcelona, Spain. While in Europe he spent time in France, where he met Diego Rivera and Georges Braque. He then traveled to Italy, where he was exposed to futurism and other currents of the European avant-garde and became acquainted with the works of the great fresco painters of the Italian Renaissance.

On his return to Mexico in the early 1920s, Siqueiros joined with Rivera and José Clemente Orozco in forming the Mexican muralist movement. He also continued his political activities, attending labor congresses in Moscow, organizing miners and peasants, and serving for a time as general secretary of the Mexican Communist Party. With Rivera, he edited a Marxist newspaper, *El Machete.* Imprisoned by Mexican authorities in 1930, he was soon released to internal exile in the mountain silver-mining town of Taxco, about fifty miles southwest of Mexico City. At the time Taxco was home to a vibrant and cosmopolitan émigré community. Siqueiros

David Alfaro Siqueiros, during his stay in Los Angeles in 1932. Photographer unknown.
Courtesy Getty Research Institute, Research Library, Special Collections and Visual Resources, Siqueiros Papers

David Alfaro Siqueiros, Peasant Mother. *Oil on canvas, 1924. This painting was shown at the Stendahl Gallery in May 1932 under the title* The Deported Mexican. *The* Los Angeles Times *art critic Arthur Millier hailed it as "a revolutionary epic" that presents "the tragedy of the ... individual in the grip of mass movements."*

Courtesy Museo de Arte Moderno, INBA Collection. All works by David Alfaro Siquerios are © Estate of David Alfaro Siqueiros/Licensed by VAGA, New York, NY

met the Soviet director Sergei Eisenstein, who was in the country filming *¡Que Viva Mexico!*, his tribute to the Mexican people. Eisenstein's theories of montage, which emphasized the dynamic juxtaposition and collision of visual elements, would influence Siqueiros's painting style.

Siqueiros also became friends with a number of leading American intellectuals, some of whom were making pilgrimages to Mexico in the belief that its culture had retained an organic connection to "the soil" that the industrial United States had lost. Among his acquaintances were the writer Katherine Anne Porter and the poet Hart Crane, who had come to write a play about Cortés and Montezuma and who seemed to find in the portrait paintings of Siqueiros the countenance of the pre-Columbian America he was seeking. With his wife, doctors, and revolutionary comrades, Siqueiros stayed for a month in Crane's house near Mexico City while he recovered from malaria—apparently letting Crane pay all the bills.[5]

Mexican Muralism

The artistic movement known as Mexican muralism arose in the early 1920s, when Mexico's new government began an ambitious cultural program to commemorate the recently ended Mexican Revolution and the nation from which it sprang. Under Porfirio Díaz's twenty-five year dictatorship, Mexico had been a land of considerable inequality, with the landed aristocracy, whose vast haciendas covered more than half of the country, controlling wealth and power while the masses of peasants lived in impoverished, feudalistic conditions.

The government's program included the commissioning of murals on various public buildings. Led by Diego Rivera, José Clemente Orozco, and Siqueiros, who were known as "los tres grandes," the movement professed the goal of developing a "public mural art" dedicated to "the native races humiliated for centuries [and] the peasants and workers scourged by the rich." It opposed the modernist European emphasis on the isolation of the artist and the quest for pure form, seeking rather to connect art with society and thereby both to express and to help shape the collective experience of the Mexican people. The painters disdained the academic realism fashionable among the aristocracy in favor of a monumental, symbolic, and elegiac art that incorporated influences ranging from Italian Renaissance frescoes and modern

In 1926 in the chapel of the Autonomous University of Mexico, Diego Rivera painted a series of fresco panels depicting the "revolutionary transformation of the ownership of the land." In The Exploiters, seen here, a boss and several mining inspectors and armed guards oppress mine workers and peasants. One worker, with his Christlike outstretched arms, suggests the artist's belief that the indigenous peoples were being crucified by those in power.

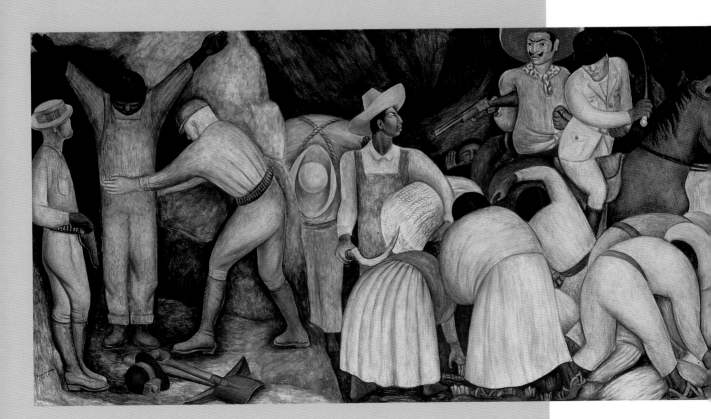

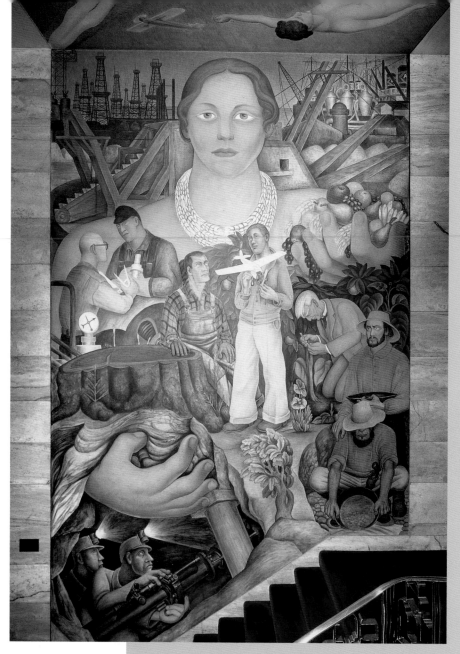

Diego Rivera's Allegory of California, *at the Pacific Stock Exchange in San Francisco, praised the state's entrepreneurial spirit. Its central figure of the tennis champion Helen Wills Moody represents the earth mother, giver of gold, fruit, and grain. Various other figures represent the labors of science and industry. Above soars an airplane and a female nude, perhaps symbolizing the creative human spirit.*

cubism to motifs and myths that had long been present in Mexican and pre-Columbian culture.

Eventually the muralists came into conflict with more conservative elements in Mexico, and the early 1930s found Rivera, Orozco, and Siqueiros in the United States. Orozco painted murals at Claremont College in California, at the New School for Social Research in New York, and at Dartmouth College in New Hampshire, where he taught fresco painting and between 1932 and 1934 painted an epic mural sequence titled *American Civilization.* Rivera painted murals at the San Francisco Stock Exchange and Institute of Fine Art and at the Detroit Institute of the Arts. In December 1931 an exhibit of his work opened to considerable acclaim at the Museum of Modern Art in New York City. The eight-week exhibit was attended by more than fifty-six thousand people, twenty thousand more than attended the musuem's other one-man show that year, a retrospective of the work of Henri Matisse.[6]

In 1933, after Pablo Picasso and Matisse had declined the invitation, Rivera accepted a commission to paint a mural for the new Rockefeller Center in New York. It was to be called *Man at the Crossroads Looking with Hope and High Vision to the Choosing of a New and Better Future,* a title that the work's patron, Nelson Rockefeller, no doubt believed would ensure a suitably uplifting and "spiritual" theme.

Rivera, however, who had recently been criticized by Siqueiros and others for forgoing revolutionary themes in murals commissioned by wealthy Americans, had something different in mind. The plan for the mural included symbolic figures representing the Peasant, the Worker, and the Soldier, but in its execution the design changed considerably. Rivera added depictions of the dissolute rich in a nightclub. And he told no one that the leader of the workers, whose features were left blank in the preliminary sketches approved by Rockefeller, would in fact be a portrait of Vladimir Lenin. He no doubt thought it quite a coup to include this portrait surreptitiously in a work adorning the lobby of one of the centers of world capitalism. His patron was not amused and asked Rivera to remove Lenin's image. The artist refused. Although arrangements had been made to move the mural to the Museum of Modern Art, it was destroyed in February 1934. Rivera later painted a replica at the Palace of Fine Arts in Mexico City.

The Mexican mural movement would continue to generate major works into the 1960s, when Siqueiros completed the epic piece *From Porfirianism to the Revolution*, at the National History Museum in Mexico City. In the decades since, it has continued with new generations of painters.

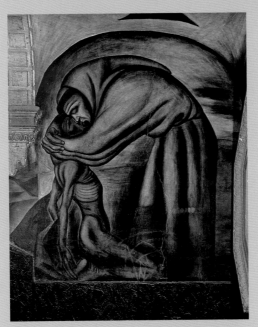

José Clemente Orozco's The Franciscan and the Indian, *at the National Preparatory School in Mexico City, offered a fierce critique of what the artist saw as the Christian European conquest of the Americas. It depicts a monk embracing an Indian, whose naked, emaciated body suggests the destructive nature of the monk's Christian love.*

Schalkwijk/Art Resource, New York; © Licensed by Orozo Valladares family through VAGA, New York, NY

Late in his life Siqueiros painted the fresco cycle From Porfirianism to the Revolution *(1964) at the National History Museum in Mexico City. In this panel, the dictator Porfirio Díaz is shown crushing the constitution underfoot while entertaining his supporters with dancing girls.*

Schalkwijk/Art Resource, New York

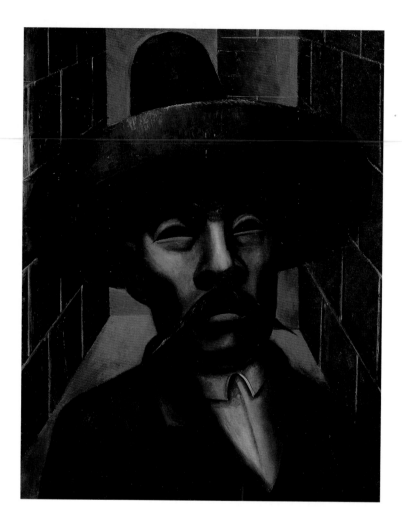

*David Alfaro Siqueiros,
Zapata. Oil on canvas,
1931. This portrait of the
Mexican revolutionary
and folk hero, painted
by Siqueiros during his
stay in Taxco, was one
of the works shown at
the Stendahl Gallery in
the Ambassador Hotel
in May 1932.*

Courtesy Hirshhorn Museum
and Sculpture Garden,
Smithsonian Institution,
Gift of Joseph H. Hirshhorn,
1966. Photograph by Lee
Stasworth

Although hard-pressed for money, Crane commissioned Siqueiros to paint his portrait. Brooding, somber, and sadly prescient, it was completed a few months before Crane embarked on his fateful journey back to New York.

In speech and in thought, Siqueiros had a fiery intensity. He considered art and politics, the two driving forces in his life, inextricably related, seeing himself as a "soldier-artist" in an age of crisis and ideology. In one manifesto, he wrote that artists must create the kind of "beauty that awakens and stirs to struggle."[7] In another, he proclaimed that "at this time of social change from a decrepit world order to a new one, the creators of

beauty must…produce ideological works of art," and emphasized the importance of "a fighting, educative art for all."[8] Siqueiros denounced traditional easel painting, which he considered an aristocratic form, in favor of a monumental, public mural art that spoke directly to the people. Such art, he also believed, should engage its architectural and social environment; murals should speak to—and, if necessary, critique—the dominant ethos of the place where they are located.

It is somewhat surprising, therefore, that Christine Sterling, in her role as manager of Olvera Street, should have approved of Ferenz's plan to commission a Siqueiros mural on the second-story south wall of the Italian Hall. She might have been encouraged by the success of Diego Rivera's recent exhibit at the Museum of Modern Art in New York, which had helped bring Mexican mural painting to the forefront of North American fashion. Nonetheless Sterling would perhaps have been less inclined to work with Siqueiros had she attended any of the artist's exhibitions held in Los Angeles that spring. An exhibit in May, at the Stendahl Gallery in the Ambassador Hotel, of fifty works mainly from the Taxco period was attended by about one thousand people, including Charles Laughton and Josef von Sternberg. The gallery notes included testimonials from Eisenstein and from Hart Crane, who two weeks earlier, en route home from Mexico, had leaped from his ship three hundred miles north of Cuba and perished in the Atlantic Ocean. The "profound commentaries" that emerge from Siqueiros's work, the doomed poet had written, "are real emotions…incrusted in vivid rocks from the Mexico of the past, that cast their shadow away into the future."[9]

The show was a succès de scandale. "The first impression," wrote Arthur Millier in his review, "is of brutality and darkness, of an

absolute absence of all 'charm,' of that pleasant manipulation of pigment which is so significant for the English and Americans." Millier noted the "brooding sense of tragedy" that pervaded the paintings and described Siqueiros as "one of the greatest masters of Mexico." Some critics objected strenuously to the "lack of pleasing color, stark outline, and untextured surfaces." A portrait of a dead child caused particular controversy when the artist got into a shouting match with an American woman who found it offensively "primitive." A number of the show's paintings sold, however, and word spread through the city's art and movie communities.

While in Los Angeles Siqueiros served on the jury of the Olympic arts competition and socialized with the Hollywood elite. He painted a portrait of von Sternberg in the director's Paramount Studios office. Once, the artist recalled, he received a late-night telephone call from the director Dudley Murphy (to whom he had apparently been introduced by John Huston), telling him that a few guests had dropped by and that several were interested in purchasing paintings. Siqueiros was quickly driven to Murphy's home in Pacific Palisades, arriving at about 4:00 A.M. to find various notables, including Charlie Chaplin, assembled there. "Charles Laughton had one of my paintings in each hand," Siqueiros later remembered. "With his typical British accent, he said to me, 'How much...How much?' I did not know what to answer." Encouraged by Murphy's gesticulations, the artist, closing his eyes, requested what seemed to him the impossible sum of $1,000. "Then I heard something that left me cold with pain: a stentorian 'No, no.' As I

Siqueiros often worked from photographs. Seen here is a painting entitled Peasant Girl *and the photograph it was based on. In the photograph, the girl smiles and the infant peers intently at the camera; in the painting, both have expressions of anguish.*

Courtesy the Getty Research Institute, Research Library, Special Collections and Visual Resources, Siqueiros Papers

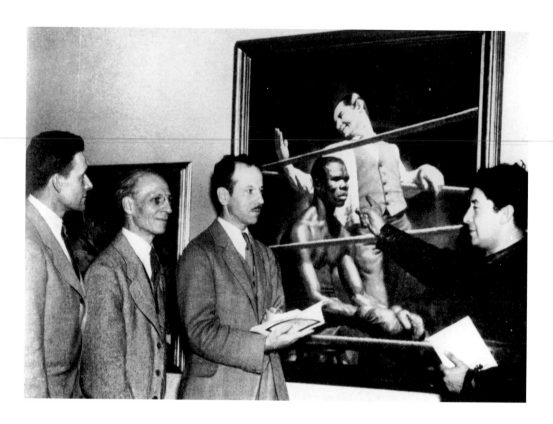

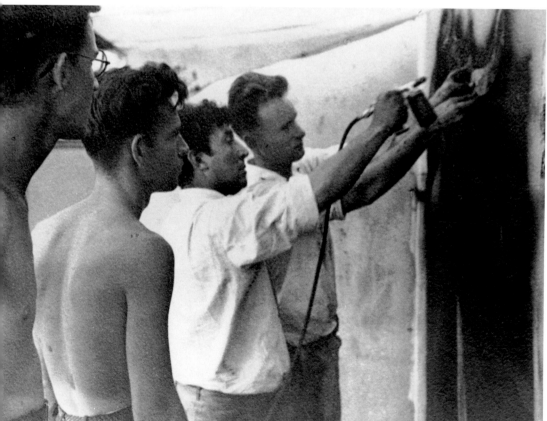

Siqueiros served on the jury of the Olympic arts competition, which celebrated the theme of sport. Here he discusses one of the paintings in the show, The Negro Boxer, *by the American artist James Chapin.*
Courtesy El Pueblo Historical Monument

Siqueiros (holding the spray gun) at work on the mural Street Meeting, *with students at the Chouinard Art Institute, in early summer 1932. The use of such modern materials in the creation of mural art was a key component of the artist's method.*
Courtesy Lee Blair and Robert Perine

prepared to open my eyes, the same voice repeated, 'Two thousand dollars, each.'" Siqueiros collapsed in a chair with relief, as the actor wrote a check, and "everybody broke out in laughter." "From that time on," Siqueiros recalled, "Charles Laughton was my biggest patron."[10]

Beginning with his arrival in April, when he attended a welcome banquet organized by labor leaders, the artist also maintained contacts with the city's Mexican American and Left-leaning communities. At a meeting of the Hollywood John Reed Club, speaking "with passionate eloquence and an atrocious accent," he presented a paper titled "The Vehicles of Dialectic-Subversive Painting," which described his approach to the making of murals. He sought to use the tools of technology in the creation of art during the modern, technological age; cement gun, airbrush, blow torch, and precolored cement mortar would replace brushes and other traditional materials. And rather than use pounces, or stencils, as had fresco painters in the past, he would project images on the wall to be painted, and their outlines would then be traced. In such ways Siqueiros brought technical innovations to mural painting methods that, in the words of one critic, "had been fixed since the Renaissance."[11]

Millard Sheets, a well-known painter and teacher at the Chouinard Art Institute, which had opened eleven years earlier, invited Siqueiros to give a class in fresco painting.[12] Ten artists, several of whom were well known, paid $100 each to join the class. The Bloc of Mural Painters, as Siqueiros called them, executed a 24-by-19-foot mural titled *Street Meeting* in the school's courtyard. At its unveiling on July 7, 1932, an audience of some eight hundred responded with varied reactions, ranging from enthusiasm to fear that the "art of fresco in this country will languish until it is able to free itself from the sorrows of Mexico and the dull red glow of

communism." *Street Meeting* was destroyed. Its makers were divided as to how and why the mural met its fate, with some claiming that it was purposely destroyed because of its overtly leftist political content and others that faulty use of the airbrush caused it to be damaged in the first rain.

Ferenz then offered Siqueiros the commission to paint *América Tropical*, perhaps in the context of another course in mural painting, this one under the auspices of the Plaza Art Center.[13] A number of leading Los Angeles artists participated, including Dean Cornwell, who had just completed a series of murals in the nearby Central Library; Fletcher Martin; Reuben Kadish; Wiard

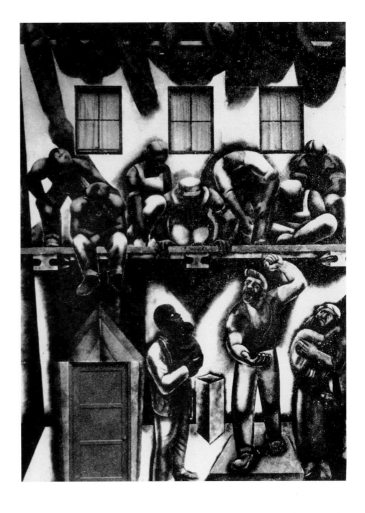

Street Meeting, *painted by Siqueiros and his students at the Chouinard Art Institute. The central figure, secretly added by Siqueiros at the last hour, was of a red-shirted orator, who is haranguing several construction workers; a black man and a white woman, each with a child, also listen intently.*

Photo courtesy Shifra Goldman

David Alfaro Siqueiros,
The Warriors. *Graphite
and ink on paper, ca. 1932.
This is a study for a section
of* América Tropical.

San Francisco Museum of
Modern Art, Albert M. Bender
Collection, gift of Albert M.
Bender. © Estate of David Alfaro
Siqueiros/SOMAAP, Mexico/
VAGA, New York, NY

Bhoppo Ihnen; and Sanford Pollock McCoy, the older brother of Jackson Pollock. Pollock himself visited Los Angeles that summer and met Siqueiros briefly; a few years later they would become close friends and colleagues. Pollock may have seen the mural, which appears to have been the first such full-scale painting on an exterior wall in downtown Los Angeles. Another participant was the Mexican artist Luis Arenal, who would become Siqueiros's longtime collaborator.

Siqueiros suspected that the theme had been suggested in the belief that it would be innocuous. "It has been asked that I paint something related to tropical America, possibly thinking that this new theme would give no margin to create a work of revolutionary character," he said. "On the contrary, it seems to [me] that there couldn't be a better theme to use. I am pleased and hope to demonstrate this."[14]

Work started in late August or early September, after the close of the Olympic Games. Various companies donated materials. The wall's architectural features—two windows with metal coverings and a double wooden door—were included in the composition. According to Shifra Goldman, "Siqueiros did most of the painting himself, assigning to his assistants the tasks of roughing the brick surface with drills, applying coats of white Portland cement, squaring the wall, blowing up the design for the final cartoon, and painting small sections."[15] Some critics contend that other painters made contributions to the work. There is no doubt, however, that while Siqueiros and his team of assistants labored through late summer and into early fall, the work's central image remained unpainted, and—at least until he was visited by Arthur Millier early on the morning of the opening—the artist's ultimate intent remained unclear.

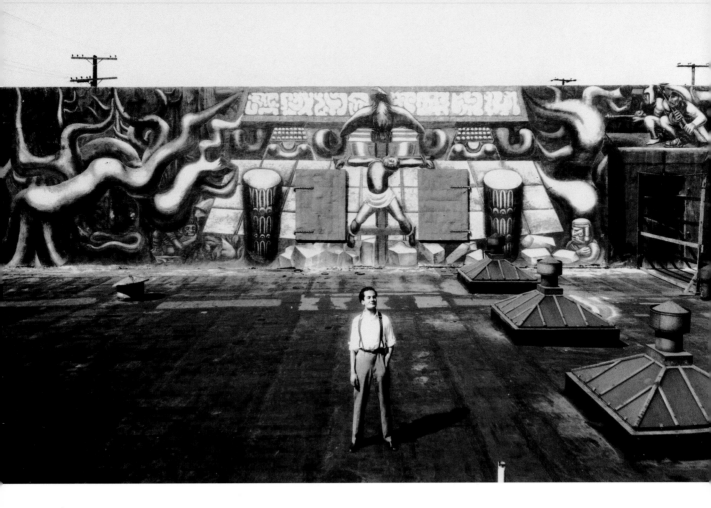

The 18-by-80-foot mural was unveiled on October 9, 1932, before a crowd packed onto the roof of the Hammel building. When the scaffolding came down, "onlookers gasped," Millier reported in the *Times*. "No one but the author had been able to visualize the close-knit powerful design so long shaded and concealed by those scaffolds."[16] In front of a Maya-like pyramid was the central figure that Siqueiros had added during the night: an Indian peon crucified on a double cross, with what the artist called an "American imperialist eagle" stretching out its talons above him. Two revolutionary soldiers, one aiming his rifle at the eagle, were depicted in the mural's upper right-hand corner. Blocks of stone and pre-Columbian sculptures scattered among the primeval growth of a great twisting tree evoked the devastation of ancient Indian civilization. Deep greens, ochres, and reds dominated.[17] For the artist, the crucified indigene had

various symbolic meanings, including a denunciation of the role of U.S. colonial interests in Latin America and "the destruction of past American national cultures" throughout the hemisphere "by the invaders of both yesterday and today."[18]

Many greeted the work enthusiastically. "Powerful is a tame word for the forms that [Siqueiros] created to vie with billboards and buildings," Millier wrote in the *Los Angeles Times*. "In the midst of our popular conception of Mexico as a land of eternal dancing, gayety, and light-headedness, this stern, tragic work unrolls its painted surface."[19] For a number of the city's artists, including those who had assisted Siqueiros, the work was tremendously exciting. Lorser Feitelson praised its "tenebrism, illusion and also this architectonic quality" and noted, "It has guts in it! It made everything else of the time look like candy box illustrations."[20] The *Los Angeles Times* story on the opening

Roberto Berdecio, a close associate of Siqueiros during the 1930s, stands in front of América Tropical, *on the roof of the Hammel building, shortly after the mural was completed. Berdecio's collection of documents concerning Siqueiros is a valuable source of information about the artist.*

Courtesy Getty Research Institute, Research Library, Special Collections and Visual Resources, Siqueiros Papers

Scene from Dean
Cornwell's mural cycle in
the Los Angeles Central
Library, completed in 1932,
reflecting an "official" view
of history in which priests
and conquistadores bring
the benefits of European
civilization to the peoples
of the Americas.

Photo by Foaad Farah.
© Foaad Farah

The Los Angeles Central Library Murals

América Tropical was not the only
major mural unveiled in Los Angeles in
summer 1932. Beginning in 1927, the
well-known artist Dean Cornwell had
been at work on a mural cycle in the
main rotunda of the Central Library,
which had recently opened downtown,
ten blocks from the pueblo. In this
mural, which reflected a view of history
very different from that expressed in
América Tropical, scenes depict in
pastel hues the pageantry of California

history. Spanish settlers and conquista-
dores, Catholic priests, and American
pioneers are shown bringing the bene-
fits of European civilization—including
the mission system—to the state's
indigenous peoples.[21] The Cornwell
murals would face their own perils, as
they were damaged in the fire that
threatened to destroy the library in
1986. Carefully restored over a period
of six years, they again went on public
view in 1994.

ceremony recorded that "Dean Cornwell, noted mural artist, who was sponsor for the Olvera Street fresco, in his address at the dedication, said the completion of the art work undoubtedly will awaken a new appreciation for the decoration of blank walls."[22] One leftist observer, Grace Clements of the John Reed Club, praised the mural highly. However, she also thought that "if the original plan had been adhered to and the wounded body of the peon was placed in the claws of the eagle, the work would have gained in revolutionary meaning and understanding."[23]

For others, however, the mural's revolutionary meaning was too clear. While acknowledging that this was "an interesting experiment," one reviewer asked, "Why get hysterical about Mexican art? ... Why imitate it and adopt it in our own country, whose traditions are entirely alien to it all?" The reviewer pleaded to "keep the Mexican motif in the Mexican quarter." The provocative image of the crucified Indian displeased civic leaders, especially those who had established Olvera Street two years earlier. Such subject matter certainly did not fit in with Christine Sterling's concept of a Mexican marketplace, which was supposed to reflect the romantic days of the dons and doñas, when life revolved around fandangos and fiestas and suffering did not exist. Sterling found the mural "anti-American." Concerned that it would damage commerce in the marketplace below, she allegedly soon told Ferenz to paint over the segment that was visible from Olvera Street. By 1938 the remainder of the work had been whitewashed.

While some Olvera Street merchants shared Sterling's dislike of the mural, others admired it. Mercedes Sousa, for example, knew Siqueiros fairly well, as her cousin was a good friend of his, and together they had

attended classes given by Diego Rivera in Mexico City. Sousa said that it was "a bad thing Mrs. Sterling did in ordering the mural whitewashed" because "Siqueiros was a very fine artist."[24]

The controversy surrounding *América Tropical* did little for Siqueiros's political standing in the United States. A renewal of his six-month visa was refused, and he was forced to leave the country by year's end. With the aid of George Gershwin, another of his patrons, he would return a few years later. His workshops in New York would significantly influence the technique of such American painters as Jackson Pollock. Siqueiros would later fight for the Republicans in the Spanish Civil War and, in 1940 in Mexico City, participate in an unsuccessful attempt to assassinate Leon Trotsky.

Before departing Los Angeles, however, he painted his third mural in the city, *Portrait of Mexico Today,* in the Pacific Palisades home of Dudley Murphy, to thank the director for his many kindnesses. The fresco depicts the

By 1933 one-third of the mural—the part visible from Olvera Street—had been whitewashed, allegedly on the orders of Christine Sterling.

Courtesy *Los Angeles Times*

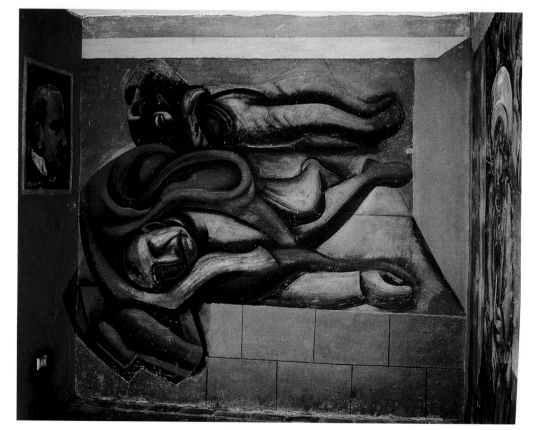

Portrait of Mexico Today
*was painted on this patio
in the backyard of the
movie director Dudley
Murphy in Pacific
Palisades. Initially titled*
Delivery of the Mexican
Bourgeoisie Born of the
Revolution into the
Hands of Imperialism,
*the mural depicts former
Mexican president
Plutarco Calles, whom
Siqueiros believed had
betrayed the revolution,
guarding two sacks of gold.
The mural's central scene
shows two women and a
child, perhaps family of
the murdered Mexicans
painted on a contiguous
wall (right). A portrait of
the financier J. P. Morgan
can also be seen.*

former Mexican president, Plutarco Elias Calles, whose order to have Siqueiros killed was, according to the artist, an important reason he had come to Los Angeles.[25] On the wall facing Calles is a portrait of the financier J. P. Morgan, suggesting what Siqueiros saw as a link between American capitalism and political oppression and corruption in Mexico. The mural, which retains much of its original vibrancy, was recently aquired by the Santa Barbara Museum of Art. Along with the patio structure that supports it, the mural was carefully moved, under the guidance of a team of conservators working with construction and transportation firms, and installed on the museum grounds. It went on view in early 2002.

The departure of Siqueiros did not end his influence on the L.A. art scene. His former students in the Bloc of Mural Painters continued to work with political themes, fashioning a mural in the offices of the Hollywood John Reed Club in which "the ordered ranks of the international proletariat" marched across the wall.[26] Early in 1933 the LAPD Red Squad raided the club offices, and a number of paintings and frescoes were damaged. The club brought suit against the city, claiming that these were valuable works fashioned by Siqueiros's students and alleging that officers had removed a number of paintings and shot or poked them full of holes. In court testimony, Captain Hynes responded that the raid had been conducted to halt performances of a Communist play and that all paintings were in perfect shape when the police left. He further explained that the hall had been cleared because those present were engaged in "dancing without a permit."[27]

F. K. Ferenz moved out of the Italian Hall in 1932. Little more is known about his life, apart from the fact that in 1941 he was

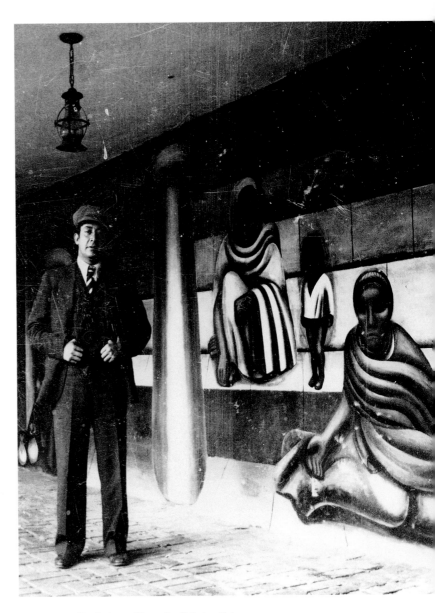

Siqueiros standing in front of Portrait of Mexico Today, *ca. November 1932.*

Courtesy Getty Research Institute, Research Library, Special Collections and Visual Resources, Siqueiros Papers

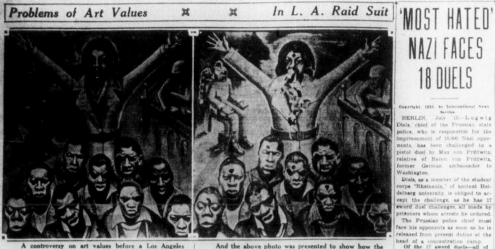

Problems of Art Values ✖ ✖ **In L. A. Raid Suit**

A controversy on art values before a Los Angeles court today in a suit for $5200 brought against the city on behalf of the John Reed Club and the "Bloc of Painters," artists' organization, on charges that murals were damaged or destroyed during a police raid on the club. The above photo was introduced to show how one of the paintings appeared before the raid.

And the above photo was presented to show how the same painting assertedly appeared after the raid, the central figure defaced and the others with "spots" on their foreheads where raiders were declared to have poked clubs through the painting. Police were said to have conducted the raid to halt the performance of an asserted Communist playlet.

'MOST HATED' NAZI FACES 18 DUELS

Copyright, 1933, by International News Service

BERLIN, July 15.—Ludwig Diels, chief of the Prussian state police, who is responsible for the imprisonment of 18,000 Nazi opponents, has been challenged to a pistol duel by Max von Prittwitz, relative of Baron von Prittwitz, former German ambassador to Washington.

Diels, as a member of the student corps "Rhenania," of ancient Heidelberg university, is obliged to accept the challenge, as he has 17 sword duel challenges, all made by prisoners whose arrests he ordered.

The Prussian police chief must face his opponents as soon as he is released from present duties at the head of a concentration camp. Of the 17 sword duels—all of which will be held only, of course, if Diels survives them as they come—six will be with the saber and 11 with the rapier.

All will be conducted under the rigid dueling code of the German Students corps.

Diels, 33 years old, is slim and of the athletic type, a badly scarred face testifying to the experience he has had in sword play. He is delighted at the prospect of facing 18 men within a period of a month.

Diels is feared and hated by Nazi foes even more than Chancellor Adolf Hitler himself, or his stern aide, Hermann Wilhelm Goering, Prussian minister of state. Yet he alone of the Hitler leaders dares to walk the streets alone, unarmed and unguarded.

In an exclusive interview with International News Service, Diels chatted lightly and gaily, revealing he looked with joyful anticipation toward the forthcoming encounters.

"Von Prittwitz objected to the manner in which I arrested him," Diels told his correspondent.

"This morning Baron Flotow called on me, acting as Von Prittwitz' second. I accepted the challenge, but I think it is amusing for a police chief to accept the challenge of a man whom he is forced to arrest.

"After all, when I arrested him I was not engaged in a social call." Here the police head smiled again. "I love to fight," he continued. "There is no grander feeling in the world than thrashing your man in a fair fight. My student corps keeps sending me messages asking when I am going to keep my dueling engagements, which, of course, have been arranged through the corps, according to custom.

"The fortunes of war so far have prevented me from meeting my opponents, but I hope to be released from these camp obligations soon."

Reminded that the pistol duel in particular, might be fatal to him, Diels replied:

"That will be fate. I am not afraid."

CLUB RAID TOLD BY MAN BEHIND CURTAIN

How Harry Buchanan hid behind a curtain in the John Reed Club and witnessed the details of a raid by the police red squad on the club at which valuable art objects were damaged or destroyed, was set forth in the testimony of Buchanan on record today in Judge J. A. Smith's court at the trial of a suit for $5200 damages brought against the city as the result of the raid.

Buchanan testified the police ordered everybody in the rooms to leave, but he hid in an office behind a curtain. He stayed there for fear of being beaten, he said.

The raiders took valuable plaques and frescoes and threw them in a pile on the floor, according to the testimony. Others of the raiders poked holes in the frescoes with clubs and sticks, tore out the wiring back of the stage and destroyed curtains and costumes. Buchanan said in reply to questions asked by Attorney J. Allan Frankel, representing the plaintiffs.

On cross-examination by E. S. Shattuck, deputy city attorney, an effort was made to show that most of the damage was done by men wearing American Legion caps and not by the police officers.

Photographs were introduced in evidence showing the frescoes and murals before the raid and also showing the condition of the clubrooms after the raid.

Above is one of the art works as it looked before the raid in which it was damaged, according to the complaint. The murals expressed the theme of the negroes' lot under economic conditions in the south, attorneys said. The defense sought to prove that most of the damage was done by others than police officers.

CAPTAIN TELLS DOOMED SHIP FIRE STORY

By United Press

NEW YORK, July 15.—Capt. F. L. Sears, master of the tanker Cities Service Petrol, shouted to rescuers from the bow of his blazing ship off the North Carolina coast, that he would go down with the ship. A few minutes later the Petrol plunged stern first to the ocean bottom. Two members of the crew accompanied Captain Sears to a seaman's death. Thirty-four others were rescued by the tanker Gulfgem.

By CAPTAIN NILSSON
Master of the S. S. Gulfgem
(Copyright, 1933, by the United Press)

ABOARD S. S. GULFGEM (At Sea), July 15.—My tanker, the Gulfgem, with 34 rescued seamen aboard, blew her whistle in requiem over the ocean grave of three gallant seamen 150 miles off the North Carolina coast early today and proceeded toward Charleston, S. C.

A few minutes before the tanker Cities Service Petrol, a blazing inferno for hours, plunged stern first to the bottom of the Atlantic.

asked to testify before the House Un-American Activities Committee—not as a Communist but as an admitted Nazi.

In *América Tropical,* Siqueiros slyly subverted what he no doubt saw as the folkloric romanticism of Olvera Street. Ironically, however, had Christine Sterling not revitalized the historic district, it is doubtful that there would have been an art center at the Italian Hall and, therefore, a commission for Siqueiros to create his monumental mural. In the years since, *América Tropical* has been widely acknowledged as a groundbreaking work, resonant of dark episodes of racial violence in the pueblo's past and interwoven with the cultural fabric of Los Angeles in the interwar years. So too is the mural of seminal importance in the rich history of the city's public art. Decades later, stimulated by renewed interest in the mural, the aging artist made plans to paint a replica of its central section on eleven wooden panels, which he wanted to present as a gift to the city. His death in January 1974 prevented this plan from being realized, and *América Tropical* would remain all but invisible for the rest of the twentieth century.

NOTES

1 Cited in Shifra Goldman, "Siqueiros and Three Early Murals in Los Angeles," *Art Journal* (Summer 1974): 324.

2 John D. Weaver, *El Pueblo Grande: A Nonfiction Book about Los Angeles* (Los Angeles: The Ward Ritchie Press, 1973), 79.

3 For a thorough discussion of the political and cultural climate in the Plaza area, see Estrada, "Los Angeles' Old Plaza and Olvera Street." On the role of the plaza in Latin American culture generally, see Setha M. Low, *On the Plaza: The Politics of Public Space and Culture* (Austin: University of Texas Press, 2000).

4 Romo, *East Los Angeles*, 89–111; also Estrada, "Los Angeles' Old Plaza and Olvera Street," 110–12.

5 John Unterecker, *Voyager: A Life of Hart Crane* (New York: Farrar, Straus and Giroux, 1969), 701.

6 Laurance P. Hurlburt, *The Mexican Muralists in the United States* (Albuquerque: University of New Mexico Press, 1989), 123–36.

7 "Manifesto of the Syndicate of Technical Workers, Painters, and Sculptors," quoted in Shifra Goldman, "Siqueiros and Three Early Murals," in Goldman, *Dimensions of the Americas: Art and Social Change in Latin America and the United States* (Chicago: University of Chicago Press, 1994), 88. This is a revised version of the 1974 *Art Journal* article cited above.

8 From "A Declaration of Social, Political, and Aesthetic Principles," 1922.

9 Shortly before he sailed, Crane had destroyed the Siqueiros portrait in a fit of drunken despair, slashing with a straight razor "across the image of his downcast eyes until the painting was reduced to ribbons of pigment and burlap" (Unterecker, *Voyager*, 745). A photograph of the painting, however, would adorn the frontispiece of Crane's *Collected Poems*.

10 Recounted in the artist's memoirs, David Alfaro Siqueiros, *Me llamaban el Coronelazo* (Mexico City: Ed. Grijalbo, 1977), 295.

11 Goldman, "Siqueiros and Three Early Murals" (1994).

12 In 1961 the Chouinard Art Institute would merge with the Los Angeles Conservatory of Music to form the California Institute of the Arts.

13 Cf. an unpublished typewritten manuscript by Siqueiros, "The Technical Revolution of Painting," Siqueiros Papers, Getty Research Institute, Research Library, Special Collections and Visual Resources (hereafter GRI Siqueiros Papers).

14 Quoted in Hurlbert, *Mexican Muralists*, 210.

15 Goldman, "Siqueiros and Three Early Murals" (1994), 32.

16 *Los Angeles Times*, October 16, 1932.

17 See the description of the mural by Grace Clements, a member of the Hollywood John Reed Club, in the unpublished manuscript "Fresco as a Subversive Art" (GRI Siqueiros Papers).

18 "América Tropical," a one-page manuscript summarizing the mural's symbolism (GRI Siqueiros Papers).

19 *Los Angeles Times*, October 16, 1932.

20 Interview with Shifra Goldman.

21 An illuminating comparison of the two murals is presented by Christopher Knight, "Walls That Speak Volumes about Two Californias," *Los Angeles Times*, March 13, 1994.

22 *Los Angeles Times*, October 10, 1932.

23 Clements, "Fresco as Subversive Art." Her reference to an "original plan" suggests that Siqueiros may have shared his intentions with some members of the Hollywood John Reed Club.

24 Interview with JBP.

25 Hurlbert, *Mexican Muralists*, 283.

26 Clements, "Fresco as Subversive Art"; Hurlbert, *Mexican Muralists*, 284.

27 *Los Angeles Evening Herald and Express*, July 18, 1933.

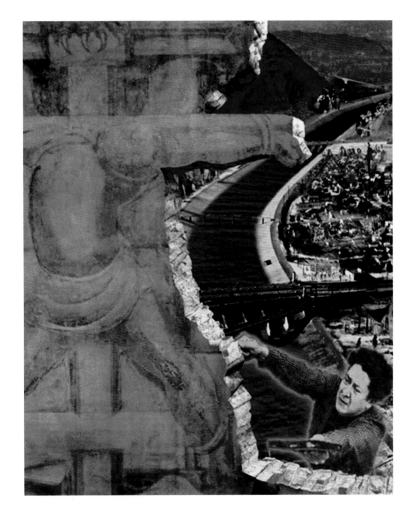

Siqueiros had a significant influence on later generations of muralists. Seen here is the portable mural Los Angeles Tropical, *by Judith F. Baca and members of her class at the UCLA César Chávez/SPARC Digital Mural Lab. The ghost of Siqueiros is depicted shoring up the ruins of* América Tropical.

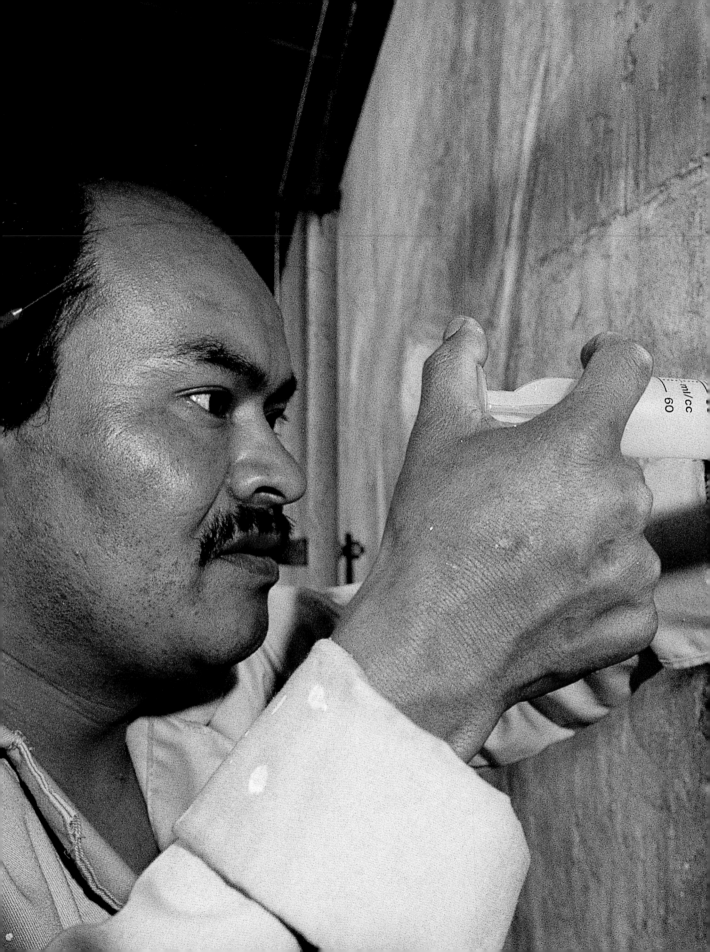

PRESERVING THE HERITAGE OF EL PUEBLO

When new management assumed direction of El Pueblo in 1977, modern methods of historic preservation had only recently begun to make inroads in Los Angeles. The following year saw the founding of the Los Angeles Conservancy, which has done so much to preserve noted landmarks in the city and to advance professional preservation practice. The decades since have witnessed considerable progress in the continuing endeavor to preserve the heritage of the city's birthplace. These years have also seen a vigorous debate emerge over what the pueblo means for the present and for the future.

A conservator injects grouting into the void space between the mural América Tropical *and the wall to which it is attached in order to help stabilize the mural.*
Photo by N. Kaye, 1990. © N. Kaye

In view of its multilayered and multiethnic history, it is not surprising that today El Pueblo represents different things to different people. Indeed, few other places in Los Angeles are imbued with a comparable complex of meanings, the richness and range of which make the pueblo one of the city's most important cultural symbols. Beginning with its founding by settlers of European, Indian, and African descent, it can be seen as a microcosm of the multiethnic history and heritage of Los Angeles. Much of this heritage is represented by the built environment—houses, commercial buildings, plazas, streetscapes. Other aspects of this legacy exist as ideas and as memories, the more passionately held, perhaps, as newer buildings replace older ones, for being separated from the material fabric that once embodied them. The pueblo today has considerable significance for the Mexican American community, for whom the Plaza and environs have retained their historic role as a vital center of social life and are a powerful symbol of cultural identity. The marketplace on Olvera Street, which began as an expression of a "fantasy heritage" and was created by a woman who had never been to Mexico, has in the decades since undergone a second transformation, integrated with the larger historical meanings of the Plaza area. It is one of the city's leading tourist destinations, and it now forms an important part of the pueblo's heritage and significance. El Pueblo also represents the origins of the city's Chinese American community in Old Chinatown, which was destroyed more than half a century ago. So too does this historic district testify to the arrival of North Americans and Europeans and the rise

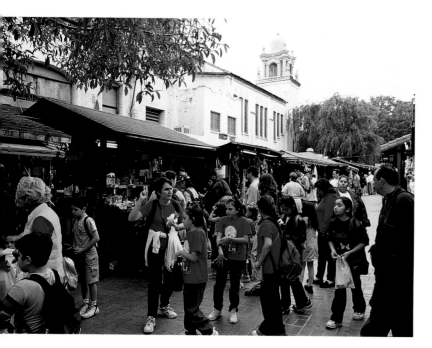

Schoolchildren visit the pueblo on field trips to learn about the history of Los Angeles. Over the years Olvera Street, which began as a fantasy romantic marketplace, has become a symbol of Mexican American identity.
Photo by Susan Middleton, 2001

The pueblo's diversity is reflected in the remarkable archaeological finds there; more than forty excavations have unearthed thousands of items, which range from prehistoric Native American materials to artifacts from the Spanish, Mexican, and American periods. On display here are pieces discovered in diggings at the Pico House and in the precincts of Old Chinatown, along with other items.
Photo by Susan Middleton, 2001

of the modern American metropolis. Finally, as the birthplace of Los Angeles, the pueblo, in an important way, symbolizes the city as a whole.

When seeking to preserve any cultural heritage site, whether it be an urban historic district or ancient archaeological ruins, conservators must often begin with assessing the various meanings each site is seen to possess. Many factors must be taken into account: the site's historical value, the aesthetic and architectural values of its buildings and art, its importance to society as a place of living culture, its symbolic meanings to various segments of the community, its economic value as a place that generates revenue through tourism and commercial ventures, and so on. Through careful consideration of such values, those involved in conserving and managing a cultural heritage site seek to preserve its overall significance.

The practices of historic preservation have evolved considerably since the days when Christine Sterling gave a lunch for the city's power brokers in an attempt to convince them to undertake a major renovation. So too have the ideas informing preservation evolved since the days when a single romantic vision of the past—the "mission myth"—could so dominate the official imagination. Today that sole narrative has been supplanted by a wide range of perspectives. This has resulted in a much richer—albeit at times more contentious—conversation about the past and how it should be preserved and interpreted. As the document creating El Pueblo Historic Monument makes clear, the pueblo's multiethnic heritage must be recognized in decisions relating to its conservation and use.

At El Pueblo, as elsewhere, historic preservation is a collaborative process involving the efforts of various groups. City, county, and state governments all play a role, as do arts and historic preservation organizations,

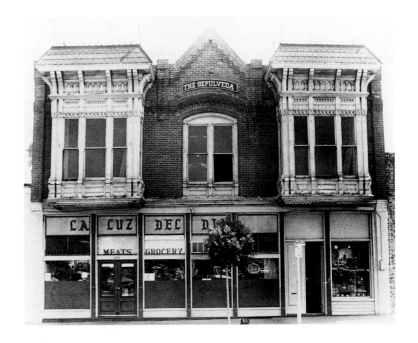

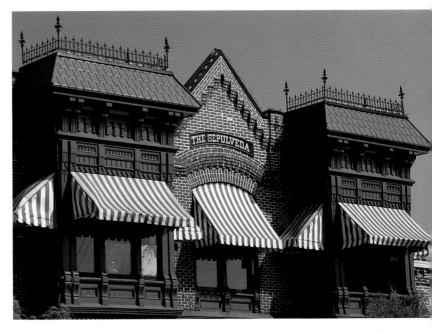

The facade of the Sepúlveda House, before and after restoration.

Courtesy El Pueblo Historical Monument (top); photo by Susan Middleton, 2001 (above)

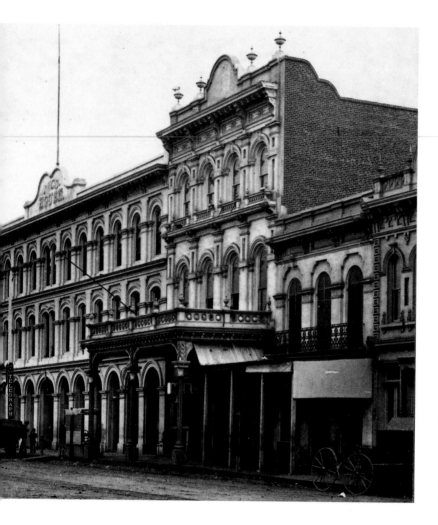

*The Pico House,
Los Angeles. Carleton
Watkins, stereograph,
1900. The Merced Theatre,
center, and Masonic Hall
are also shown.*
Courtesy California State Library

The California State Park system by then had established a historical landmarks committee, and in 1953 legislation was passed turning the pueblo area into a state historic park. Steps were taken to acquire by eminent domain all the buildings in the immediate area, and by 1958 the last building had become part of the park, which was run by the city under agreement with the state and county. The total cost of the purchase was $1.5 million, of which the State of California paid half and the city and county each paid one-fourth. While creation of the El Pueblo State Historic Park was an important first step, it did not ensure the immediate institution of modern practices of historic preservation. In the following years some progress was made, beginning with the old Plaza Firehouse, which after a period of considerable decline reopened in 1960 housing a museum depicting the early history of fire fighting. Yet for several decades much restoration work at El Pueblo was undertaken with plans that had very little to do with the conservation of historical resources. During the 1960s and 1970s the Pico House, the Merced Theatre, and the Garnier building would lose almost all of their original interior decor though ill-considered and expensive "restoration." To a significant extent, modern preservation practices are new at El Pueblo.

An important part of preserving the pueblo's heritage is preserving its historic buildings. Whereas in the past "restoration" often meant updating or changing a building's appearance, the conservation of historic districts is now generally characterized by an emphasis on both historical authenticity and social significance. Restoration projects at El Pueblo today emphasize the need to maintain the historical integrity of the buildings and streetscapes while taking into account the various social and cultural meanings that

historical societies, the commercial occupants of the historic buildings, and civic groups of various backgrounds and ethnicities. Working out differences of opinion and finding consensus on a common approach that will preserve all values can require time and patience. It is, however, a central—and ultimately rewarding—part of cultural heritage conservation today.

At the time Olvera Street was transformed into a Mexican marketplace, the historical preservation movement in the United States had barely begun. The years following World War II brought new life to the movement in California, owing in part to the gold rush centennial celebrations of the late 1940s.[1]

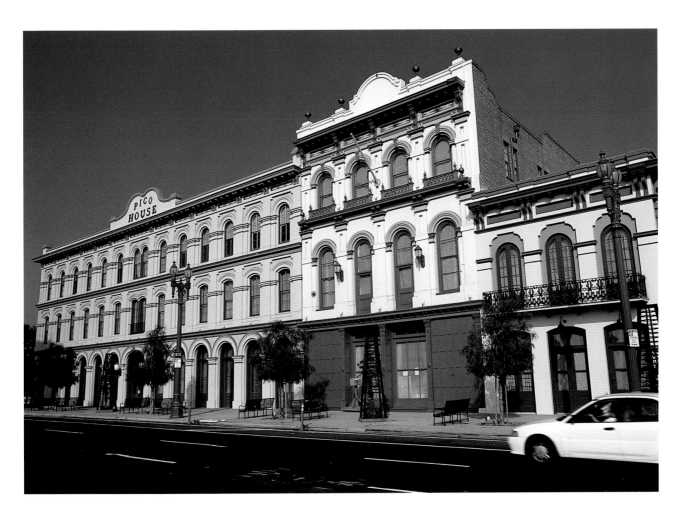

the site possesses for those whose history is mirrored there. The challenge facing those involved in preserving the site—including conservators, architects, government officials, entrepreneurs, civic groups, and others—is to find new uses for old buildings that are consistent with the buildings' histories and that will preserve and enhance the various values associated with them.

A building's significance is often complex, of course, and those involved with preserving the site may need to determine which of its meanings is most important. For one structure this might be its architecture, for another, its historical significance, and so on. Conservators also take into account the site

as a whole, as well as its relationship to the larger cultural environments in which it exists. In the early 1990s, when plans were formulated for the commercial development of the Pico and Garnier buildings, some of the new uses that were proposed generated controversy. One of these was the suggestion to put a French restaurant on the ground floor of the Pico House. This would certainly be consistent with the history of the building, which housed the city's most elegant French restaurant when it opened in 1870. However, it was felt by some that such a restaurant today might violate the integrity of the Plaza as a symbol of the pueblo's

The preservation and restoration of historic buildings seeks to retain the integrity of the pueblo's historic streetscapes. Seen here are the restored facades of the Pico House, Merced Theatre, and Masonic Hall.

Photo by Susan Middleton, 2001

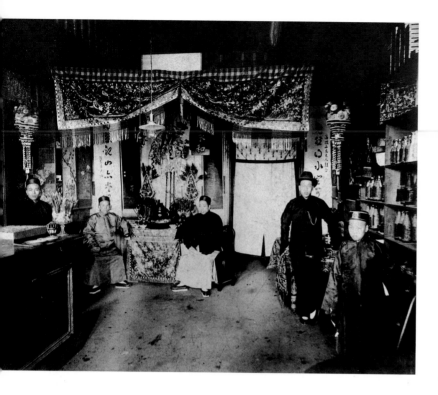

The Sun Wing Wo store, seen here in 1902, was housed in the Garnier building for some forty years.

Courtesy El Pueblo Historical Monument

Mexican heritage. A similar disagreement arose when plans were narrowly defeated in 1976 to create a Mexican *mercado* in the Plaza Substation; this would have been in keeping with the Mexican theme, but it would have significantly altered much of the interior and borne little relation to the building's original purpose.

It is often the case in historic preservation that much work involves undoing earlier harmful attempts at restoration. At El Pueblo, a general plan adopted in 1980 provides clear guidelines for preservation, restoration, and development of the park. It stipulates that the integrity of original buildings must, as far as possible, be preserved, not changed to reflect the tastes and ideas of a later time. The plan requires that a historic structures report be prepared for each building. This report recommends new uses that retain the building's structural integrity, are economically viable, and are consistent with

the building's history. All work must meet the secretary of the interior's standards for historic preservation. According to this concept, known as adaptive reuse, a building can be adapted for new purposes, as long as the original fabric is as far as possible preserved. In recent years preservation work at El Pueblo has focused on redressing the mistakes of the past and on pursuing new courses of action that rigorously respect current preservation standards.

Because of the major threat posed to all the city's historic buildings by earthquakes, it was important to retrofit the pueblo's buildings, many of which had been badly damaged in the 1971 Sylmar quake. The Avila adobe needed to be almost completely restored, while the Sepúlveda House, which lost much of its facade, also required considerable new work. Seismic stabilization has since been carried out on most of the buildings. Since the late 1980s, preservation work at El Pueblo has slowly gained momentum, and a number of projects are in progress to conserve the historic quarter's heritage.

A face-lift has brightened the Pico House's landmark facade, now repainted in gray and maroon to resemble its original colors. The interior, virtually gutted by earlier construction work, is being refurbished with historically accurate color schemes. The hotel's grand staircase has been stabilized, missing wainscoting and balustrades have been replaced, and an 1870s-style chandelier and new period carpeting and wallpaper are being added. In carrying out this work, restorers studied old photographs and even examined an antique chair from the hotel that still retained its original upholstery. Kept in the family of Clemente Antonioli, who managed the establishment around the turn of the century, it will help to re-create the original design and color scheme of the grande dame's glory days. No final decision

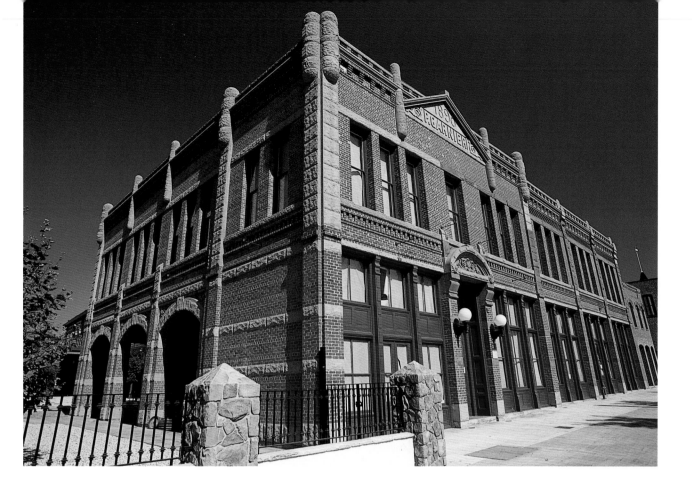

The renovated Garnier Block will house the Chinese American Museum. Exhibits will include a replica of the Sun Wing Wo store.

Photo by Susan Middleton, 2001

has yet been made about the final use of the Pico House. Future projects might include state-of-the-art exhibits there documenting its days as the city's first grand hotel.

The Chinese American Museum began in the early 1980s as a discussion between El Pueblo Historical Monument and the Chinese Historical Society of Southern California. In its early phases the project met some challenges, largely because the historic role of Chinese at El Pueblo was not well known. However, the museum project found broad support with the formation in 1988 of the Friends of the Chinese American Museum and with careful plans to restore the Garnier Block, in which the museum would be located. Funding was also provided by the State of California, the City of Los Angeles, El Pueblo Monument Association, and the Chinese Historical Society, among others. The museum reflects the Chinese American experience in Los Angeles. Permanent exhibits will include an herbalist's store; a re-creation of the Sun Wing Wo store, which was housed in the building for forty years; and a wide range of artifacts, some donated by Chinese American families and businesses, others discovered in archaeological excavations in the former precincts of Old Chinatown.

Another important element of the pueblo's heritage is David Alfaro Siqueiros's *América Tropical,* which carries a wide range of artistic, historical, and cultural meanings. Its conservation needed to take into account the full range of values associated with the mural. It, too, involved collaboration between several organizations, including El Pueblo Historical Monument, the Getty Conservation Institute, and private design firms and other consultants.

After the mural was allowed to languish for decades in the southern California sun, initial efforts to preserve the fading masterpiece began in the 1970s. But it was not until the 1980s that substantial steps were taken

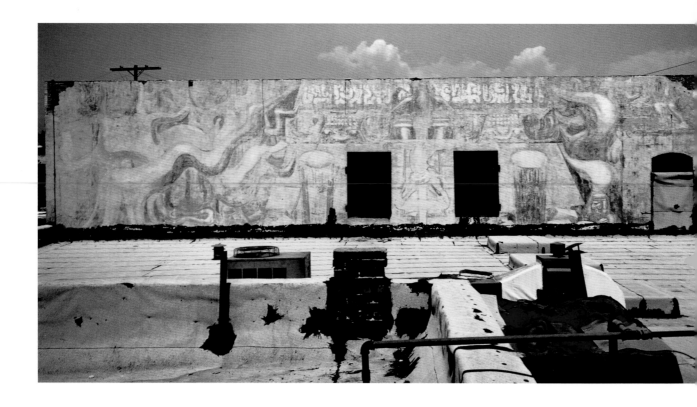

América Tropical as it appeared in 1978. Exposure to sun, wind, rain, and air pollution has gradually eroded the white overpaint, which was meant to hide the mural but also wound up protecting it. Colors on the right third, which was probably covered with two coats of whitewash, appear slightly brighter than those on the rest of the painting. The mural has faded and peeled, and the 1971 earthquake caused the upper right corner to collapse. Along the bottom, tar has stuck to the mural surface. Photo by Lloyd Ziff, 1978

to save the only surviving public mural by Siqueiros in the United States.

The deterioration of the mural was caused in part by techniques and materials that Siqueiros had used. It was painted on wet cement, after a pneumatic drill had first been used to roughen the wall surface in order to give the paint greater adhesion. Because cement dries rapidly, Siqueiros used an airbrush to apply the paint, no doubt hoping that the result would prove durable. Indeed, one contemporary review of the mural concluded that "rains will never wash it off, nor sun dim its details, for it is cement!"[2]

Unfortunately, the passage of time has not confirmed this appraisal. In the following decades, the mural, covered with a coat of white overpaint, endured the effects of sun, rain, smog, and earthquakes. The paint layer underneath began to deteriorate, as the white overpaint itself slowly eroded. In places the mural faded and peeled. Sections of the painted plaster started detaching from the

wall, and after the 1971 earthquake a plaster segment in the upper right corner collapsed. Heavy air pollution, meanwhile, coated the mural's surface in dirt.

In the treatment of artworks there is an important distinction between conservation, which seeks to preserve the work in its current state, and restoration, which seeks to return it to its original glory. In the early 1970s, when the art historian Shifra Goldman and the Los Angeles filmmaker Jesús Salvador Treviño spearheaded the first attempts to save the mural, they arranged for two Mexican conservators to come to Los Angeles to determine whether *América Tropical* could be restored.[3] The specialists agreed that the mural had deteriorated too severely for restoration, but they thought that it could be conserved, with the remaining white overpaint removed, thereby improving its legibility. At that time, however, neither the Olvera Street merchants nor the park administration cared much about preserving it. Some were still influenced by

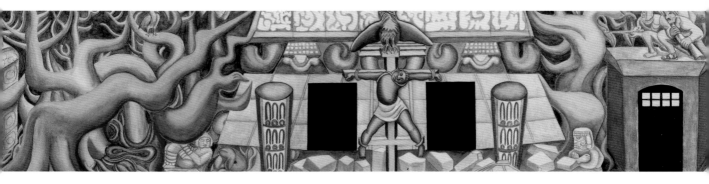

the attitudes of Christine Sterling and other civic leaders, who felt that the mural's revolutionary message did not fit in with Olvera Street's theme.

The new administration that took over management of El Pueblo Park in 1977 joined with others to seek the technical assistance and resources necessary to save what remained of the mural. El Pueblo management also sought to convince the merchants that conserving the mural would draw more visitors and, therefore, provide economic benefit. Experts were brought from Mexico to make recommendations about conservation of the mural, and a temporary wooden cover was installed to protect it from sun and rain. Further conservation was held up by lack of adequate funding and lack of agreement over which conservation treatment was preferable.

Over the ensuing decade, additional research and fund-raising were carried out, but actual work on the mural was at a standstill. In 1987 the Getty Conservation Institute (GCI) became involved, and the following year the GCI's Scientific Department, using samples taken from the site following the 1971 earthquake, analyzed the mural's

This color rendering by conservator Agustín Espinosa reflects how the mural might have looked originally and how it might appear were it to be restored. It was decided not to restore the mural but to conserve it in its present state.
Courtesy Friends of Mexico, 1989

A cover was installed in 1982 to protect the mural from further damage caused by exposure to the elements.
Photo by N. Kaye, 1990.
© N. Kaye

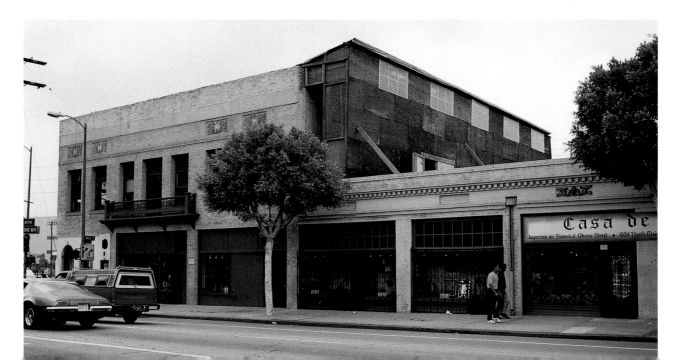

92

Conservators cleaning the mural surface (right). A moveable camera and computer (far right) used to capture a digital image of the mural, segment by segment. The segments were joined together to form a composite image of the mural. A conservator (below) applies fomic acid to treat the mural surface.

Photos by N. Kaye, 1990, 1994.
© N. Kaye

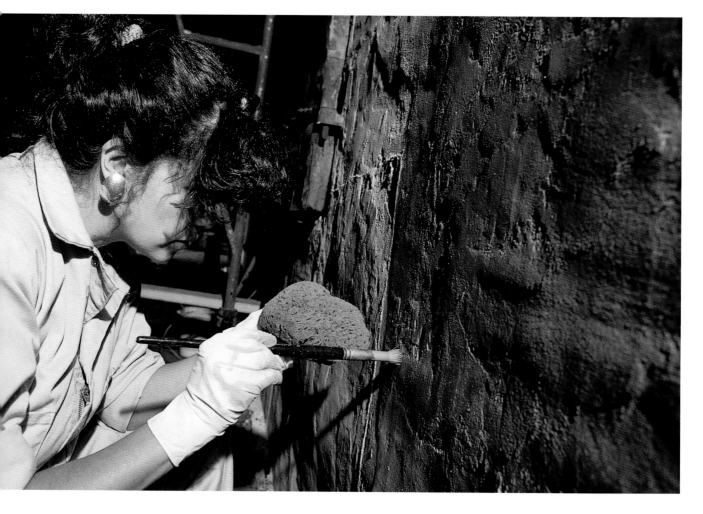

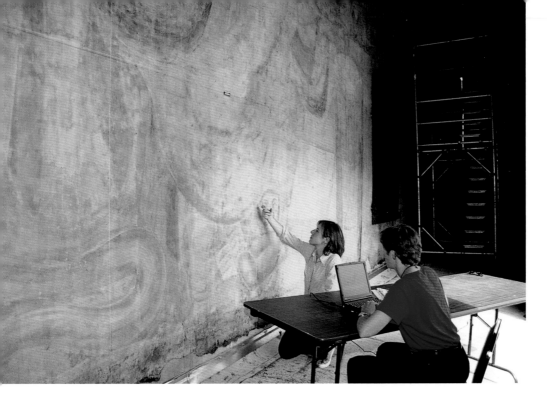

chemical composition, including the paint pigments used, in order to understand why and how it had deteriorated. This analysis suggested that the paint's binder was probably cellulose nitrate. When Siqueiros sprayed his paint on the wet cement, the alkalinity and moisture of the wet plaster activated decay processes that began immediately. Adhesion between the paint layer and the plaster, therefore, was probably poor from the beginning, resulting in delamination and paint loss. Most of the paint that is still visible is trapped within the porous cement plaster. Under the strong sun and heat of downtown Los Angeles, additional thermal and photochemical deterioration occurred.

The scientists also determined that under the remnants of whitewash some original paint remained and that while the mural could not be restored, it could — and should—be saved. In 1988 the GCI officially joined with El Pueblo Park and, for a time, with the Friends of the Arts of Mexico Foundation, and a comprehensive program for saving *América Tropical* was developed. The first phase began in 1990, when a Mexican team headed by the prominent conservators Agustín Espinosa and Cecilia

Espinosa, assisted by two students from the wall paintings conservation training program of the Courtauld Institute of Art in London, began work, removing the remaining white overpaint and traces of asphalt at the base of the mural, cleaning and consolidating the underlying paint layer, and reattaching loosened cement plaster to the brick wall.

In 1991 the GCI installed an environmental monitoring station, which for more than a year and a half measured such factors as wind speed and direction, rainfall, temperature, humidity, and the movement of sunlight across the mural's surface. The data thus collected indicated that it would not be enough to stabilize the mural; it would also be necessary to design a protective shelter. In 1994, in preparation for the final conservation, the GCI used digital imaging to record the mural's condition. Once the permanent shelter is installed, the final cleaning, stabilization, and consolidation of the mural can proceed. Meanwhile, the GCI is working with the design firm I.Q. Magic to prepare an interpretive exhibit on Siqueiros and the mural to be installed on the second floor of the Sepúlveda House, three doors away.

*Remaining traces of
white overpaint were
carefully removed.*

Photo by N. Kaye, 1990. © N. Kaye

Visitors will be led over a rooftop walkway
to a platform on top of the Hammel building
to view the mural.

The conservation of *América Tropical* did
not seek to return the mural to its original
state. The problematic materials used in its
creation, along with years of neglect, have
left the Siqueiros masterpiece a faded ghost
of its original incarnation. Nevertheless,
much of the work's artistic power remains.
That it has been so badly treated is now part
of its—and the city's—history. As the inter-
pretive center explains, even in its present
condition the mural is "telling a story" of
both political controversy and the freedom
of artistic expression. It has also left a con-
siderable legacy in terms of the public art
so interwoven into today's Los Angeles,
which claims more than two thousand
public murals.

There are a number of potential projects
for the future at El Pueblo as well. The
Merced Theatre may become a performing

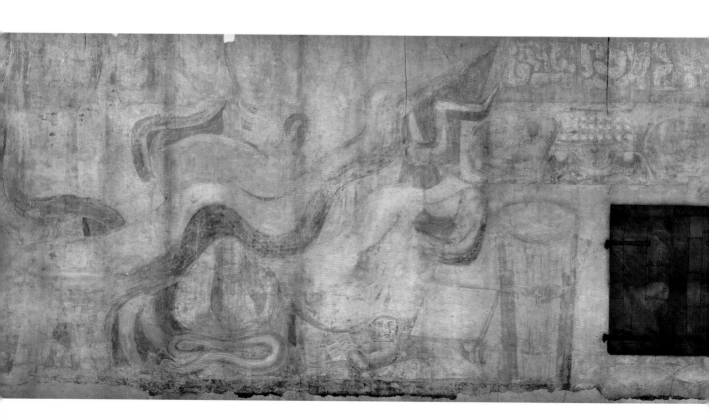

arts theater again. The Historic Italian Hall Foundation is working with El Pueblo Historic Monument to install a museum focusing on Italians in Los Angeles, particularly those involved with the history of the pueblo and Olvera Street. With a grant from the Metropolitan Transit Authority, it is hoped that the renovation of the Plaza Substation can proceed, with the purpose of installing a museum housing exhibits on the city's old trolley cars. Perhaps a research center and a replica Native American village could be built in Father Serra Park, to complement the memorial garden honoring the area's first inhabitants and to inform the public about the exciting archaeological finds at El Pueblo. Finally, in the pueblo's early days, the Campo Santo, the town's first cemetery, lay just south of the Old Plaza Church. After a new cemetery was established in 1844 on what is today North Broadway, this one became an orange grove, which some years back was paved over for

a parking lot. Perhaps some day it could be planted as a garden, in memory of those early settlers.

The preservation work currently underway at El Pueblo coincides with various other initiatives. Among the foremost are the continuing efforts of the Los Angeles Conservancy to save a wide range of landmarks, such as the Broadway movie palaces and the Seventh Street shopping district a few blocks southwest of the pueblo. Another is the restoration of Los Angeles City Hall, which was completed in 2001. Such endeavors seek to ensure that the city's rich heritage find an appropriate place in the evolving identity of downtown Los Angeles.

NOTES

1 Hata, *Historic Preservation Movement in California*, 31–39.
2 See Jeffrey Levin, *"América Tropical,"* in *Conservation: The Getty Conservation Institute Newsletter* 9, no. 2 (summer 1994): 4–8.
3 It was at this time that Siqueiros made plans to paint a replica of the central portion.

Digitally captured image of América Tropical *as it looked in 1994, closely resembling its appearance today. The mural has been stabilized and cleaned, and missing portions, such as in the upper right corner, have been filled in.*

Digital photograph, Eric Lange, Getty Conservation Institute, 1994

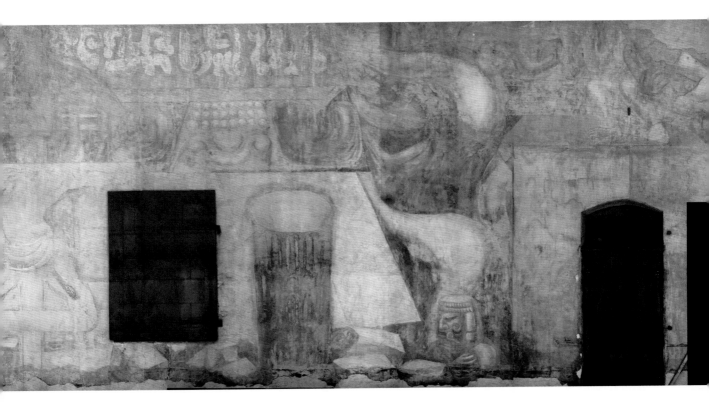

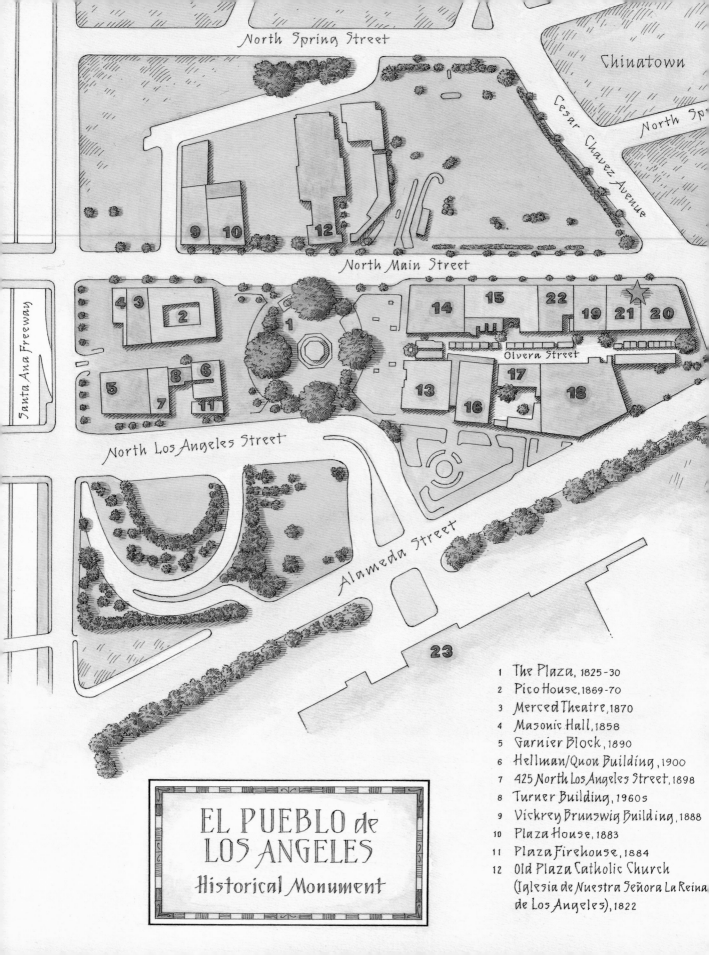

North Spring Street

Chinatown

Cesar Chavez Avenue

North Sp...

9 10 12

North Main Street

4 3 2 1 14 15 22 19 21 20

Olvera Street

8 6 17

5 13 18

7 16

11

Santa Ana Freeway

North Los Angeles Street

Alameda Street

23

EL PUEBLO de LOS ANGELES
Historical Monument

1 The Plaza, 1825-30
2 Pico House, 1869-70
3 Merced Theatre, 1870
4 Masonic Hall, 1858
5 Garnier Block, 1890
6 Hellman/Quon Building, 1900
7 425 North Los Angeles Street, 1898
8 Turner Building, 1960s
9 Vickrey Brunswig Building, 1888
10 Plaza House, 1883
11 Plaza Firehouse, 1884
12 Old Plaza Catholic Church
 (Iglesia de Nuestra Señora La Reina
 de Los Angeles), 1822

EL PUEBLO'S HISTORIC BUILDINGS

Strolling through El Pueblo, a visitor will encounter a variety of architectural styles, from old Mexican adobes to palatial Italianate facades, from the elegant simplicity of nineteenth-century brick commercial and residential structures to the ornamentation of Spanish Churrigeresque. These buildings also reflect the pueblo's rich heritage in the stories they tell of the people who built and occupied them. Ranging in date from around 1818, when the Avila family's town home was constructed, to 1926, when the Plaza Methodist Church was completed, the historic buildings of El Pueblo—many of which have now been restored—are among its greatest treasures.

13 Plaza Methodist Church and Biscailuz Building, 1925-26
14 Simpson/Jones Building, 1894
15 Jones Building, ca. 1888
16 Plaza Substation, 1903-4
17 Avila Adobe, 1818
18 The Winery, 1870-1914
19 Pelanconi House, 1855-57, and Pelanconi Warehouse, 1910
20 Italian Hall, 1907-8
21 Hammel Building, 1909
22 Sepúlveda House, 1887
23 Union Passenger Terminal Station, 1933-39
★ América Tropical mural, 1932

A map of El Pueblo today.
illustration © 2002 John Burgoyne

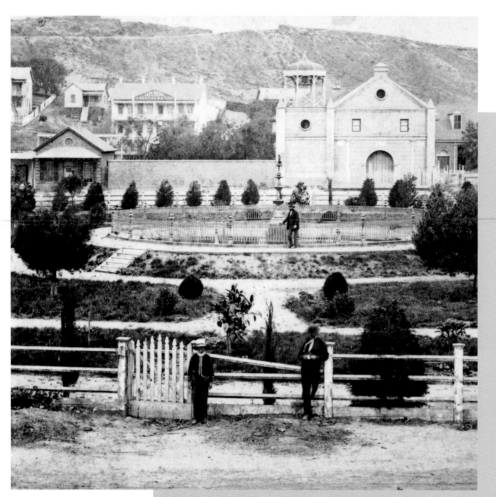

The Plaza, 1825–1830

In the heyday of the ranchos, the Plaza was the gathering place for the community, where fiestas, religious festivals, and other celebrations took place. Originally founded east of its present position and laid out in a rectangular shape, the Plaza was moved several times, once in 1815 when floods threatened the land nearer the river. It was established in its present position between 1825 and 1830. Prominent early settlers with houses here included José Antonio Carrillo, Vicente Lugo, Ignacio del Valle, Pío Pico, and Juan Sepúlveda. Agustín Olvera had a house on the north side in the 1850s, as did Pedro Seguro, Cristobal Aguilar, and, later, John G. Downey, a governor of California. Where the Plaza Firehouse is today was the adobe of Francisco Ocampo, whose front yard was known as the Plazuela.

By the 1860s the Plaza had declined, and complaints about its seedy character were often voiced in the press, along with calls for it to be landscaped. It was rounded off in 1871 and a fountain was installed. In 1875 it was landscaped with orange and cypress trees, and a walk was laid out. Today it is paved in cement, with brick stripes radiating out from the bandstand in the center, which was erected in 1962. The low wall was topped with brick in 1930, the year the Olvera Street marketplace opened. These bricks may have been inlaid to prevent loiterers from sitting or lying there. Seats were included. Planters contain various trees and plants, including the four towering Moreton Bay fig trees planted around 1878 from seeds brought from Missouri that came originally from Australia. Today the Plaza retains considerable social and cultural importance for the city's Hispanic community and serves as a major landmark and place of pride for all Angelinos.

The Plaza, Los Angeles, ca. 1880. The view is from the second floor of the Lugo House. To the left of the Plaza Church is the adobe of Andrés Pico; Fort Moore Hill, an early Los Angeles landmark, rises in the background. Carleton Watkins, albumen stereograph.
Courtesy the J. Paul Getty Museum, Los Angeles. 96.XC.25.7

ABOVE
The Plaza today.

LEFT
*A plaque honoring the
original pobladores; and
a statue of Carlos III of
Spain, under whose reign
the pueblo was founded.*

Photos by Susan Middleton, 2001

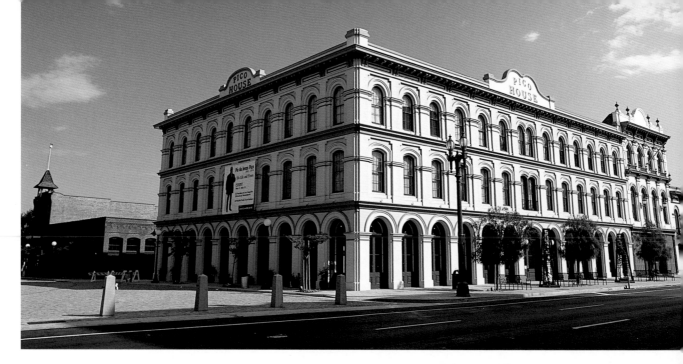

The Pico House, Merced Theatre, and Masonic Hall. The red-brick Firehouse and Hellman/ Quon building can be seen in the background.

Photo by Susan Middleton, 2001

Calling card of the Pico House, ca. 1880.

Courtesy El Pueblo Historical Monument

Pico House, 1869–1870

With its recent renovation, the Pico House is once again the most imposing building in El Pueblo. The first grand hotel in Los Angeles, it was built by Don Pío Pico, who in 1845–46 had been California's last Mexican governor. To raise the necessary capital, Pico and his brother Andrés sold most of their vast landholdings in the San Fernando Valley for $115,000. Pico hoped that this hotel, erected on the site of an old adobe that had belonged to his brother-in-law, José Antonio Carrillo, would help to revitalize the Plaza area. Construction began on September 4, 1869; by the time the structure was finished, expenditures topped $48,000; the elegant furnishings, purchased in San Francisco, cost at least another $34,000.

The Pico House opened on June 9, 1870, in the festive atmosphere of a public holiday. A few days earlier, while conducting a tour, Pico had accidentally walked through a large mirror on one of the hotel's landings, emerging with wounded pride but otherwise unscathed. The opening, however, attended by civic and business leaders, went flawlessly.

The hotel was designed by the architect Ezra F. Kysor in the Italianate style, with round-arched windows and doors set into stately facades of red brick and gray stucco. It was the city's first three-story building, and it boasted eighty-two guest rooms, twenty-one parlors, and amenities without peer in southern California. Guests could dine in its French restaurant or make travel arrangements in the offices of the Wells Fargo Express Company. The main lobby featured a grand staircase and was lit by a handsome gas chandelier. There were bathrooms on each floor. In a service court, luggage was unloaded from carriages onto the city's only dumbwaiter, which hoisted it upstairs.

The most expensive suites, along with dining rooms for women and children, were found on the exclusive second floor. Furnished in walnut or in finely carved rosewood, the suites cost $3 per night. Some overlooked the inner courtyard, where balconies were festooned with "vines and drooping plants," caged birds chirped, and water gurgled in a cast-iron fountain. This floor also had a private entrance to the Merced Theatre next door, so guests could pass directly to their boxes and watch the show without having to mingle with the crowd.

For a time, the new hotel appeared to fulfill its owner's dreams. Guests included Avilas, Sepúlvedas, Lugos, and, later, Helen Hunt Jackson. The hostelry's shining moment came perhaps in 1876, when the railroad was cut through from San Francisco, linking Los Angeles to the East Coast. The hotel's chef, Charles Laugier—known locally as French Charlie—prepared a gala dinner on the evening of September 5, after the last spike had been hammered in at Lang Station, near Newhall, and the first train from northern California had arrived in Los Angeles. That year, too, Archduke Ludwig Salvator of Austria, traveling incognito around southern California, stayed for several weeks at the Pico House, which, he later wrote, served as the rendezvous for "the elite of the city."

The hotel's heyday would prove short-lived, and Pico's hopes of restoring the Plaza area to its former prominence would not be realized. Nearby, the notorious Calle de los Negros, long a center of crime and prostitution, was also troubled by racial strife, culminating in the infamous Chinese Massacre just over a year after the hotel had opened. The city's business heart gravitated south on Main Street to the area between First and Second Streets. Pico's later life was shadowed by financial misfortune, and his risky practice of borrowing money at usurious rates obliged him to put up the hotel as collateral. In 1880 the San Francisco Savings and Loan Company took over ownership of the Pico House for the paltry sum of $16,000.

In the next decades, with frequent changes in management, the hotel gradually declined. In 1896 it was rented to two Italians, one of whom would purchase the building in 1930. By 1950 the *Los Angeles County Museum Quarterly* would describe the once-refined hostelry as "a dreary rooming house with a shabby bar and pool room." With the exterior recently restored, it once again boasts the grand appearance of its glory days, when for a brief decade it was the most elegant hotel in Los Angeles.

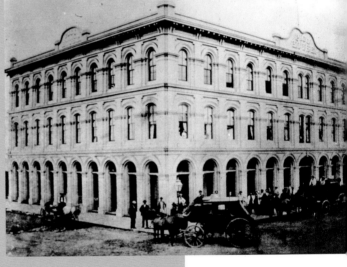

The Pico House, ca. 1870. During the 1870s, stagecoaches would pick up passengers at the port in San Pedro and carry them to the hotel, in the heart of town.
Courtesy El Pueblo Historical Monument

Merced Theatre, 1870

Six months after the Pico House opened, the Merced Theatre, the first building constructed in Los Angeles specifically for the presentation of dramatic performances, opened next door. It was built by William Abbot, son of Swiss immigrants who had traveled by wagon train from Indiana to San Francisco. Abbot arrived in Los Angeles in 1854, advertising himself in the *Los Angeles Star* as "furniture dealer and repairer, upholsterer, coffin-maker and bathhouse proprietor." In 1858 he married Merced García, youngest daughter of two longtime pueblo residents, and twelve years later he named his new theater in her honor. The *Los Angeles Star* reported regularly on its construction, announcing on July 27, 1870, that excavation had started the previous day and reporting on September 18 that "Los Angeles would soon be in a position to do full justice to the art theatrical."

Like the Pico House, the Merced was designed by Ezra F. Kysor in an ornate Italianate style, with gold-painted finials adorning the roof and balconies and arched windows deeply set along the facade. The ground floor featured a saloon and a billiard hall, the second floor housed the theater, and the third floor contained the residence of the Abbots and their eleven children. The Merced opened on December 30 with a concert and lecture. The following evening, a grand New Year's Eve ball, organized by prominent citizens such as Pío Pico and John G. Downey, was held there. The theater's ornate drop curtain, painted with an Italian landscape, first went up on January 30, 1871, for a melodrama called *Fanchon the Little Cricket,* which

Masonic Hall, 1858

Efforts to establish a fraternal lodge in Los Angeles began in 1851. Lodge 42 A & FM (Accepted and Free Masons) was accordingly chartered in Los Angeles on May 5, 1854, by the Grand Lodge of California, which had been inaugurated in Sacramento in 1850.

Early meetings were held in an adobe house on North Main Street. In 1858 Mason William Hayes Perry and his partner, James Brady, were asked to build a lodge meeting room on the second story of a building they were constructing at 426 North Main Street for their carpentry and furniture-making store. Lodge 42 lent them the money for construction, and by November the building was finished. Lodge 42 paid a rent of $20 per month for its space in the upstairs premises, which served as its headquarters until 1868 when the Masons moved to larger quarters.

Early members of Lodge 42 included many leading citizens, such as the American city's first two mayors, Alpheus P. Hodges and Benjamin D. Wilson. But members in those first years were Anglo-Americans only, and

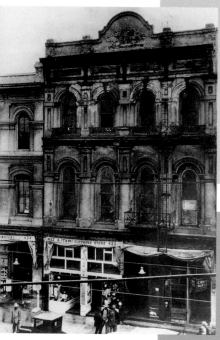

TOP
The Merced Theatre today.
Photo by Susan Middleton, 2001

ABOVE
The Merced Theatre in about 1930.
Courtesy California State Library

OPPOSITE, TOP
Merced García Abbot.
Courtesy El Pueblo Historical
Monument

had a run of nine days. Other melodramas—the Merced's preferred genre— included *Uncle Tom's Cabin* and *Ten Nights in a Bar Room*. For five years the Merced was the queen of Los Angeles theaters.

The May 1876 opening of Wood's Opera House four doors to the south would soon end the Merced's reign. Built by the showman Colonel J. H. Wood, the "opera house" soon was featuring such fare as boxing matches and bawdy farces whose actresses would mingle with the clientele. The last performance at the Merced was given on New Year's Day 1877 by a troupe of Spanish dancers. While Wood's establishment had drawn away the Merced's customers, contemporary accounts also comment on noises of children thumping around on the floor above. The following year the Merced was rented to the Los Angeles Guards, but it continued to decline. A decade later it was the scene of a ball that, according to the *Los Angeles Times*, more resembled "a prostitutes' carnival." Abbot had died eight years earlier, but Merced and some of her children were still living upstairs. In the decades that followed, the building would have various tenants, including the Salvation Army, a pawn shop, and the Barker and Allen furnishing business, later known as Barker Brothers Department Store. Merced's daughter Kate inherited the building and continued to rent it out until her death in 1937. It was then bought by a tenant who opened a night spot called the Plaza Club in the basement. Current plans call for the Merced to be renovated as a live theater or concert hall.

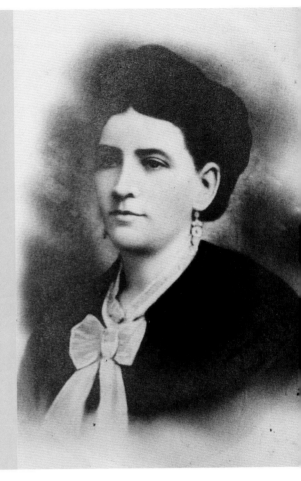

while Jews and Catholics were welcomed, no Hispanic surnames can be found among the membership before 1868. The Masonic Hall was primarily used as a furniture- and cabinet-making store that was noted for its coffins. By the turn of the century it was being used as a cheap lodging house and a pawn shop. In the early 1950s it was threatened by the construction of the Hollywood/Santa Ana Freeway. However, Masons associated with the state park system and members of Los Angeles Lodge 42 intervened to save the building and make it part of El Pueblo de Los Angeles State Historic Park. The Masonic Hall was restored by the state in the 1950s, and in 1960 the Masons furnished it. Nine original wall lamps, some 1871 mahogany chairs, and a melodeon dating from the 1860s adorn the hall. In 1981 the building was rededicated as a meeting place for Los Angeles City Masonic Lodge 814. It is operated by the Old Temple Committee (a committee of the Grand Lodge of California) as a museum; it also houses the historic record books and memorabilia of Lodge 42.

Photo by Susan Middleton, 2001

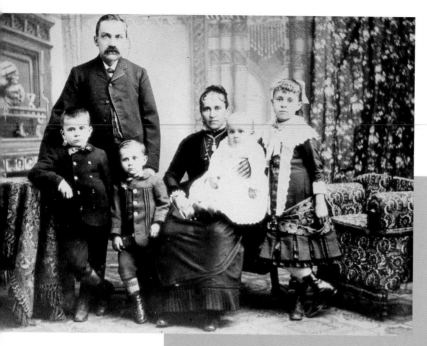

Garnier Block, 1890

The Garnier Block, built by the Frenchman Philippe Garnier, was the most important building in the early Chinatown of Los Angeles, housing pioneer Chinese business establishments and volunteer organizations that were highly influential in the community. Constructed of brick and sandstone, it was designed in what could be described as the Richardsonian Romanesque style by the young Abraham Edelman, son of the first Jewish rabbi in Los Angeles. He would later become one of the town's most prominent architects, with such major buildings as the Wilshire Boulevard Temple to his credit. In part because so much of San Francisco's Chinatown was destroyed in the great earthquake and fire of 1906, the Garnier Block today may be the oldest and most significant Chinese building in a California metropolitan area.

The five Garnier brothers came to Los Angeles from Gap, a town in the Hautes-Alpes in southeastern France. They bought Rancho Los Encinos in the San Fernando Valley, where they raised large herds of sheep. Philippe joined the board of the influential Farmers and Merchants Bank and was a director from 1879 to 1890. Many Chinese merchants had accounts there, and Philippe may have decided to capitalize on the expanding Chinese market by building a commercial block—a term that in Victorian days often referred to a single brick building—and renting it to Chinese interests. Shortly before the building was completed, he signed a six-year lease with Chong Kee, representing the Hep Tuck Company. Philippe and his family then returned to Gap, where he died in 1898.

According to Chinese tradition, because a building's upper floors are closer to heaven, they are more appropriate for temples, schools, and organizations that exert authority. In the Garnier Block, commercial customers such as the Sun Wing Wo Company, which remained for forty years, occupied the lower floors. Leading fraternal, social, and religious

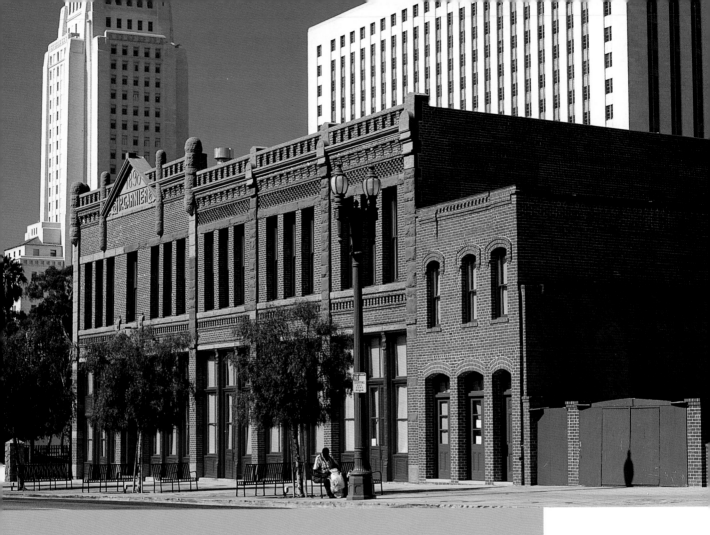

institutions had quarters on the second floor, including the Chinese Consolidated Benevolent Association, the Chinese American Citizens Alliance, the Wong Gon Ha Association for single men, the Chinese Christian Mission School, and the Chinese English School. These organizations helped the poor, arbitrated differences between various groups, and acted as liaison with the dominant American population. They were greatly needed because of widespread—often virulent—anti-Chinese prejudice in Los Angeles during the late nineteenth and early twentieth century. The Chinese Chamber of Commerce and the Chinese Laundrymen's Association also were located in the building, which in addition served as a hall for dances and theatrical performances. Recently renovated, a portion of the Garnier Block will house the Chinese American Museum.

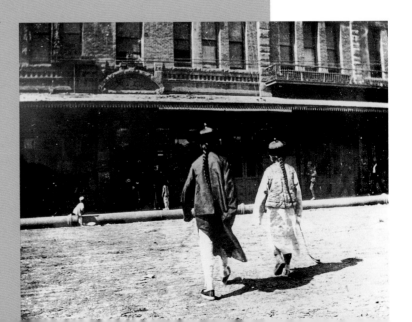

Hellman/Quon Building, 1900

This building is named after its two longtime owners, Isaias W. Hellman, who had come to Los Angeles from Bavaria and who built it in 1900, probably with the intention of renting to Chinese tenants, and Quon How Shing, a highly regarded Chinese businessman who owned it from 1921 until it was acquired by the State of California in 1954. Hellman had founded the Farmers and Merchants Bank on Fourth and Main Streets in 1871, which was heavily patronized by Chinese merchants. The Hellman/Quon building has two wings, separated by a narrow passageway; there are seven separate units, with at least ten exterior doors. This arrangement enabled residents and tenants to enter, unseen, from Sanchez Street through the rear. Following Hellman's death in 1920, the building was sold to Moses Srere, who sold it one year later to Quon How Shing. The businessman helped many Chinese to learn English and taught them how to adapt to the different customs of American society. The building was densely populated, serving as home to many families and single men. Various activities took place there, including gambling and, it seems, some opium smoking. A hidden button installed under a ground floor windowsill rang an electric bell, which alerted occupants to the arrival of possibly unwelcome visitors.

425 North Los Angeles Street, ca. 1898

With its small scale and proportioned design, this attractive brick two-story commercial building located just north of the Garnier Block on North Los Angeles Street reflects a simpler time in the life of Los Angeles. Its owner was Sostenes Sepúlveda, eldest of the large family of Juan María and María de Jesús Sepúlveda. It was first used by Chinese tenants. In about 1916 occupancy changed to the Cavour Restaurant, named for Camillo Benso Cavour, who is credited with helping to unify Italy in the 1850s. In the 1930s and 1940s Chinese residents once again lived here, and in 1937 the Four Families Association had offices and a meeting hall on the second floor. It is being restored as part of the Chinese American Museum.

Vickrey Brunswig Building, 1888

William Vickrey came to Los Angeles in 1861, at the age of twenty-seven, from Dearborn, Indiana, seeking his fortune in a milder climate. He started the Eastside Bank and acquired the property on North Main Street, hiring the architect R. B. Young to construct a five-story brick residential and commercial building on the site, which had once housed an adobe belonging to Jesús Dominguez.

The new structure had a dentiled cornice and a central triangular pediment that bore the legend "Vickrey Building, 1888." In addition to family members, early residents included Thomas Temple, editor of the Spanish-language newspaper *La Crónica*.

The German Savings and Loan Company, however, foreclosed on the building and sold it to the F. W. Braun Drug Company, wholesale druggists, which also bought the old Gas Company building next door, now referred to as the Brunswig Annex, to use as a showroom. Vickrey wound up working as a carpenter.

One of Braun's partners was Lucien Napoleon Brunswig, a Frenchman and doctor's son who had arrived in Los Angeles in 1887. He eventually bought out Braun, and the Brunswig Drug Company soon had the largest manufacturing laboratories west of Chicago. The Vickrey building was renamed the Brunswig building. (Today its name honors both of its progenitors.) A major philanthropist, Brunswig founded the School of Pharmacy at the University of Southern California. He also was one of six donors who in 1928 gave $5,000 each to Christine Sterling and Plaza de Los Angeles Inc. to help create the Mexican marketplace in Olvera Street. He died in 1943.

The County of Los Angeles acquired the Brunswig properties in 1930. For a time they housed a courthouse and the Los Angeles Sheriff's Department crime laboratory. Today they are being developed by the county.

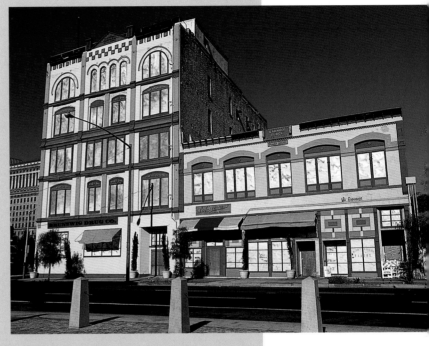

Trompe l'oeil facades have been painted on the Vickrey Brunswig building and the two-story Plaza House.

Photo by Susan Middleton, 2001

Plaza House, 1883

Built by Philippe Garnier and designed by Ezra F. Kysor's partner, Octavius Morgan, the Plaza House was intended for both commercial and residential purposes, and it had a hotel on the second floor. Unfortunately, the building has been vacant since the closure of the well-known La Esperanza bakery and restaurant in the 1960s and has fallen into disrepair. The exterior was defaced by the removal of its ornamentation after the 1971 earthquake, but the attractive second-floor interior still retains much of its original molding. The house was built on land that had earlier belonged to Charles Baric, a French sea captain, who constructed an adobe there in 1841. The County of Los Angeles has plans for its restoration and adaptive reuse.

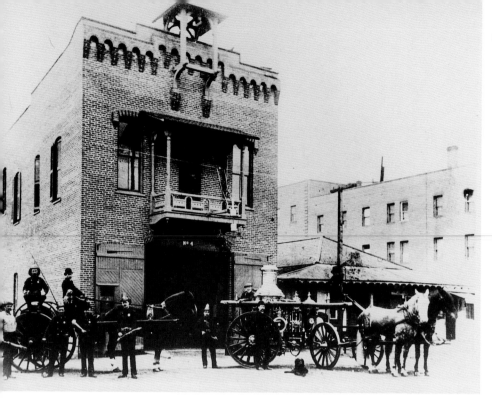

Members of the Los Angeles Fire Department, in front of the Firehouse, 1886. To the right is Pío Pico's former adobe, which by the 1880s was occupied by Chinese tenants.

Courtesy Security Pacific National Bank Photograph Collection/Los Angeles Public Library

Plaza Firehouse, 1884

The Plaza Firehouse, the first structure in the city designed specifically for fire fighting equipment and crews, is today a museum that traces the early days of fire fighting in Los Angeles. Exhibits include a chemical fire engine and historical photographs and other memorabilia.

The architect was William Boring of the firm Boring & Haas, and the contractor was Denis Hennessy. Boring's two-story brick firehouse resembled fire stations in his home state, Indiana. It has a balcony facing the Plaza and is adorned with a small, wood-shingled tower topped by a pole on which perches a weather vane in the shape of a fire helmet. It provided high-ceilinged stables for the horses on the ground floor and quarters for the men on the second floor. A turntable enabled the horses to pull the fire engine behind them into the building and then go directly into their stalls. After that, the engine could be revolved 180 degrees so as to be ready for the next foray.

The city fire department, made up of volunteers, began in 1871. The team installed in the newly built Firehouse in September 1884 was known as the Volunteer 38s, the number of men in Engine Company No. 1. In addition to the steam fire engine, the crew had a hose cart and three horses. Another volunteer company, Confidence Engine Company No. 2, was an archrival. Each was equipped with an Ahrens steam engine that had been paid for jointly by the City and County of Los Angeles. The volunteer companies used the Plaza area to stage parades, holiday fireworks displays, and colorful musters.

They also competed with each other to be first at the scene of a fire. When the alarm sounded, crew members at the Plaza Firehouse slid down the brass pole from their quarters on the second floor, hooked up the horses that had come out of their stalls when the chains holding them in were released, scrambled into their places on the engine, and raced off. The competition at times got out of hand, and in 1885 the city created its first paid fire department. Many of the Volunteer 38s signed on. Eventually, it turned out that the City did not own the land on which the Firehouse had been built. The owner, Ludovica Bigelow, took the City to court, which decided in her favor, and from then on she charged rent. After its lease ended in 1897, the fire department moved away from the Plaza. From 1897 until 1954, when it was purchased by the State of California, the Plaza Firehouse was divided into smaller segments and rented out variously as a saloon, boardinghouse, poolroom, Chinese vegetable market, drugstore, and seedy bar with the unlikely name Cosmopolitian Saloon. By the 1940s it had declined into a cheap rooming house.

Although the building was quite run down by the time the state acquired it in 1954, the walls and beams were still in place. Funds were raised for the restoration of the building and for the acquisition of appropriate furnishings, and the state was able to reconstruct the original distinctive features of the Firehouse, including the turntable, the horse stalls, and the hayloft. The Firehouse was rededicated on October 1, 1960, as a museum of fire fighting equipment and memorabilia of the late nineteenth and early twentieth century.

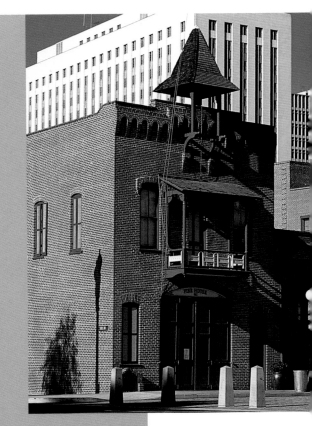

The Firehouse today.
Photo by Susan Middleton, 2001

Buildings fronting the Plaza on the south, 1918. From bottom right: the Plaza House roof, the Pico House, the Hellman/Quon building, and the Firehouse, which was then being used as a saloon and a cigar store. Beyond are the precincts of Old Chinatown.
Courtesy California State Archive, Public Utilities Commission, Case 970, H. G. Weeks Photo Album

Old Plaza Catholic Church (Iglesia de Nuestra Señora La Reina de Los Angeles), 1822

The Old Plaza Catholic Church is the only building in the pueblo area that continues to be used for the purpose for which it was originally built—a parish church. It was never a Franciscan mission, although several Indians of the pueblo were baptized there. Always at the heart of the original pueblo, today it serves a large Hispanic population, who refer to it affectionately as "La Placita."

After the pueblo outgrew the small chapel built in 1786–87 on the northwest side of the original Plaza, the foundation stones of a new church were laid in 1814 near present-day Aliso and Alameda Streets. The following year, however, the Porciúncula River overflowed and the church location had to be moved to higher ground. To raise funds for the new church, several Franciscan missions contributed barrels of brandy, which was sold "drink by drink." Construction began in about 1815. Funds were soon exhausted, however, and after 1819 the pueblo's citizens refused to contribute further, because the governor diverted their donations for construction in Monterey. At this point the local missions made substantial gifts of cattle, mules, and land, as well as brandy and wine, to raise the funds necessary to complete the structure.

The church's construction was aided by Joseph Chapman, the first American to reside in Los Angeles.

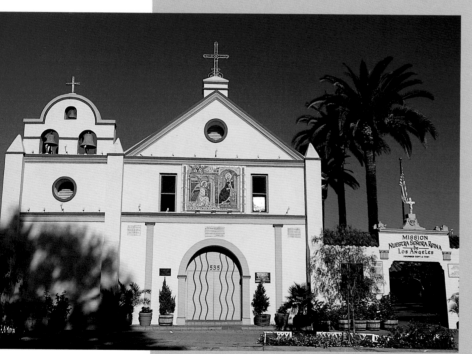

ABOVE AND
OPPOSITE, BOTTOM
The Plaza Church today.
Photos by Susan Middleton, 2001

OPPOSITE, TOP
The Plaza Church, 1890.
Courtesy Security Pacific National
Bank Photograph Collection/Los
Angeles Public Library

This adventurer and jack-of-all-trades had been a member of the pirate Hypolite de Bouchard's raiders, who had sacked Monterey in 1818. Chapman was captured near Santa Barbara and sent to work as a convict laborer for the missions in southern California, where he impressed the priests with his wide range of skills, and he wound up working on the church, marrying a Santa Barbara girl, and becoming a winemaker.

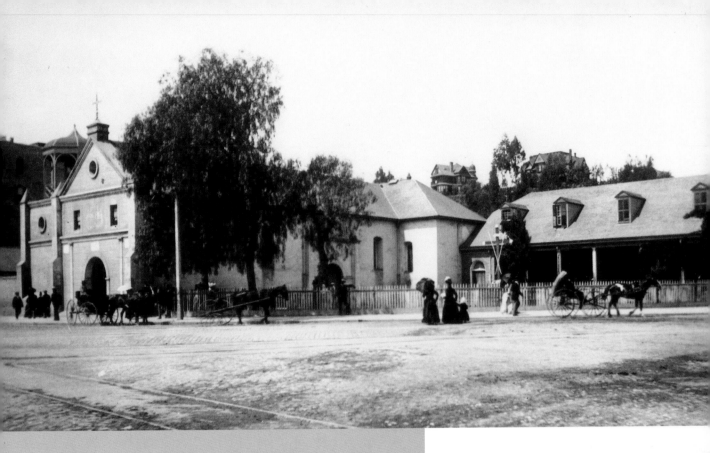

La Iglesia de Nuestra Señora (the Church of Our Lady) was finally dedicated on December 8, 1822. The whitewashed adobe structure had a round gable topped by a cross, and on the south side there was a bell tower with four niches. Three bells were donated by Mission San Gabriel. The fourth is said to have been donated later by Captain Henry Delano Fitch, in penance for having eloped with Josefa Carrillo in 1832. The first pastor was Father Geronimo Boscana, a padre at Mission San Gabriel who started the baptismal register in 1826. There was a cemetery on the north side, and another was added on the south side.

Later in the nineteenth century the name of the church was lengthened to Nuestra Señora La Reina de Los Angeles (Our Lady Queen of the Angels), and the French artist Henri Pénélon, who had settled in Los Angeles, was hired to paint frescoes on the inside and outside walls. When St. Vibiana's Cathedral opened a few blocks away in 1876, most of the English-speaking parishioners transferred there, leaving the Spanish-speaking residents to continue supporting the old Plaza Church. In 1965 La Placita narrowly escaped being torn down when a large parish church went up behind it, and since then it has been used as a chapel and for smaller services. On September 4, 1981, during the Los Angeles bicentennial, a new mosaic mural on the old church's facade was dedicated; this was a replica of a mural depicting the Annunciation painted in 1393 by Ilario da Viterbo in the Franciscan chapel of the Porciúncula, near Assisi, Italy.

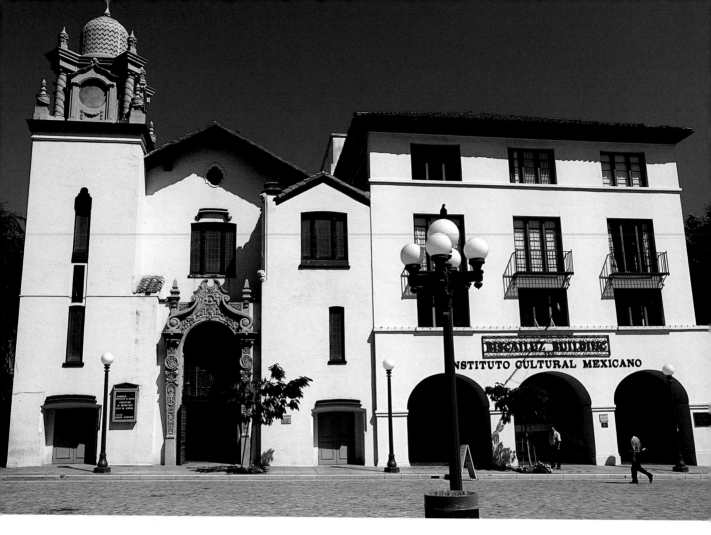

Plaza Methodist Church and Biscailuz Building, 1925–1926

The Plaza Methodist Church (La Iglesia Metodista de la Placita) and the Biscailuz building are the two most recent buildings at El Pueblo. The church was built on the site of the old Olvera adobe, which had been built between 1830 and 1845 and had previously belonged to Bartolo Tapia, a mayor of the pueblo, who had passed it on to his son Tiburcio. The Olvera adobe was occupied by Chinese from the 1880s until 1893, when Los Angeles Methodists leased it as a mission to Mexican people. Later the Los Angeles Land Company bought the adobe from Olvera's daughter, then sold it to the Methodists, who established a clinic and training school for the handicapped known as the Plaza Community Center. In 1917 the Olvera adobe was torn down to make room for three new frame structures.

The church and the former headquarters of the United Methodist Church Conference were designed by the architects Train and Williams. The church was built in the Spanish Churrigeresque style, with sculptural orna-mentation and a Moorish dome of yellow and green tile with a garlanded

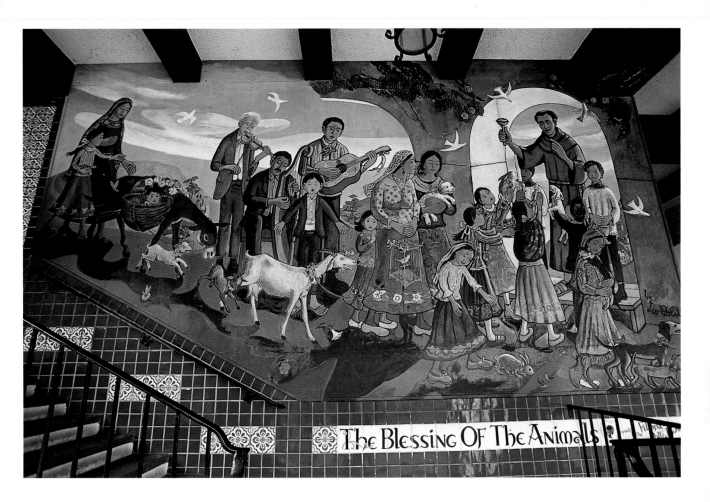

The Blessing Of The Animals

finial at each corner. Inside, the church had attractive Spanish-style décor, which was modified in the 1960s. Once the church was built, the Plaza Community Center moved next door into the headquarters building, which was larger and more utilitarian in design. The United Methodist Church paid the State of California for a fifty-year lease at a dollar a year.

In 1965 the headquarters building was renamed in honor of Sheriff Eugene Biscailuz, who had done a great deal to help Christine Sterling realize her plans for Olvera Street. After the structure was renovated to give it a more Hispanic appearance, first the Mexican Consulate General and then, since 1991, the Mexican Cultural Institute have been located on the premises. El Pueblo de Los Angeles Historical Monument moved its administrative offices into the upper floors in 1992.

Los Angeles Trolley Cars

The intersection of North Main and Marchessault Streets, 1918. Machine shops in the Simpson/ Jones building front the Plaza. At upper right are the Plaza Substation and, beyond, the railroad yards. At upper left, a painted sign adorns part of the second-floor wall of the Italian Hall, where Siqueiros would paint América Tropical *fourteen years later.*

Courtesy California State Archive, Public Utilities Commission, Case 970, H. G. Weeks Photo Album

From the late nineteenth century, Los Angeles had a first-rate mass transit system. It consisted of two networks of trolley cars: the smaller, yellow cars of the Los Angeles Railway Company, which served metropolitan Los Angeles, and the Big Red Cars of the Pacific Electric Railway, which operated the suburban routes connecting Los Angeles with a vast number of outlying communities.

Both companies were owned by Henry E. Huntington (1850–1927), who had worked with his uncle Collis P. Huntington, one of the "Big Four" railroad magnates, who constructed the Southern Pacific Railroad joining the eastern seaboard to the West Coast. Henry Huntington came to Los Angeles in 1892 and acquired a large estate in San Marino, which now houses the famous Huntington Library, Art Collections, and Botanical Gardens. He purchased the Los Angeles Railway Company in 1898 and bought out other interests to create the Pacific Electric Railway in 1901. Together these companies provided Los Angeles for more than half a century with the finest transportation system it has ever known.

Horse-drawn trolley cars had started service in Los Angeles in 1874. These were replaced by cable cars in 1885, and they gave way to the electric streetcars in 1896. The Los Angeles Railway cars had narrow-gauge tracks (3′6″ wide) as opposed to the wider Pacific Electric tracks (4′8½″). Within a decade the system was remarkably complete, reaching San Pedro, Pasadena, Santa Monica, and many other communities.

Following its heyday in the 1920s, however, the streetcar system was gradually replaced by buses and automobiles, although it enjoyed a momentary reprieve during World War II. In 1945 the Los Angeles Railway Company was sold by heirs of the Huntington estate to a conglomerate composed of General Motors, Firestone, Standard Oil of California, and other interests in the auto industry. Its name was changed to the Los Angeles Transit Lines, and it was gradually phased out of operation. In 1958 it was sold to the Metropolitan Transit Authority; five years later the electric streetcar system was a thing of the past.

Jones Building, ca. 1888, and Simpson/Jones Building, 1894

These were erected for industrial use by Doria Deighton Jones, the Scottish widow of John A. Jones, a well-to-do businessman who had come to Los Angeles in 1851. The Jones building was constructed to house machinists, plumbers, blacksmiths, tailors, and other tradespeople. It now opens onto Olvera Street and is part of the Mexican markeplace there. The Simpson-Jones building now bears the name of Jones's daughter Constance Jones Simpson; it was she who unsuccessfully filed suit in 1929 to prevent Olvera Street's closure to vehicular traffic. In 1960, when a Bank of America branch moved in, the building was altered to look like a Mexican *banco*, in spite of the fact that there had never before been a bank there. Longtime tenants included William Gregory Engines, the Diamond Shirt Company, and the Soochow Restaurant. In the late 1960s La Luz del Día Restaurant moved in next to the bank, adding a patio area with a wrought-iron railing and a tiled roof. The restaurant is well known for its homestyle Mexican food and the tortillas freshly made by hand each day in view of the patrons.

The Simpson/Jones building (top), the Jones building (above), and the Plaza Substation (below).
Photos by Susan Middleton, 2001

Plaza Substation, 1903–1904

Edward Sigourney Cobb, engineer and designer. This was the first and largest of fourteen substations built to supply electrical power for the Los Angeles Railway Company, which operated the yellow electric streetcars providing mass transportation for metropolitan Los Angeles between 1896 and the 1960s. It is the most significant of the four such stations that still exist. Among its architectural features is an unusual system of trusses that holds up the roof. Current plans call for the building to house a museum on the Los Angeles trolley cars.

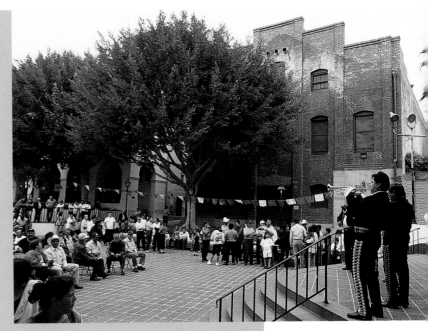

Avila Adobe, ca. 1818

The Avila adobe, the oldest existing house in Los Angeles, served as the town home for the prosperous Avila family, owners of the nearby Rancho La Cienega. They stayed here when they visited El Pueblo to attend mass or social functions.

The adobe has been restored, and today it houses a museum depicting life in the pueblo during the rancho period of the 1840s. The Avilas were a typical ranchero family, and their hospitality was well known. Among the first visitors was the famous American fur trapper Jedediah Smith, who spent the night December 1, 1826. He might have dined in the family room, which is now furnished with period reproductions; a black lacquer sewing table, however, is original. The office was used for business transactions of the ranch and vineyard, the kitchen for storing cooking utensils, because all cooking was done outside until the fireplace was added in the 1850s. The master bedroom, used by the lady of the house for her prayers, is furnished in a style reflecting the trade of the time,

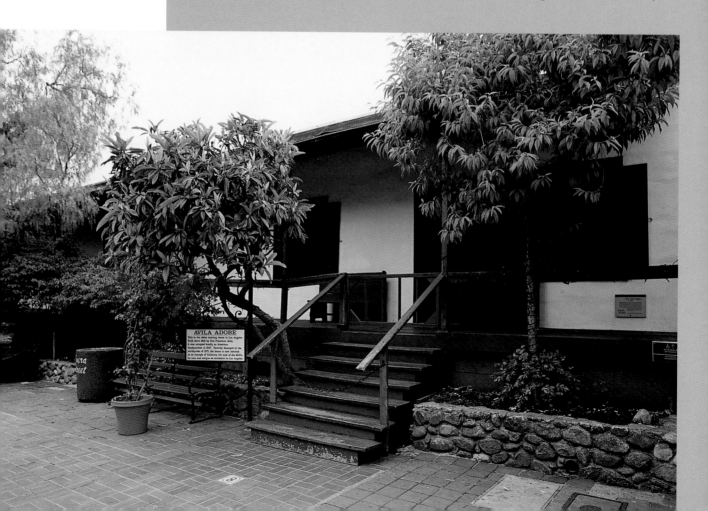

with a Chinese shawl as the bedspread and a Canton trunk owned by the family. The lovely inner courtyard, which served as kitchen and garden, has been relandscaped to resemble its original appearance. There is a wagon as well as cacti and other plants that would have grown here in the heyday of the Avila family.

Don Francisco Avila, who came to Los Angeles in 1794 from Sonora, Mexico, was alcalde of Los Angeles in 1810. In 1822 his first wife died, leaving him with three small children. A few months later he married Encarnación Sepúlveda, the daughter of his friend Francisco Sepúlveda. He was fifty, she was fifteen. They had three more children. He died in 1832 at the age of sixty and was buried at the cemetery next to the Plaza Church. When American forces under Robert Stockton occupied the pueblo in 1846, Encarnación took refuge in the home of the French wine-maker Jean-Louis Vignes, and Stockton took over the vacant Avila adobe, which he used as his headquarters while peace was being negotiated. Encarnación, who had remarried, would live in the adobe with her daughter Francisca until her death in 1855. Francisca continued to live there with her husband, Theodore Rimpau. They had fifteen children. In 1868 the family moved to Anaheim, where Theodore would become mayor.

In the following decades the adobe was rented out as a boarding-house and an Italian restaurant and hotel, until its threatened demolition in the late 1920s inspired Christine Sterling to begin the transformation of Olvera Street. When the area became a state park in 1953, Sophia Rimpau sold the adobe to the State of California. Visitors today will find an exhibit honoring Sterling, as well as an exhibit recounting the story of water in Los Angeles.

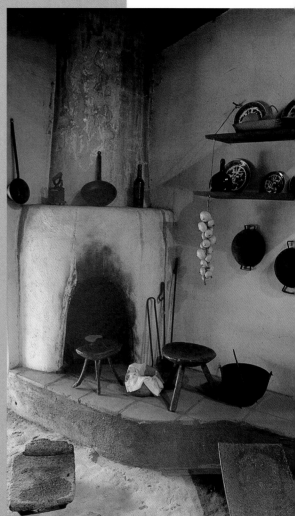

The main bedroom and kitchen have both been restored to resemble their appearance in the 1840s.

OPPOSITE
The Avila adobe fronts Olvera Street.
Photos by Susan Middleton, 2001

The Italians at El Pueblo

The Italian presence at El Pueblo dates to the early decades of the nineteenth century. Perhaps the first to settle there was Giovanni Leandri, who in 1823 opened a general store and built his home where the Plaza Firehouse now stands. Fifteen years later, Matias Sabichi built a home on the east side of the Plaza and opened a saloon. Both men married daughters of local Mexican residents. Their sons were educated in Europe, and both returned to Los Angeles as accomplished linguists.

For several decades in the mid-nineteenth century, wine merchants plied their trade in the short lane known as Calle de las Vignas, or Vine Street, later renamed Olvera Street. Their vineyards were located close to the pueblo, especially on the fertile lands stretching east toward the river. Giuseppe Gazzo and Giuseppe Covaccichi operated a winery on Alameda Street. Covaccichi was a Dalmatian or Croatian settler. He is said to have built what later became known as the Pelanconi House between 1855 and 1857. It was later purchased by José Mascarel, a Frenchman and former mayor of Los Angeles.

Antonio Pelanconi, a native of Lombardy, arrived in Los Angeles in 1853. After trying other trades, he associated himself with Gazzo and learned the wine-making business. In 1871 Pelanconi purchased the house from Mascarel, along with the building across the street now known as the Winery. Pelanconi's wife, Isabel, was a daughter of Juan Ramírez and Petra Avila de Ramírez, who owned a number of properties on Vine Street as well as extensive vineyards between the pueblo and the river. Pelanconi also had vineyards in Tropico (now Glendale). Sadly, of the Pelanconis' eight children, three were lost in the same year to diphtheria and another drowned in the zanja madre. Their eldest son, Lorenzo, would carry on the family wine business.

In the late nineteenth century, the pueblo's Italian community continued to thrive. The Società Garibaldini di Mutua Beneficenza was organized in 1877 in Antonio Pelanconi's business offices. For many years the society met in the Sepúlveda House, until the Italian Hall opened in 1908. The hall's only tenant was Frank Arconti, a prominent member of the Italian community and secretary of the Società Garibaldini. He moved the organization into the Italian Hall, where he also operated a hardware store.

Between 1901 and 1910 Lorenzo Pelanconi rented the Winery to another Italian, Giovanni Demateis, but by 1914 Lorenzo was back in business, requesting a city permit to build an extension of his winery on North Alameda Street. The arrival of Prohibition put a damper on his affairs, and Lorenzo was reduced to making soft drinks and sacramental wines. The winery barely survived until Prohibition was repealed.

The Pelanconis probably stored their better-grade wine in the Pelanconi House, and they may also have made brandy. This may have been the liquor discovered and enthusiastically consumed by the prison gang working on Olvera Street in 1929. The descendants of Frank Arconti, meanwhile, would operate stores in the Olvera Street area until 1987.

Lorenzo Pelanconi.
Courtesy El Pueblo Historical Monument

Banquet of the Italian American Club, in the Italian Hall, June 7, 1908.
Courtesy the Historic Italian Hall Foundation

60 mo. anniversario della promulgazione Dello Statuto Italiano
L'ITALIAN AMERICAN CLUB
7 Giugno 1908

Giovanni Demateis (left) rented the Winery from 1901 to 1910, when this picture was taken.
Courtesy El Pueblo Historical Monument

The Winery, 1870–1914

This was one of several wineries operated by Italians living in the pueblo area in the late nineteenth and early twentieth century. The Café Caliente moved into the building in 1936. In 1955 El Paseo Inn moved over from its former quarters in the Italian Hall, where it had opened as Casa di Pranza. After repeatedly being asked what an Italian eatery was doing on a Mexican street, however, the Italian owners changed the name and the menu to Mexican. Today the Winery's original brick walls are visible inside the restaurant. The building also houses an exhibition gallery for El Pueblo.

Pelanconi House, 1855–1857, and Pelanconi Warehouse, 1910

The oldest fired brick building still standing in Los Angeles, the Pelanconi House was built by Giuseppi Covaccichi and purchased by the winemaker Antonio Pelanconi in about 1871. It was painted white in the early 1920s. When the Olvera Street marketplace opened in 1930, La Golondrina Café moved into the building. It was reputedly the first restaurant in the city to serve food described as Mexican rather than Spanish, and it is the oldest business at Olvera Street. The handsome fireplace of stones from the remnants of the zanja madre, fashioned by the restaurant's original owner, Señora Consuelo Castillo de Bonzo, can be seen inside the restaurant.

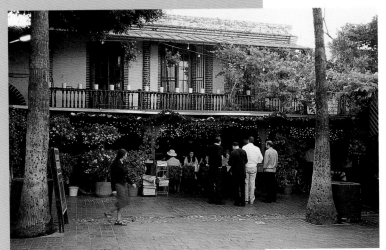

Photos by Susan Middleton, 2001

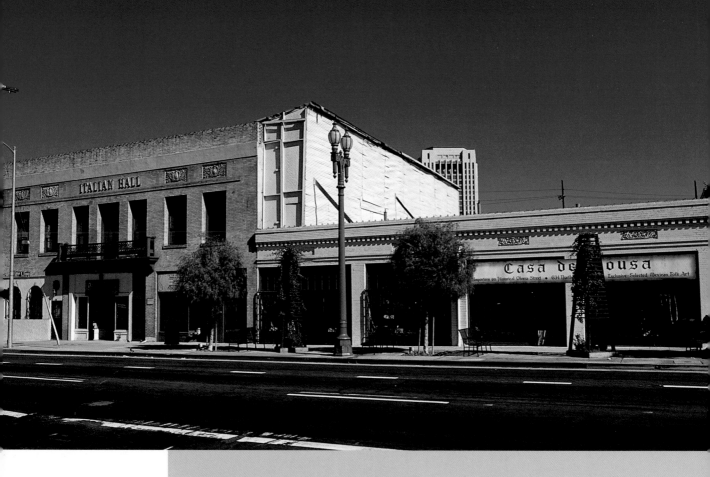

The Italian Hall and the Hammel building. The protective shed covering América Tropical *can be seen.*

Photo by Susan Middleton, 2001

Italian Hall, 1907–1908

Julius W. Krause, architect. This was the social center for the town's growing Italian community, and it was used for banquets, weddings, and dances in the first decades of the twentieth century. It also served as the headquarters of the Società Garibaldini and other Italian civic organizations. It was constructed of fancy yellow brick on the Main and Macy Street sides and common brick on the Olvera Street side, which then was an unpaved alley. When the Olvera Street marketplace opened in 1930, with shops and restaurants on the building's ground floor, the Italian groups decided to find larger quarters. In 1931 F. K. Ferenz opened the Plaza Art Gallery in the large room on the second floor, and the following year he commissioned David Siqueiros to paint *América Tropical* on its south exterior wall. Current plans, prepared in cooperation with the Historic Italian Hall Foundation, call for the upper floor to house a museum on the history of the Italian settlers in Los Angeles.

Hammel Building, 1909

Initially this building was used as a machine shop, one of several in the neighborhood. The land on which it and the adjacent Italian Hall are located had belonged to Don Juan Ramirez before being acquired by André Briswalter, a vegetable farmer from Alsace who shrewdly amassed a great deal of property. He left this building to one of his business partners, a German settler named Henry Hammel. After Hammel's death in 1890, it was inherited by his widow, Marie Ruellan Hammel, who was born in Paris in 1845 and had come to Los Angeles at the age of twenty-three. The year after she had built the Italian Hall she hired the architects Hudson and Munsell to construct the building that now bears her name. In the 1940s, after Olvera Street was transformed into a Mexican marketplace, small basements were excavated to provide additional shops for merchants.

Sepúlveda House, 1887

Today this landmark houses the Monument's Visitors' Center. There is also a historic museum, where period rooms re-create the original kitchen and part of Señora Sepúlveda's private quarters as they might have looked in 1890. On the recently restored second floor will be an exhibit interpreting the history of the building and of the Siqueiros mural, *América Tropical*, located nearby on an exterior wall of the Italian Hall.

Eloisa Martinez de Sepúlveda came to Los Angeles from Sonora, Mexico, when she was eleven. She married Joaquín Sepúlveda in 1857. A woman of some property, Eloisa owned cattle, horses, and land, and she registered her own cattle brand in 1856. Joaquin registered his brand in 1866 but appears not to have owned much property, for he left no estate when he died in 1880.

Believing that the population boom of the 1880s would last and that this part of Los Angeles would prosper, Eloisa decided to build a business and residential building on land she had received from her mother. Although Main Street had been widened in 1886, cleaving off the front of the property, Eloisa proceeded, hiring the architects George F. Costerisan and William O. Merithew to design and construct her building. They chose an Eastlake style common on the East Coast but seldom seen in the West. The house had twenty-two rooms, including two large stores fronting on Main Street. Señora Sepúlveda's private quarters in the rear were set off by a breezeway with large double doors. Upstairs there were fourteen bedrooms for boarders, and one small bathroom.

Señora Sepúlveda's hopes for the prosperity of Main Street were not to be fulfilled, and by 1900 many nearby buildings were serving light industrial uses, while others had become cheap hotels and boardinghouses. The Sepúlveda House may have been used as a bordello between 1911 and the 1920s. The upstairs rooms were still being used in the 1930s for lodgings when Christine Sterling persuaded Forman Brown, Harry Burnet, and Richard Brandon to open their Yale Puppeteers in the building. A tearoom and the studios of artists and photographers were also installed upstairs. The house gained further renown when a USO canteen was located in it during World War II.

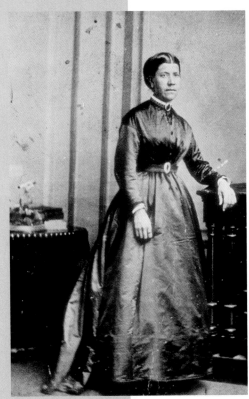

TOP
The Sepúlveda House today.
Photo by Susan Middleton, 2001

ABOVE
Eloisa Martinez de Sepúlveda, ca. 1890.
Seaver Center for Western History Research, Los Angeles County Museum of Natural History

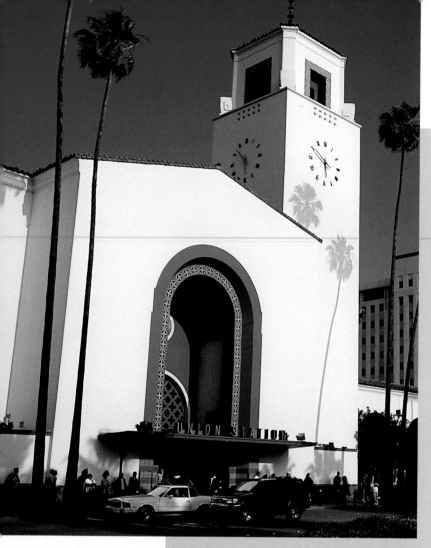

Union Passenger Terminal Station, 1933–1939

The Union Passenger Terminal Station, across Alameda Street from El Pueblo, was built and operated by three railroad companies: the Atchison, Topeka & Santa Fe; the Southern Pacific; and the Union Pacific. Popularly known as Union Station, it was constructed between 1933 and 1939. When it opened on May 7, 1939, with a great parade on Alameda Street, no one could have foreseen that it would be the last major railroad station built in the United States.

The entire Plaza area was threatened in the 1920s by plans for a new railroad station. A special election was held in 1926 to resolve the knotty question of where the new station would be located, and the Plaza area was narrowly chosen. Rather than wipe out all the historic buildings east of Main Street, however, the mayor and the railroads came up with an alternative location, which did, however, bring about the destruction of much of the city's original Chinatown. Union Station cost $11 million and covered a forty-five-acre site. Many of the Chinese residents and businessmen resettled northwest of the station in the area then known as Sonoratown and now known as New Chinatown.

Designed by the firm of John and Donald Parkinson, the station was constructed in a combination of Streamline Moderne and Mission Revival styles. Chief designer for the Parkinson firm was Edward Warren Hoak, who deserves the credit for the main buildings, which were intended to exemplify the California lifestyle of the time, when California's decaying missions were being restored and Mission Revival architecture was sprouting all over the state. Hoak's design included the soaring interior and its enormous vestibule with arched ceilings and mosaic marble

*Union Station entrance (top)
and main passenger lobby (above).*
Photos by Susan Middleton, 2001

Chandeliers adorn the lobby's soaring celing.

Photo by Susan Middleton, 2001

tiled floors. Marble from Belgium, Spain, Vermont, and Tennessee, as well as Montana travertine, was incorporated into the decor. Black walnut trim, wrought-iron grillwork, and bronze doors adorned the interior. Trees and brilliant flower beds brightened the land-scape outside.

In its first three years of operation, thirty-three trains carrying seven thousand passengers passed through the station daily. Each railroad had its own booth in the large lobby to the left of the main entrance. At the end of the enormous waiting room, ten train gates opened to a wide subterranean passageway leading to the tracks, of which there were thirty-nine, with sixteen for passenger trains and the rest for baggage, mail, private cars, storage, and switching.

During World War II, traffic tripled, with one hundred trains per day served by some one thousand employees. By 1958 the number of trains had been reduced to forty-eight. In 1959, as the first jets arrived at Los Angeles Airport, Union Station began to grow deserted. Today few buildings in the state evoke with comparable splendor the great days of train travel.

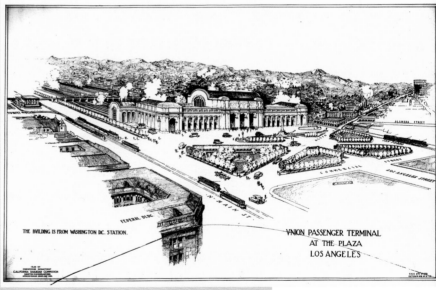

An early proposal would have built the city's new train station on the site of the pueblo, completely destroying the historic district.

Courtesy California State Archive, Public Utilities Commission, Case 970, glass plate negative, proposal

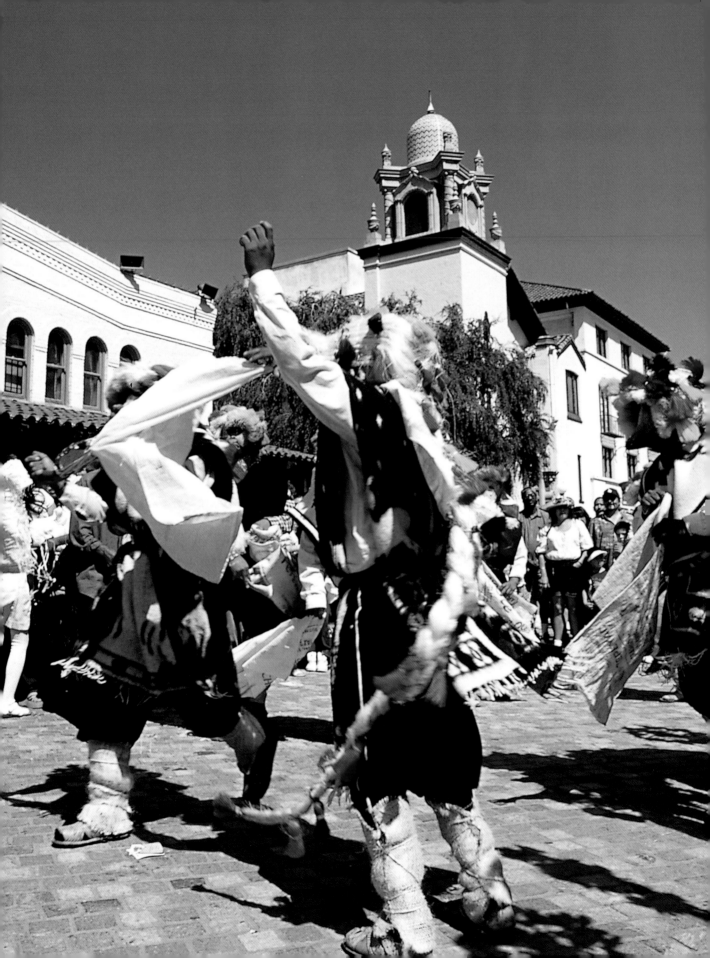

A LIVING HERITAGE

On a spring afternoon, El Pueblo is swarming with people. Under the spreading fig trees, traditional dancers perform in the Plaza. Smoke and smells of *carne asada* barbecue rise from food stalls into the day's late sunlight. Pinatas blow in the breeze. Down the hill in Father Serra Park, a crowd listens to a Tex-Mex band. It is Cinco de Mayo, the holiday honoring the Mexican army's defeat of the French at the Battle of Puebla in 1862.

El Pueblo today is much more than a historical site. It is also very much a place of living culture, whose heritage is remembered in the rituals of daily life and celebrated in festivals held throughout the year.

Native American dancers perform in the Plaza.
Photo by Susan Middleton, 2001

For much of the Mexican-American community, the Plaza has retained its importance as a vital center of social life and cultural expression. The Plaza Church, the oldest building in Los Angeles still used for its original purpose, is among the city's most important religious symbols. Families from throughout the area attend service on Sundays and holidays, and after church they chat in the courtyard and stroll around the Plaza, much as the town's residents might have done on Sunday afternoons in the 1840s.

More than seventy years after the Olvera Street marketplace opened, a number of its shopkeepers are direct descendants of those who tended puestos and stores on that first Easter Sunday in 1930. Gradually integrated with the Plaza's larger significance, Olvera Street has come to be seen not just as a tourist fantasy but as a landmark with a history of its own. As one of the city's leading tourist destinations, it is visited by more than two million people annually.

Many visitors also tour the nearby museums, interpretive spaces, and historic buildings. Each of these tells a different part of the pueblo's story, from the days of the Californio ranchos of Mexican Los Angeles to the streets of Old Chinatown, from French and Italian winemakers to the norteamericanos and others who took up residence here as the town grew into a modern metropolis. And there is the *América Tropical* mural, an artistic landmark that recalls the traditions of resistance and political protest that are also part of the pueblo's heritage.

On El Día de los Muertes, families set up special altars on the Plaza (opposite) and dress up in costume, in honor of friends and relatives who have passed away. Puestos and shops are decorated, and in the evening there is music, dancing, and a parade.

Photos by Susan Middleton, 2001

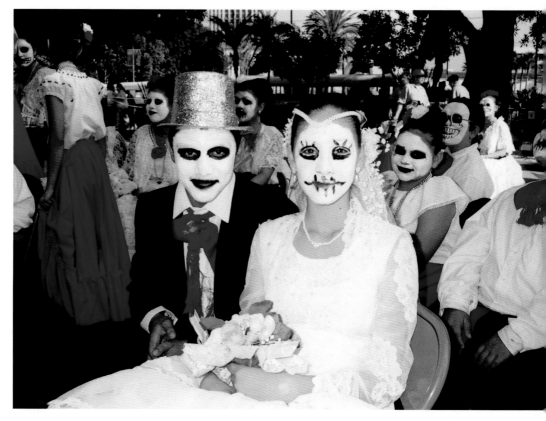

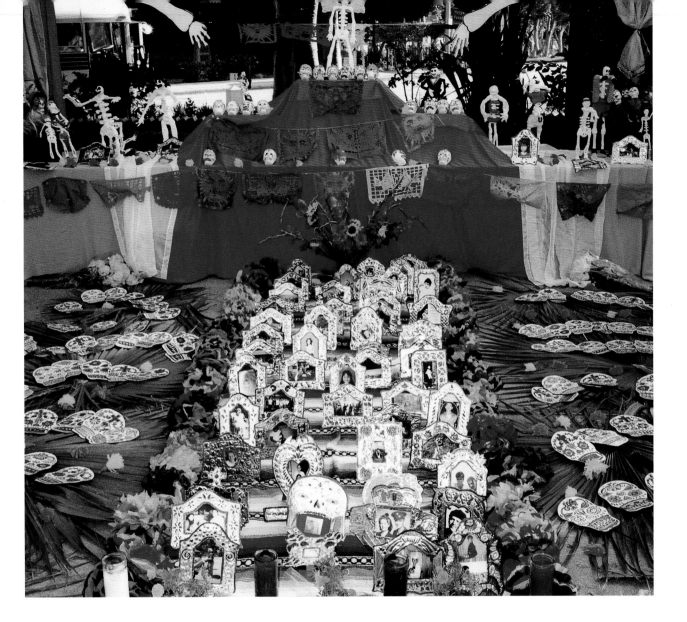

Visitors come to celebrate the festivals held here as well. Along with Cinco de Mayo, one of the most colorful is El Día de los Muertos, or the Day of the Dead, commemorated on November 2. Special altars are set up on the Plaza in honor of friends and relatives who have died. Puestos and shops are decorated, and in the evening there is music and dancing. Mexican Independence is commemorated both on the actual holiday, September 16, and on the nearest weekend, while Mardi Gras is feted in February before the beginning of Lent.

The Saturday before Easter, the Blessing of the Animals is celebrated, in gratitude for the services animals have given to humankind. It follows a custom said to have started in the fourth century following the death of the patron saint of animals, San Antonio de Abad. The ceremony generally starts at two o'clock, when gaily dressed merchants and members of the public with their various animals parade up Olvera Street, as a Roman Catholic prelate sprinkles them with holy water.

Each December the journey of Joseph and Mary to Bethlehem is depicted over nine nights in candlelight processions called Las Posadas. The rancheros' town homes once served as the *posadas,* or inns, where the procession representing the holy family sought

*Dancers perform on the
Plaza's bandstand stage.*

*A crowd in the Plaza on
Cinco de Mayo.*

Photos by Susan Middleton, 2001

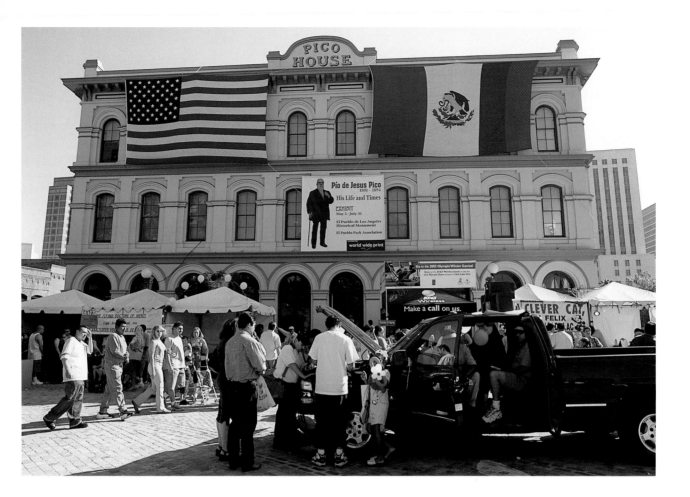

shelter. Various Olvera Street shops now serve this function. After the procession each night, a large piñata is broken in the Plaza, scattering candy and peanuts among the crowd.

The birthday of Los Angeles, generally celebrated on September 4, when the original pobladores are said to have been given their house lots and fields, is observed at El Pueblo on Labor Day. Members of Los Pobladores 200, a group of descendants of the original pobladores, lead a walk from Mission San Gabriel to El Pueblo, honoring those first settlers and commemorating the beginnings of the city.

Today, more than two centuries after its founding, El Pueblo serves as a prism through which Angelinos can contemplate—and, perhaps, celebrate—the complex cultural identity of the city that surrounds it. This is evident in the pueblo's Cinco de Mayo celebrations, which recall the fiestas in the time of the great ranchos, updated to express contemporary Los Angeles. Visitors throng Olvera Street. On the crowded Plaza, young people and families stroll about. A tenor saxophonist follows fandango dancers on the bandstand stage. News vans parked along North Main Street prepare for the evening's broadcast. Overlooking it all is the grand facade of the Pico House—this day adorned by American and Mexican flags. It was built more than 130 years ago, in an attempt to revive the neighborhood, by the man who had been the last governor of Mexican California. The old don surely would be pleased were he to witness the festive scene in the Plaza below.

The Pico House, on this day housing an exhibit honoring its founder, is adorned with Mexican and American flags.
Photo by Susan Middleton, 2001

SUGGESTED READING

Books

Balderrama, Francisco E., and Raymond Rodriguez. *Decade of Betrayal: Mexican Repatriation in the 1930s.* Albuquerque: University of New Mexico Press, 1995.

Bancroft, Hubert Howe. *History of California.* 7 vols. Santa Barbara: Wallace Hebberd, 1966.

Beandreau, Charles, and Fernand Loyer. *Le guide français de Los Angeles et du sud de la Californie.* Los Angeles: Franco-American Publishing Company, 1932.

Bell, Major Horace. *Reminiscences of a Ranger.* 1881; rpt. Santa Barbara: Wallace Hebberd, 1927.

Cleland, Robert Glass. *The Cattle on a Thousand Hills.* San Marino, Calif.: The Huntington Library, 1969.

Davis, Mike. *City of Quartz: Excavating the Future in Los Angeles.* Los Angeles: Verso, 1990.

Griswold del Castillo, Richard. *The Los Angeles Barrio, 1850–1890: A Social History.* Berkeley: University of California Press, 1979.

Harlow, Neal. *California Conquered: War and Peace on the Pacific, 1846–1850.* Berkeley: University of California Press, 1982.

———. *Maps and Surveys of the Pueblo Lands, 1853–1913.* Los Angeles: Dawson's Book Shop, 1976.

Heizer, Robert F. *Handbook of North American Indians.* Vol. 8, *California.* Washington, D.C.: Smithsonian Institution Press, 1978.

Hurlburt, Laurance P. *The Mexican Muralists in the United States.* Foreword by David W. Scott. Albuquerque: University of New Mexico Press, 1989.

Low, Setha M. *On the Plaza: The Politics of Public Space and Culture.* Austin: University of Texas Press, 2000.

McWilliams, Carey. *North from Mexico: The Spanish-speaking People of the United States,* 2d ed., updated by Matt S. Meier. 1948; New York: Praeger, 1975.

———. *Southern California: An Island on the Land.* Salt Lake City: Gibbs M. Smith, Peregrine Books, 1983.

Newmark, Harris. *Sixty Years in Southern California, 1853–1913.* 4th ed. 1916; Los Angeles: Zeitlin and Verbrugger, 1970.

Pitt, Leonard. *The Decline of the Californios: A Social History of the Spanish-speaking Californians, 1846–1890.* 2d ed. Foreword by Ramón A. Gutiérrez. 1966; Berkeley: University of California Press, 1998.

Ríos-Bustamante, Antonio. *Mexican Los Ángeles: A Narrative and Pictorial History.* Encino, Calif.: Floricanto Press, 1992.

Robinson, John W. *Los Angeles in Civil War Days, 1860–1865.* Los Angeles: Dawson's Book Shop, date TK.

Robinson, W. W. *Los Angeles from the Days of the Pueblo,* 2d ed., rev. Doyce B. Nunis Jr. 1959; San Francisco: California Historical Society, 1981.

Romo, Ricardo. *East Los Angeles: History of a Barrio.* Austin: University of Texas Press, 1983.

Villa, Raúl Homero. *Barrio-Logos: Space and Place in Urban Chicano Literature and Culture.* Austin, University of Texas Press, 2000.

Warner, Col J. J., Judge Benjamin Hayes, and Dr. P. J. Widney. *An Historical Sketch of Los Angeles County.* 1876; rpt. Los Angeles: O. W. Smith, 1936.

Weaver, John. *Los Angeles: The Enormous Village, 1781–1981.* Santa Barbara: Capra Press, 1980.

Articles and Booklets

Adler, Patricia. "History of the Avila Adobe." El Pueblo de Los Angeles Historical Monument, 1971 (History Division Files).

Estrada, William. "Los Angeles' Old Plaza and Olvera Street: Imagined and Contested Space." *Western Folklore* 58, no. 2 (winter 1999): 107–29.

Goldman, Shifra. "Siqueiros and Three Early Murals." In Goldman, *Dimensions of the Americas: Art and Social Change in Latin America and the United States.* Chicago: University of Chicago Press, 1994.

Kelsey, Harry. "A New Look at the Founding of Old Los Angeles." *California Historical Quarterly* (winter 1976–77): 327–39.

Levin, Jeffrey. "*América Tropical.*" *Conservation: The Getty Conservation Institute Newsletter* 9, no. 2 (summer 1994): 4–8.

Owen, J. Thomas. "The Church by the Plaza." *Historical Society of Southern California Quarterly* 42, no. 1 (March 1960): 6–28; no. 2 (June 1960): 186–204.

Piqué, Francesca, et al. "Original Technique of the Mural *América Tropical* by David Alfaro Siqueiros." In *Materials Research Society Symposium Proceedings* 352 (1995).

Sterling, Christine. *Olvera Street: Its History and Restoration.* Long Beach, Calif.: June Sterling Park, 1947.

Treutlein, Theodore E. "Los Angeles, California: The Question of the City's Original Spanish Name." *Southern California Quarterly* 55, no. 1 (spring 1973): 1–6.

Wood, Raymund F. "Juan Crespí: The Man Who Named Los Angeles." *Southern California Quarterly* 53, no. 3 (fall 1971): 199–234.

ACKNOWLEDGMENTS

As the birthplace of Los Angeles, El Pueblo de Los Angeles has long held an eminent place in the history of Southern California. With its multicultural legacy, the pueblo ranks among the most important cultural symbols in Los Angeles. We are happy to have this book present the story of El Pueblo to the public.

An important part of that story is the continuing effort to preserve the pueblo's rich heritage. Much progress has been made in recent years, including the conservation and restoration of such grand historic buildings as the Pico House, the Sepúlveda House, and the Garnier Block, where the new Chinese American Museum is scheduled to open soon. A number of other projects for El Pueblo are being developed as well.

The Getty Conservation Institute became involved in the conservation of the mural *América Tropical,* by David Alfaro Siqueiros, in 1987, and we are looking forward to the moment when the mural, so important to the city's traditions of public art, can go on view once again. We thank the many GCI staff members who over the years have contributed to the success of the project. A special debt of gratitude is owed to Miguel Angel Corzo, former director of the GCI, under whose guidance the project to conserve the mural began, and Kristin Kelly, who is seeing the project through to completion. Friends of the Arts of Mexico served as a valued partner during the project's early phases. Tom Hartman, president of the design firm I.Q. Magic, has been a valuable partner in the effort to present the mural and interpret it for the general public. Juan Gomez-Quiñones has offered consistent encouragement.

This book has similarly benefited from the contributions of a number of people. Chris Hudson, publisher, and Mark Greenberg, editor in chief, Getty Publications, and Neville Agnew, former head of publications at the GCI, have encouraged the project from its inception. Our thanks go to Leslie Rainer, Francesca Piqué, Martha Demas, and Jeff Levin, all at the GCI, who reviewed chapters of the manuscript, and to GCI staffers Mitchell Bishop, Rand Eppich, and Valerie Greathouse, who assisted with the research. We would also like to thank the El Pueblo Monument Association for its assistance. Paquita Machris deserves our particular gratitude for her generous contribution to help offset the development and photography costs of the book. A special debt of gratitude is owed to William Estrada, Richard Griswold del Castillo, and Suellen Cheng, who read the manuscript and made valuable suggestions about how it could be improved, and to Shifra Goldman, who reviewed the

Siqueiros material and generously provided several photographs from this period. Huston Horn and Julie Sandoval helped in the manuscript's preparation. We would like to thank Doyce B. Nunis, Jr., Judson Grenier, Fernando Guerra, the late William B. Mason, and the late J. Thomas Owen. Several colleagues at sister institutions provided particularly helpful assistance with picture research: Carolyn Cole, of the Los Angeles Public Library photo collection, Lisa Escovedo, of the Natural History Museum of Los Angeles County, and John M. Cahoon, of the Seaver Center for Western History Research, Natural History Museum of Los Angeles County. Staff at other institutions throughout the state generously assisted with photo research as well. Susan Middleton carried out the fine photography of El Pueblo as it is today.

Finally, we would like to thank the authors. Jean Bruce Poole has devoted more than twenty-five years of her life to the management and preservation of El Pueblo. During this time she has tirelessly worked to safeguard and promote its heritage, and the citizens of Los Angeles are in her debt. Tevvy Ball, editor at Getty Publications, did a fine job on this book as well. Special thanks also go to Sheila Berg, who copyedited the manuscript; Jim Drobka, who designed the book; and Anita Keys, who coordinated its production.

Timothy P. Whalen
Director
The Getty Conservation Institute

INDEX